STARTING UP A GALLERY AND FRAME SHOP___

ANNABELLE RUSTON

Published by Fine Art Trade Guild & A&C Bla...

ISBN 978-0-7136-8475-9

Researched and edited by Annabelle Ruston
Page and cover design: Tina Tong and James Watson
Project managers: Susan Kelly and Sophie Page

Preface by Dayle Flude of The Frog & Mouse Picture Company

Although every effort has been made to ensure that all the
information in this publication is correct, the Fine Art Trade
Guild and A&C Black cannot be held responsible for any errors
or for financial transactions made on the basis of information
in this publication.

Fine Art Trade Guild
16–18 Empress Place, London SW6 1TT
Tel: 020 7381 6616 Fax: 020 7381 2596
info@fineart.co.uk
www.fineart.co.uk

Printed and bound in Great Britain
by MPG Books Ltd, Bodmin, Cornwall

Contents

Acknowledgements

Thank you to Christrose Sumner, Managing Director of the Fine Art Trade Guild, for her guidance and numerous contributions to this book. Particular thanks are also due to Kanak Dhutia for her invaluable advice on financial matters.

Thanks also to Neil Duguid GCF, Susan Ilett GCF, Ian Kenny GCF and Martin Tracy GCF. Information they provided has immeasurably strengthened this book. I am also very grateful to Dayle Flude for taking time out from her busy schedule to write a preface to the book.

Preface

This is the ultimate resource for anyone thinking about starting up in the picture business. I have been running a successful gallery and picture framing workshop for the past ten years. While the overall experience has been a joy, at the start there was much to learn and numerous personal challenges and stresses.

This book is full of essential small business information and user-friendly advice relevant to the picture business. It will equip you to identify business opportunities, find the right type of premises, raise finances for start up and growth, understand pricing and making a profit, help you to find and keep your staff and to keep up-to-date with the latest legislation.

Old hands, like me, will wonder how they ever got started in the business without it and can take inspiration from it to reflect upon and re-examine business practices.

So if you are serious about starting up in the picture business you need to keep this book within easy reach.

Dayle Flude
The Frog & Mouse Picture Company

Introduction

There are excellent business manuals available, a good many focusing on how to start up and run a small business. The strength of this volume is my wide experience in working with the owners and managers of independent art galleries and picture framers. While other books explain many of the joys, pitfalls and technicalities involved in running a small retail business, none embrace the expertise required to buy and sell pictures and offer a professional framing service. This book does both.

Many aspects of running a gallery or frameshop do not apply to most other types of retailer. For example, galleries may handle artists' original work on a sale or return basis, and add value to images with creative framing, while framing combines elements of professional consultation, manufacturing and retailing, as well as craft skills.

In the course of editing *Art Business Today* and working for its publisher, the Fine Art Trade Guild, which is the trade assocation for the art and framing industry, I am in daily contact with gallery owners, picture framers, artists, print publishers, framing wholesalers and fine art printers. I commission articles from within the sector, interview key players and have to keep abreast of all pressing issues. Every day brings contact from a range of people within the industry, airing and discussing their successes, challenges and opportunities.

The Fine Art Trade Guild is the information hub of the art and framing industry. I feel sure that our wealth of information will offer valuable help and guidance to people embarking on a career as independent retailers in this sector.

It should be pointed out that this book is not a technical framing manual. Rather, I examine how to run, market and develop a successful framing and art retail business. There are books and training recommended by the Fine Art Trade Guild which are designed to teach the technical aspects of picture framing; these are regularly updated on the Guild website, *www.fineart.co.uk*, and are listed at the end of this book.

Annabelle Ruston
Fine Art Trade Guild

Chapter 1

Getting started

Is running your own business for you?

Providing you have the right temperament and financial circumstances, running your own business can be incredibly rewarding. The quality of life and level of job satisfaction can be fantastic. Just walking up to the fascia decorated with your business name and logo each morning can make it all worthwhile.

Starting a new business requires clear objectives that closely match your skills and strengths. You need to decide which areas it would strengthen your business for you to delegate. There are various types of art and framing business; you need to be clear about which type you want to open, and which services you will offer. Many picture framers begin framing as a hobby, which then develops into a business. People tend to frame because they are creative and love a technical challenge; they have an eye for design and like working with their hands. Similarly, many galleries are owned by artists and are an extension of their passion for art, rather than primarily a business venture.

Whether you are buying artwork or making quick decisions everyday about which frames will best suit customers' artwork, you need to understand colour. There are numerous books and articles on this subject, but you still need some personal flair and instinct for what will look best and which images will sell. Knowledge of art and art history gives an additional, important, perspective.

Many gallery owners and framers say that they are not in it for the money; they love the work, the product and the variety of their day-to-day work. They relish being their own boss and having control of how they work, and they delight in the end of office politics or the stress of management making decisions over their heads.

A 2004 survey conducted by leading trade magazine *Art Business Today* revealed that only five per cent earn more than £65,000 a year. About a third earn less than £25,000. So, for many, going into retailing means not only the end of the stability of a regular wage, but a considerable drop in their standard of living. And this is particularly likely to be the case at the beginning of your venture.

Self-employed people who go back into employment are often heard to say that, in the end, they could no longer handle chasing debts and the stresses of tight cashflow; they were happy to swap the so-called freedoms of self-employment for the re-assuring tyranny of a regular monthly pay slip. You might think you are your own boss, they add, but in reality you are a slave to the bank manager, your landlord and the tax office.

The highest earners run the largest outlets, generally employing more than five people. They also work very hard, with more than half of them working over 50 hours a week. In fact, any small retailer will confirm that the hours and commitment far exceed the levels required when they were working for somebody else.

As well as long hours and low pay, independents repeatedly explain that once you are self-employed you never really get a day off at all, since you are always thinking about the business. This lifestyle is not for everybody; it requires sufficient self-discipline to ensure that you can separate work and home life to a healthy extent.

Tremendous skill and determination are required to set up on your own. Once it might have been enough for a framer to be a skilled craftsman, but in today's highly competitive culture a framer also needs marketing and sales skills, an understanding of retailing, business and financial matters and IT skills. On top of that, independent retailers also need to be organised, to have the ability to stand back and look at their business objectively, to be able to negotiate when buying, to have a manner that entices people to buy, to stay calm in a crisis, to have a good memory for names and faces . . . the list goes on. So it goes without saying that independents also need to be good at managing their time and prioritising. There are not many jobs that

13

demand such a range of skills. Underestimating the skills necessary to survive in today's marketplace can result in undercharging, insufficient investment in new materials and equipment and attracting customers unwilling to pay for a professional service. It is too easy to end up working all hours for a pittance and to feel out of control.

Small retailers often feel isolated, which is one of the reasons for joining a trade association and why many enjoy getting to know sales reps. People who have been employed may miss the reassurance of acknowledgement from their boss when they do well, or the shared comradeship of a workplace and regular staff meetings. When you are self-employed, there's no going to your boss and asking for a transfer to another department.

Many independents do not draw a salary from a new business for several years. Some have the financial support of a domestic partner, others have redundancy money, a loan, a part-time job or savings. Whatever your financial circumstances, the chances are that for the first few years you will be living on a tight personal budget. It is worth mentioning here that one of the main reasons that some people choose to buy an existing business rather than start from scratch is that they should be able to draw the same salary as the outgoing owner right from the start; see Chapter 3: Should you buy an existing business? (p.40).

Many people dream of opening their own business but just don't quite have the nerve to go for it. For those that do, life as a self-employed retailer can be a dream come true.

Is your business idea viable?

Once you have established that your personality and circumstances are suited to life as an independent retailer, the next step is to ensure that your idea and your plans for implementing it are viable. It is now time for some serious research. Many entrepreneurs fall in love with their idea and are so enthusiastic about it that they neglect to carry out proper feasibility studies and market research. Careful planning and financial forecasts are essential. You can't just picture the best possible scenario and then go for it; your business is far more likely to succeed if you plan each phase of its development carefully and cost out each one. Your idea does not have to be original. The essential thing is to be more effective than your competitors. In fact, a totally unique idea would probably be rather hard to sell, as you would need to educate your potential customers into first understanding your product or

service and then convince them that they need it. Market leaders such as Specsavers, Starbucks and Snappy Snaps did not begin by doing something that no one had done before; they provided a service for which there was a proven demand and made the advantages of taking your business to them abundantly clear.

Proper feasibility studies and market research must be carried out in the following areas:

1. USP

You must be absolutely clear about your Unique Selling Point, or USP. If you are not clear about it, your customers will not understand your message. There needs to be a concrete reason why people should shop with you, rather than spend their precious disposable income elsewhere. There must be something that you do better or differently from your competitors, and you must make sure that your customers know what it is.

Below are some USPs that are used by successful art and framing retailers. However, the list could go on, these are merely some (hopefully inspiring) suggestions:

Customer service and product knowledge
People can buy frames and prints all over town, but no one else can offer such valuable advice and specialist knowledge. Artwork is really safe in the hands of this expert, and no one knows more about which artists' materials are best for which job. A delivery service and quick turn-around time might be part of this package.

Exclusive range
Your USP might be your exclusive range of carefully chosen high-quality images and gifts, many of which won't be seen anywhere else in the area. Customers could feel confident that anything they bought from you was in the best possible taste. Or you may specialise in certain subject matter, such as aircraft, birds or country scenes, making you a destination shop for people interested in those areas.

Master craftsman
You might be master craftspeople who can gild frames in the traditional manner, to a standard that no one else for miles around can aspire to. You could advertise the fact that 'nothing is too unusual for us to frame'. Being a qualified Guild Commended Framer is a USP if no one else is offering this level of professionalism (see the section on

framing in Chapter 9: Which services to offer (p.96) for details about this qualification). If your competitors afre GCFs you need to pass an Advanced GCF module in order to stand out.

Affordable art
It might be right for you to position yourself as selling original art at affordable prices, and to make it clear that all of your artwork is priced at less than, say, £3000. You might emphasise that your selling environment is relaxed and staff are friendly, in order to attract buyers who might otherwise be intimidated about buying art.

Whatever your USP, you need to ensure that it guides all your marketing and product sourcing choices.

2. Demand
Check and double check that there is sufficient demand for an art and framing business in your area. Look at the advantages of your product and how many people in your proposed location would find these beneficial. For example, a benefit of owning professionally framed limited edition prints might be that your home is visually enhanced. The type of people who want this benefit would be house-proud and have some disposable income, but would not be sufficiently wealthy to buy original paintings for thousands of pounds.

Also analyse whether the type of customer you want to reach is a growing or receding demographic, or whether growth is stagnant (see the section on 'target customers' below). The more information you can find to back up the idea that your target customer will be in easy reach of your premises, and in large numbers, the better.

Consider your price range and whether there is proven demand in your area for homewares and gifts in this price bracket. Look at the average prices for luxury items in the surrounding shops.

Assess how much business local shops achieve. You can do this by watching how many people come out of the surrounding shops holding carrier bags. Visit local shops during the lunch hour, at weekends and at a range of times in order to see how busy they are. Try to build up a picture of how many people are actually buying, rather than browsing or killing time.

Also look at social trends. For example, the current popularity of interior design, home makeover and gardening in the media indicates that people are interested in improving their homes, which is good for art and framing retailers. The popularity of cookery and wine as media topics indicates that people like entertaining in their homes, so should want to enhance them.

A visit to *http://pulse.ebay.co.uk/* shows which products have been selling best through this internet giant. It is worth looking to see how many pictures and frames have been selling.

If there isn't an art and framing business of your proposed type in the area already, consider why not. If independents are moving into the street you have in mind and are selling homewares and jewellery, perhaps a gallery would be the ideal complement. But if they are mainly fashion boutiques then perhaps your target customer wouldn't have buying art in mind when shopping there. If there are already galleries and gift shops in your area it may be that there is still room for another one as the area is developing a reputation for this type of shop and 'destination shoppers' are going there.

3. Target customers

You need to analyse who you want your target customer to be, then ensure that your marketing message will reach that type of person. For example, if you think that your shop will mainly appeal to middle-class people decorating their homes and buying gifts, you need to ensure that this type of person will pass your shop in sufficient numbers and respond to your marketing initiatives. Spend time in the area in which you plan to open your shop and watch the type of people that go into other retail outlets; see which carrier bags they are holding, how they dress and what cars they drive.

People who buy art and framing are likely to be home-owners, so it would be important to know that your chosen location has a higher-than-average percentage of home ownership, preferably with plenty of turnover. Retired people often take up painting (so buy art materials) or sewing (so buy craft kits), and may particularly value good customer service and affordable framing. However, retired people are less likely to be furnishing their homes, and may even be down-sizing, so could be less good customers for a gallery.

Artists and art students buy framing, art materials and digital printing services. While it would be fair to say that these demographic groups tend to be price-conscious, they can generally be relied upon for repeat business and have the benefit of needing a range of products and services.

Demographic and local authority websites include information on what type of people live in the area, how much their houses are worth and whether the area is up-and-coming. There are a number of websites that just require you to type in a postcode in order to retrieve a host of invaluable data. You need to look at, for example, the size of property that is selling best, how many people are living alone and their ages. It is a good sign for businesses selling pictures and frames in most price brackets if new homes are being built at a good rate in your chosen location. Some broadbrush demographic data will form a valuable part of your business plan (see Chapter 7: Writing a business plan on p.81).

If you plan to handle highly specialist framing work, and will be targeting galleries and museums for business rather than the public, then you may not need much passing trade so an out-of-town site might suit you better. In this case, you need to ensure that you are easy to find, that there's ample parking and that there is a good concentration of galleries and heritage sites nearby.

4. The competition

You will of course have competitors; not just other art and framing retailers, but fashion, technology and homewares shops that are competing for the same slice of disposable income. You need to feel confident that the surrounding shops will help attract your target customer, rather than take business away. Other businesses in the area must complement yours, not present a threat.

Chains and discount stores are competitors with extensive marketing budgets. A big advantage for the small retailer is that they can respond to changes in fashion and demand very quickly, without a long paper trail or office politics. They can also offer a personal bespoke service and meet individual customers' precise requirements, which staff in chain stores may not have the freedom to do. Chains and discount stores have taken over much of the market for ready-made frames and inexpensive prints, leaving independents to focus on more sophisticated aspects of the market.

Many in the trade believe that art and framing will never be sold in a big way via the internet, as they are visual products which need to be

actually seen, and held in a certain light, before people decide to buy. Also, many customers lack the confidence to buy art without the reassurance and expertise of a reputable gallery, and want to discuss their requirements with a knowledgeable and trustworthy person.

However, the power of the internet cannot be dismissed. There are businesses that are successfully selling artwork online, and experienced collectors who know what they are buying may choose to buy this way. Retailers who do have secure shopping on their websites tend to report that work by established artists sells in this way, but people are less willing to buy something from a new artist without seeing it first. A quick Google search or look at eBay shows how much art is sold via the internet.

5. Broadbrush financial scenario

Before you progress very far with your idea you need to check that it is financially viable, i.e., that the business will generate sufficient revenue to pay all your overheads and that you can sell products and services at prices that generate sufficient profit. This is discussed in Chapter 5: The financial side of setting up (p.60).

6. Evolving challenges

You must consider how circumstances affecting your business might change in the future. For example, there might be plans to build an out-of-town retail park or shopping mall in a location that will take business from you. Or there may be plans to change parking regulations, put up the cost of parking, set up a paid-for congestion charge zone or close roads to traffic for a long time while public transport links are improved. You may be thinking of moving into an area that is changing fast; go to the town hall and study demographic changes such as which types of housing are increasing.

As well as challenges affecting your chosen geographical location, you must look at changing buying patterns. Look at the impact of the internet and mail order catalogues on your type of products and services. For example, more and more art materials are sold from catalogues and via the internet, as these low-overhead operations can sell at highly competitive prices.

7. SWOT analysis

Having worked through all of the above, you should use the information you have gathered to compile a 'SWOT analysis'. This acronym

stands for: strengths; weaknesses; opportunities; threats. Draw up four columns and fill in ideas and findings, with the aim of bringing the vulnerable areas in your plans to the fore. If the negatives (weaknesses and threats) outweigh positives (strengths and opportunities) you need to re-think your plans. There will always be some negatives, but you need to feel confident that you can survive these.

One of your strengths, for example, might be that independent homewares shops are booming in your area. A weakness might be that you have no previous experience in launching a retail business; an opportunity might be that there is no other gallery in the area; a threat could be that rents are rising rapidly and a few chain stores have opened, which could drive them up even further.

Industry statistics

While assessing whether your business idea is viable you may look for statistics about the size of the market. These look professional as part of a business plan and can help convince bank managers and investors that you have carried out thorough research.

There are very few published facts and figures about the art and framing industry as the sector is too small for the government or private industry to see it as worthwhile to invest in expensive market research. Leading trade magazine *Art Business Today* commissioned research into the industry in 2003; the exercise was extremely costly and may not be repeated for a number of years.

The research revealed that the total UK turnover, excluding export, for the framing supply industry was £82million. The retail price for bespoke frames is normally four times the cost of materials (or three times in the volume trade, where margins are smaller) so the retail value of the UK framing industry was worked out at between £246million and £328million.

The UK print and poster publishing and distribution sector was valued at £140million retail, based on distributor turnover for UK activity of £70million.

Statistics for the greeting card industry are available on the Greeting Card Association website. This retail sector is valued at over £1.2billion, which shows that art and framing, by comparison, is a small specialist sector.

Your trading name

It is essential that your name should appeal to your target customer and convey your USP. In other words, your name should reflect the core values and aims of your business. When thinking of names you should also consider the colours, logo and graphics that might accompany it on your shopfront, stationery and marketing material.

It is a good idea for your trading name to make it clear to people what you do, which the suffix 'gallery', 'fine art', 'framing' or 'gallery and frame shop' will achieve. This means that people looking for your type of shop will see your name and immediately know to come to you. This type of descriptive name may also win you business when people are searching the internet for a local framer or gallery, as it may help bring your business to the top of a search engine list. Words like 'design', 'creative' and 'bespoke' can be effective when included in the name of an art and framing retailer.

A name such as Grosvenor Fine Art, for example, sounds English and traditional, and arguably up-market, so might be good for a gallery selling high-end Victorian paintings or engravings. Fantasy Framing sounds as if its work would be imaginative, while The Bespoke Framing Company sounds professional and dependable.

Names such as Art Attack and Off the Wall are memorable, which is a good thing, but some would argue that puns convey a slightly unsophisticated image. Wacky names may not appeal to older customers, or people with conservative tastes, but younger customers may be drawn to such businesses and a wacky name might help indicate that you sell unconventional artwork.

Something simple like Guildford Art & Framing can do the job of telling people what you do and where you are located, but is not that memorable. This name does not give away whether you are selling traditional landscapes or edgy abstracts, but may be fine for a business that sells a broad range of artwork and offers a general framing service (rather than a highly specialist one).

Beware of having a name that is too similar to that of an existing business, as it may be rejected by Companies House if you try to register the business as a limited company. It is easy to search the database of company names on the Companies House website. This is

worth considering even if you are setting up as a sole trader (see Chapter 2: The formalities on p.24), because you may want to switch to becoming a limited company at a later date and, in any case, it avoids costly wrangles.

Also, if your name if too similar to someone else's you may find that suppliers get muddled and deliveries go wrong. For example, there are a number of businesses nationwide called variations of Frameworks, Frame Works, The Frame Works etc; the others may be located many miles away, but you may be buying from the same suppliers.

Companies House can also reject names that are misleading, offensive or which are already registered as trademarks. The use of certain words in business names are controlled by law, for example, British, Royal and Bank.

See 'Registering your web address' (p.29) as you should check that your proposed name is available as a web address before you finally decide upon it.

Your logo and corporate identity

Your corporate identity communicates an easily recognisable image of your company. It functions subliminally, creating powerful associa-tions in people's minds. The idea is that a combination of particular graphic elements can pack in all kinds of messages about a company. Your corporate identity should be employed consistently throughout your marketing, branding and display materials.

Your target customers should instantly recognise your ads, leaflets, packaging and delivery vans. Your logo, corporate identity, including house colours and typeface, should work with your name to make your business memorable and to tell people what type of business you are and what you actually do.

Your logo might just involve initials, or your name in a certain typeface, or it might include graphics. It must however reflect the values at the core of your business and speak to your target customers. The key point is that once you have a logo you must stick with it and use it consistently wherever possible. The logo on your shop front, van, car-rier bags, clothing, and even your bicycle, is working to publicise your business 24-hours a day. This compounds the effectiveness of your advertising and marketing.

A retailer whose USP is timeless craftsmanship would chose a very different corporate identity from one who is promoting edgy contemporary art. Typeface, colour and graphics need to reinforce the message that you are seeking to convey.

Consider print costs; a logo that can be printed in a single colour, or maybe two colours, will save money. Ideally it should work when printed in black as well, so that you can use it successfully in Yellow Pages and local newspaper advertisements. It is best if your logo does not involve subtle shades of the same colour, as these may not photocopy or fax clearly; it is preferable if there is a strong contrast between the graphic and the background.

When you have chosen the 'corporate colours' that will feature in your logo make sure that you know the Pantone reference for these colours, as well as the CMYK breakdown. This latter refers to the percentage of each primary colour, plus black, that makes up your colour. You can then supply all printers, sign-writers and manufacturers with this data to ensure that they produce artwork in exactly the right colour.

Make sure that your logo is stored on your computer and is properly backed up. It should be available to advertisers and printers in JPEG and TIFF format.

You may decide to appoint a graphic designer to come up with a logo for you and design your stationery and blueprints for marketing material. Designing a logo need not cost a lot of money; some quick internet research will show that you can pay anything from £100 to £1000 for this job. The same goes for graphic design.

It may be a good idea to pay a graphic designer at the beginning, who will come up with a house design style and typeface, which you can then mirror throughout your marketing material in the future.

Some businesses have a 'strapline' or slogan that accompanies their logo and is part of their corporate identity. A strapline can encapsulate your business aims and be very effective at conveying them to customers. It is interesting to think, for example, about how different an impact the slogan 'perfect picture framing every time' has from 'perfect picture framing at the right price'.

Chapter 2

The formalities

There are various legal requirements to consider before you start trading. Subjects such as VAT and registering with Companies House might sound uninspiring, but getting such matters sorted out from the start can save time and money, and can also help clarify your thoughts on how the business will be run.

Should you be a limited company?

1. Sole traders and partnerships

Many picture framers work alone and their legal status is that of a sole trader. This means that it is not legally necessary for them to pay an auditor to look at their accounts each year, their accounts should be simple and tax and national insurance payments are lower than they would be for a limited company. It is easy to start trading as a sole trader, but the major disadvantage is that you are personally liable for all your business debts.

If you are working from home, turning over well under £100,000 a year and each framing job is worth little more than £150 or so, it may be best to operate as a sole trader. Such businesses are not generally owed large sums of money; the worst scenario is a few uncollected frames and work is nearly always paid for before it is taken away. This type of sole trader is likely to have little money tied up in stock and other overheads. So liability for the business's debts should not cause too many sleepless nights.

Partnerships have a similar legal status to sole traders, but a critical point is that each partner is personally liable for all the business's debts, regardless of who may be deemed to have caused the debt. A prime reason why small businesses fail is disputes between partners, so if you are going to form a partnership you need to be sure that a thorough legally binding document is drawn up between you. See 'Partnership agreements' below.

Once a business grows, so do its potential liabilities. People should consider forming a limited company if they take on a commercial lease and are investing considerable sums in stock or equipment.

Bear in mind that sole trading businesses and partnerships are harder to sell than limited companies, and investors tend to be less keen to invest in them. They can appear highly personal and less professional than limited companies; their value is deemed to be in the owner, rather than in professional foundations and business structures.

2. Limited companies and limited liability partnerships

A key advantage of forming a limited company, providing you are trading lawfully, is that your liability is generally limited to the amount you have invested in the company (although many businesspeople have given personal guarantees to secure loans or to landlords).

Limited companies have more commercial credibility than partnerships and sole trading businesses, so it is easier to attract investment, to sell the business and to buy goods on account.

There may be tax advantages for the directors of limited companies once their earnings are high enough for them to have money to invest in pension plans. Your accountant should advise you on the current options, as these are subject to change.

The annual accounts for limited companies are more complicated than for sole traders, and take up more time and money, such as paying an accountant. It is more complicated to form and wind up limited companies than sole traders or partnerships. Limited companies must be registered with Companies House, which publishes a useful booklet on its rules, *www.companieshouse.gov.uk*.

It is possible to buy limited companies 'off the shelf' from Companies House, which can be more cost-effective than setting one up from scratch. It doesn't matter what the company is called, you can still

trade under your chosen business name, so long as your invoices and letterhead state your registered business name and number.

Limited liability partnerships are similar to limited companies in that the partners have limited liability for debts and annual accounts must be filed, but tax may be lower. Your accountant should advise whether this legal structure would be beneficial for you.

Partnership agreements

Employing people is discussed in Chapter 17: Employing staff (p.193), and this is a separate issue from agreeing the terms and division of responsibility between partners. It is essential to do this at the outset, as it will go a long way towards preventing disputes. Your partnership agreement needs to be agreed and signed by all parties involved.

You need to decide:

- Who is responsible for each area of the business
- How each partner's performance will be assessed
- How profits and losses are to be shared, and how much money each partner can withdraw from the business and at what dates
- How many hours each is expected to work, including holiday entitlement and sick leave
- The amount of money each partner can spend without consulting the other (cheques over a certain value should require two signatures)
- How to handle a situation where one partner wants to get out of the business, dies or is unable to work effectively due to ill health.

This last point is particularly important. If one partner wants to get out, you want to avoid the necessity of the other having to sell-up in order to buy them out. Arrange a schedule of gradual payments and profit shares. How this is organised will depend upon how much capital each partner invested in the first place, whether your shares in the business are equal, whether the business could continue trading with just one of the partner's skills etc. A solicitor will advise on the most sensible plan for your particular circumstances.

Income tax, national insurance and corporation tax

You need to notify your local tax office and the Department for Work and Pensions when you start trading, whatever your legal status. Working out exactly how much tax and national insurance you need

to pay depends on the current tax rates and allowances. The actual calculations are done by means of tax tables available at the HM Revenue & Customs website (*www.hmrc.gov.uk*).

All traders can offset certain overheads against tax. These include office furniture and equipment, cars, interest on loans, travel and some entertaining; you need to be able to justify inclusion of the item to the Inland Revenue. The term 'offset' means that the expenditure reduces your profit so, in effect, you do not pay tax on the income that pays for that expenditure. There are rules and regulations surrounding the offsetting of tax, of which your accountant will advise you; for example, hire purchase payments on a car can be offset, but not the first £1000, and depreciation of that car can be offset against tax.

Many small business owners see doing their accounts as a tiresome chore and feel resentful that they are doing the Inland Revenue's work for them, so they do not treat their accounts as a priority. In fact, efficient book-keeping means that you should be fully aware of your cash-flow status and understand how well you are doing. Without a clear picture of your current financial position and trends you cannot manage your business effectively, so it is sensible to view book-keeping as an essential part of driving your business forward.

1. Self-assessment for sole traders and partnerships

Sole traders and partnerships pay tax on their profit, which is worked out on a self-assessment basis. As far as the tax office is concerned, profit is excess income before the owners have withdrawn any salaries. These types of business do not pay income tax (unless they have employees), or corporation tax, though the owners must make national insurance contributions as well as pay their self-assessed taxes.

2. Income tax

For the 2007/08 tax year there was a basic rate of tax of 22 per cent and a higher rate of 40 per cent, payable on salaries over £34,600. When you form a limited company you cease to own the business, rather, the owners become employees of the company. Therefore the owners must pay income tax on their salaries, as well as corporation tax on their profits (see below).

3. National insurance

Payment of national insurance allows access to state benefits including a basic pension. Contributions are compulsory whether you are a sole trader, partnership or the director of a limited company.

Rates vary and there are between exemptions, but for the 2007/08 tax year employed people earning £100 and £670 a week must pay 11 per cent of this amount. Those earning more than £670 a week pay one per cent of earnings above that sum.

For the 2007/08 tax year, self-employed people pay national insurance at a flat weekly rate of £2.20, plus a percentage of taxable profits. This amounts to eight per cent on annual taxable profits between £5,225 and £34,840 and one per cent on any taxable profit over that amount.

4. Corporation tax

Corporation tax is paid by limited companies on their profits. If your company is liable to pay corporation tax you must tell HM Revenue & Customs; either download the appropriate form from their website or contact your local tax office. You must then submit tax returns, which will entail keeping accurate records of income and expenditure. Late pay-ment can result in fines so make sure that you are clear when your tax must be paid and your tax return submitted. You, or your accountant, has to work out how much is owed on a self-assessment basis based on how much profit you made in the accounting period covered by your company tax return. In 2007/08 small companies, i.e. those with profits of less than £300,000, must pay a 20 per cent rate of corporation tax.

5. Tax and national insurance for employees

See Chapter 17: Employing staff (p.193).

VAT

If you turn over more than a certain amount (£64,000 in 2007/08) you need to register for VAT, even if you turnover more than quarter of that amount in one financial quarter. If you expect to achieve this fig-ure in sales pretty quickly, you should register before you start trading. While this of course means that you will have to submit quarterly VAT returns and charge 17.5 per cent VAT to your customers, it also means that you can claim back the VAT on materials and supplies that you buy. VAT is payable to HM Revenue & Customs each quarter, and is

payable a month after each quarter ends. You will be fined if you pay your VAT late. Once registered, you need to issue VAT receipts and keep the correct records.

Not all goods attract VAT at 17.5 per cent. Some goods, such as basic groceries, are exempt, while reduced VAT of five per cent is payable on other types of groceries and cleaning products. Trade cash and carry stores mark their receipts with the amount of VAT on each item, or you can look on the HM Revenue & Customs website or ask your accountant which items are VAT-rated and to what extent. Books are zero rated, which can affect galleries selling art books and those that get catalogues printed (catalogues are treated as books).

The VAT Margin Scheme applies to businesses selling second-hand goods, works of art, antiques and collectors' items. Whereas VAT is normally due on the full value of goods sold, under the Margin Scheme it is only due on the difference (or margin) between your buying and selling price. If no profit is made, no VAT is payable. The reasoning behind the scheme is that most retailers can claim VAT back on the stock they buy, but retailers who mainly buy from artists or private individuals who are not registered for VAT cannot do this.

Most artists are not registered for VAT, as they do not have a high enough turnover. It is a good idea to ask them to supply you with a letter confirming that they are not VAT registered, which is confirmation that you are eligible to sell their work under the Margin Scheme. However, some artists are registered, in which case you both have tax liabilities to split between you, or you may decide to charge VAT at 17.5 per cent to the client on top of the sale price.

Registering your web address

Before you finalise your business name it is important to check whether this is available as a web address. Even if launching a website is not your first priority, you should register the domain name for use at a later date, otherwise someone else may take it. Nominet is the business that regulates domain name registrars, and a quick look on *www.nominet.org.uk* will show whether the name you want to register is available. Nominet also has a database of registrars, so you can go onto one of their websites and register the name. It is likely to cost less than £50 to register your domain name, and it might be worth taking a couple (eg .com and .co.uk) if they are available.

When you put your website online you need to select a company to host the site. It is worth doing this as soon as you start trading, even if you have not developed a website straightaway, as you can then include your business name in your email address, which looks professional (e.g. people could email info@leedsgallery.co.uk). This should cost well under £50.

Insurance

You must have adequate insurance cover before you start trading. We live in an increasingly litigious world, so it is advisable to consider every function that your business will carry out and make sure that your insurance covers it. For example, a framer may in good faith dry-mount a piece of artwork, only for the customer to come back in a few years threatening litigation because the value of the piece has been diminished by the adhesive.

The Fine Art Trade Guild recommends the use of brokers that offer tailor-made insurance to framers and galleries, covering areas that are key to the art trade, but which more general retail policies may not address. The Guild's brokers offer discounts to members. For example, your cover can include exhibiting at art fairs, work on sale or return from artists, damage to artwork during framing, artwork being transported and work that is left with clients overnight while they decide whether or not to buy it.

If you are employing people, even part-time, you must have Employers' Liability Insurance. It is also essential that you have third party cover, but this should be included in any commercial policy.

The extent to which you need to insure a rented property depends upon the terms of the lease. Many tenants have to pay all insurance costs, while in some cases the fabric of the building is insured by the landlord, or insurance may be covered by a service charge.

Trade association membership

Professional art and framing retailers join the Fine Art Trade Guild to take advantage of its financial savings, specialist information, net-working and so that they can re-assure customers that they are reputable and abide by its Code of Ethics. Most save more than the annual cost of membership by using the Guild's many benefits.

Registering for Droit de Suite or Artist's Resale Right payments

If you are going to sell work acquired on the secondary market, or buy certain types of art outright from publishers and distributors, you need to register for Droit de Suite, or Artist's Resale Right, which became law in Britain in 2006. This royalty allows artists and their descendents three to four per cent of the sale price when work in copyright, valued at €1000 (about £700), is sold by art professionals, after being bought from another art professional. There are a number of collecting agencies for ARR, the main one of which is The Design and Artists Copyright Society (DACS); see their website for full details of the fee and how to pay it, *www.dacs.org.uk/arr*.

Health and safety

It is important to ensure that your premises comply with health and safety regulations. Before taking premises on, consider the cost of bringing them up to scratch so you can start trading. Your surveyor should tell you whether the premises comply with current regulations.

Owners have a legal responsibility to assess the risks at work, whether they employ people or not; don't forget that customers and suppliers are at risk too if your premises are unsafe. There are even more extensive legal requirements if you employ more than five people. The Health & Safety Executive provides comprehensive information (*www.hse.gov.uk*).

Glass, knives, mechanised blades, toxic substances and air-pressured equipment are some of the potential hazards that are found in any framing workshop. Common sense and good working practices can help to drastically reduce accidents and avoid costly legal action.

When conducting a risk assessment employers must identify potential hazards, then assess whether the risk of harm is high or low. The risk assessment consists of five main steps:

Step 1: Identify potential hazards
This includes all sources of ignition, fuels, blades, glass, air-pressured equipment, electrical equipment, badly-stored materials, low ceilings etc. Talk to employees about what they consider to be hazardous and be vigilant about checking hazard labels on new materials

Step 2: Who might be at risk?

As well as staff this includes customers (including customers with disabilities), delivery people, cleaners etc. Note how all of these people would escape from a fire

Step 3: Evaluate the risks

Look at the risks you have noted and decide whether your existing precautions are adequate, or whether more could be done to reduce the risks. Serious thinking is required here. You need to aim to reduce each risk as far as is reasonably practicable

Step 4: Identify significant findings

Note anyone who is especially at risk and whether further action is required. Keep a record of your findings. Have a health and safety file containing suppliers' information leaflets and important contact information

Step 5: Revise your assessment

Changes at the workplace must be recorded and their impact on the assessment noted down.

Common hazards

1. Waste

Rubbish that could cause people to trip or fall, that is a fire risk or that could breed bacteria should be properly disposed of.

2. Working at height

You must have procedures in place for storing items high up, hanging pictures and moving lights along a track. If you do not have a safe ladder or other place to stand back problems can occur, as well as a risk of falling. People should not, for example, stand on a swivel chair to change a light bulb; those responsible for changing bulbs should be shown where the step-ladder is kept.

3. Trips and falls

Trips and falls are a major cause of accidents. Consider loose cables, things left on staircases, projections into walkways, uneven flooring, slippery floors and spillages.

4. Obstructions

Potentially dangerous obstructions include anything preventing the

safe operation of machinery, blocked fire exits and the prevention of airflow when solvents are being used.

5. Electricals

Electrical sources and appliances are a source of potential danger. Think carefully about plugs and switches, faulty wiring, handling electrical products with wet hands and wrongly rated fuses. Avoid sparks landing in solvents and remember that even dust-filled rooms can start fires or cause explosions. All portable equipment must be suitably earthed. There must be minimal chance of power cables being severed by cutting equipment and watch out for residual current (circuit breakers help here). Remember that the proper maintenance of electricals is essential, and overloading may lead to overheating and fires.

6. Lighting

Proper lighting is essential. Poor lighting can cause eye strain or be hazardous when working with sharp tools or machinery. Fluorescent strips can make rotating blades appear stationary, while spotlights placed too close to objects can start fires.

7. Machinery

It is important to enforce good working practices when using machinery. Employees should be trained to handle all equipment correctly and should be aware of the dangers of each. Machines of course need to be properly maintained; poor maintenance means wear and tear is not spotted, so parts may be thrown off, or blunt cutting edges may slip more easily. Working without the correct safety guards, or with them incorrectly set, is inexcusable, as the potential dangers are huge. Machinery using pressurised air or fluids have their own sets of regulations, though risks are normally from poor maintenance or untrained operation. You should have a rule that no one talks to a person who is using framing machinery, as this can be dangerously distracting.

8. Tools

The incorrect handling of tools can be dangerous. Employees should be shown your 'house rules' for using each tool, including where to store it, how to carry it and where to use it. Stanley knives cause a surprising amount of accidents, largely because people get too gung-ho. They try to cut too much too fast and don't take proper precautions. It's easy to cut the area between your fingers and thumb if you are not careful. People tend to be wary about big noisy machines, but forget

33

the dangers inherent in more everyday items.

9. *Flammable and toxic substances*
Flammable and toxic substances must of course be handled with care, and must be stored and labelled correctly. Staff must be properly trained in their use and potential risks, and must wear personal protective equipment such as gloves and masks when handling them. You must pay particular attention to legal exposure limits and ventilation; remember that solvent-soaked rags can spontaneously combust. Fumes may be given off when bending or cutting plastics, and soldering and welding may involve harmful materials and give off toxic fumes. Aerosol particles may remain suspended in the air for up to a couple of hours if the pigments are very fine. It is essential to have suitable fire extinguishers readily available. Spray guns have their own legal rules for use, particularly if you are using them to apply solvent-based paint, as this carries a risk of explosion.

10. *MDF dust*
There have recently been well-publicised health scares about the dangers of working with MDF, as it contains formaldehyde, which can be dangerous when inhaled with dust particles. Though many framers use MDF, it is unlikely that many cut enough of it to be at grave risk, particularly as much MDF now contains highly reduced levels of the chemical, or is formaldehyde-free. Framers are advised to source the latter. You must ensure that ventilation is adequate, that framers are not exposed to wood dust for too long and that safety goggles and masks are worn where appropriate. Framing equipment suppliers sell portable dust extractors that can be fitted to your cutting machinery.

11. *Glass*
Training is essential; employees must be aware of the correct handling procedures and potential hazards. Sensible footwear must be worn, as well as gloves and wrist bands, when handling glass. It must be clear where offcuts should be disposed of, and the glass bin must be clearly marked. Glass should never block aisles and should be stored upright at a slight angle, without large gaps between the sheets.

12. *Noise*
If you have to shout to be heard over your machinery, the chances are that you need ear protection. Noise from multiple power tools can be a risk, as can loud music.

13. Stress and personal health

You can't ask staff to take on too much work for the time available, give unrealistic deadlines, provide inadequate training, provide badly designed workbenches or insist on excessive time in front of computers. Staff need to have regular breaks, and even irate customers can present unacceptable levels of stress.

14. First aid

You must hold current first aid supplies that are appropriate to the type of work that you are doing. Staff must know where these are kept. If employees are using framing equipment and handling glass it is advisable to ensure that at least one person is a qualified first aider (courses are readily available).

Fire

UK businesses must have a written Fire Risk Assessment in place, which is a legal requirement and criminal action can be taken against employers who neglect to do this. This assessment can be part of your general five-step risk assessment (see above). The aim of the assessment is to identify risks and then to take steps to eliminate, reduce or control these. Providing premises have been built in accordance with Building Regulations and maintained, undertaking a risk assessment should be straightforward and inexpensive.

Businesses are required to:

1. Carry out a fire risk assessment
2. Monitor, review and revise the risk assessment as appropriate
3. Inform staff of the risks
4. Plan for an emergency
5. Provide staff information and training
6. Nominate people to act in the case of fire (fire marshals, etc.)
7. Establish means of detecting and warning about fire
8. Ensure that there are means of escape
9. Ensure that emergency lighting is available where required
10. Ensure that current British Standard fire safety signs are in place
11. Provide fire fighting equipment.

Once steps 1-5 of your fire risk assessment have been conducted (see above) you need an emergency plan. This will be specific to your workplace and will detail pre-planned procedures for use in the event of fire. It must include the following features:

1. Action on discovering a fire
2. Warning if there is a fire
3. Calling the fire service
4. Evacuation of the workplace including those most at risk
5. Power/process isolation
6. Places of assembly and roll call
7. Liaison with emergency services
8. Identification of key escape routes
9. The fire fighting equipment provided
10. Specific responsibilities of staff in the event of fire.

In order to ensure that the drill works, you must conduct drills and training at various times so all staff are aware of what to do in the event of fire.

Further advice is available from the fire service website, *www.fireservice.co.uk*.

Security and personal safety

Employers have a legal duty to provide their staff with a safe workplace, and the owners of businesses that don't employ anyone still need to consider their own safety. Retailers inevitably come into daily contact with strangers, they handle cash and, in some cases, high value goods, and staff are often alone in small shops. So a personal safety strategy is essential.

Systems need to be in place for staff to react to theft, intimidation, physical violence and verbal abuse. Staff, including the owners of the business, must be trained to understand these systems.

Risk assessment and training

Begin by carrying out risk assessments, then plan strategies for dealing with difficult situations. All employees should be involved with this process. It is worth contacting your local police station and asking about patterns of crime in your area.

Working alone

Working practices need to be assessed; for example, it may not be necessary for one member of staff to be alone with customers if working rotas and tasks are adjusted. You should be able to arrange visits from sales reps for when more than one person is in the shop (which is sen-

sible anyway). Shops are vulnerable when they are opened up in the morning, closed up at night and after dark, so if someone needs to be left alone during the day, try to avoid these times. Think about the layout of the shop; for example, maybe a partition could be moved slightly so that the person dealing with customers could be seen from the workshop at the back. The fact that someone is working alone should not be publicised, and try to avoid people working alone at regular times that it would be easy for an outsider to identify.

A 'buddy system' is a good idea, whereby someone else nearby is always aware that a person is working alone and a system of checks is in place. A buddy system with other local shops can work well, with staff looking out for each other; if they are aware that someone is alone they can respond quickly to emergency signals.

Dealing with abuse and violence

No one should have to continue meeting with people who have subjected them to abusive, racist or sexual harassment. Even if the owner thinks the comments light-hearted, if the person concerned is offended, then the situation is not acceptable.

Staff need to be trained to handle verbal abuse and threats of violence as safely as possible. Retailers must have an incident book in which such occurrences are recorded; the manager must review this and make any possible changes to procedures.

Handling verbal abuse needs structured training. Staff should stay calm and make it clear that they are listening and trying to help. They should try to stay behind the counter, or stay separate from the person.

Make it clear to staff that they must always put their personal safety first and know how to operate security equipment. You should never try to resist or follow violent offenders, but should try to remember a description of the person and record the incident immediately.

Staff should feel confident to follow their instincts: if they are concerned for their safety they should walk away from the shop and leave it empty. Goods and cash are replaceable, whereas people are not, and staff need to understand that they would be doing the right thing in walking away, and that tackling a violent person would be the wrong thing to do.

Handling cash

All shops are known to handle cash, so violent robbery is always a possibility. Staff must be told to stay calm, avoid sudden movements and dashes for the alarm, and they should not stare or make eye contact. Clarify to all personnel that they should give the robbers what they want, as this is the best way to avoid personal harm.

The person banking the takings must also take precautions. Try not to empty the till and take money to the bank at the same time each day. Vary your route and timings. Try not to make it obvious that you are emptying the till, and if anyone sees you do it, then don't go immediately out of the shop with the takings. Carry cash in an inconspicuous bag and make sure that coins do not jingle as you walk. A personal alarm is a good idea when carrying cash.

Shoplifting

Shoplifters may become violent when approached, so employees need to know under what circumstances they should approach them and what they should say. It is inadvisable to tackle a shoplifter if you are working alone. The vast majority of shoplifters will go quietly with shop staff if they are approached in an authoritative professional manner and are out-numbered.

Some shoplifting is inevitable if you are selling small items such as art materials and gifts, and this will probably happen when your shop is at its busiest. You cannot accuse anyone of shoplifting until they have left your shop with the item, as they could claim that they were just about to pay for it. If you see someone put an item in their bag or pocket, they may put it back if you politely say something that lets them know you saw them take the item, such as 'Would you like to leave that on the counter until you're ready to pay?'

The way you display your stock can help minimise shoplifting. Try not to put small, pocketable items just by the door. If you display pictures on easels in your window it is easy to attach these to the easel with wire, making it hard for the casual thief to remove them. Small pictures and those hung closest to the door should also be firmly attached to your hanging rods or hooks with wire.

Craft jewellery and other gifts can be displayed in glass-fronted cabinets that you unlock at your discretion. Make sure you lock it again

when showing goods to a customer, as shoplifters often work in pairs; one person distracts you while the other steals from you. And don't take out too many items at once.

Burglar alarm

Your insurance company is bound to insist that you install a burglar alarm system, and they will specify certain types of door and window locks. Shops are generally required to have alarms that alert the police if they are activated. Alarm companies give very different quotes so it is worth shopping around; you may find a small local supplier gives a much better price than a well-known company, which is fine so long as the supplier can provide good references from other local businesses.

Panic buttons and personal alarms

It is advisable to equip staff with a panic button by the counter for emergencies, as well as the option to keep the door locked and buzz in certain people at their discretion (bear in mind that this last option can discourage browsers, so should only be used if a member of staff is alone and feeling threatened).

Personal alarms which emit a screeching sound are a good idea, particularly if anyone will be left in the shop alone, and some of these can be programmed to contact a security company.

Security cameras

Security cameras can deter shoplifters, though experienced thieves are adept at hiding from these. Shops with several floors or rooms find these particularly valuable. A camera pointing at the till (but not at the point where customers key in their PIN numbers) can be effective, and might also deter staff from stealing.

Be aware that there are restrictions on video surveillance under the Data Protection Act 1998; the main point is that staff and customers must be aware that they are being monitored, though this should not be a problem as clear signage about surveillance equipment is a key part of its deterrent effect.

Chapter 3

Should you buy an existing business?

When opening a retail outlet one of the things you have to decide is whether your money would be better spent buying a business that someone else has already put time and energy into building up, or whether you would be better off opening up from scratch.

Why buy a business?

The main advantage of buying an existing business is that you should be able to earn a salary immediately, whereas many people who start new businesses do not draw salaries for a few years. In theory, if a business makes profits of £50,000 a year a new owner should be able to walk in and immediately make similar profits, which is an enticing prospect. Some people simply cannot afford to be without an income.

A high percentage of new businesses fail within three years and an even greater proportion fail within five years, for reasons including insufficient operating capital, poor management and an unworkable business concept. Existing successful businesses have a track record of profits that may continue long after the business is sold, and you can apply new ideas and renewed energy to take the business to greater heights. You will have existing customers, so won't need to struggle through a long start-up peri-

od when you are trying to attract customers. Many would argue that the success rate for new business owners who buy an existing business is much higher than for those who start from scratch.

However, you will only benefit from buying an existing business if it really is as profitable as the owners claim. You need to be sure that you will retain existing customers and that the reputation of the business really is as glowing as you are being urged to believe. Some extremely thorough and painstaking research is required to ensure that you are spending your money wisely. You need to be certain that the existing business model is sound and that the brand is strongly developed and right for the marketplace. Bear in mind that many people sell because things are not going well; even if the owners are retiring, they might postpone their retirement if business was booming.

If a business is profitable and running efficiently you are likely to have to pay more for it. Some people buy existing businesses because they don't have the confidence to start from scratch; that is only sensible if you are certain that the business is a good buy.

One reason for buying an existing framing business, for example, is if you have retailing skills and see a niche for a framer in your area, but are not a framer yourself. You may want to own and run an art and framing business, but not have skills in framing or employing framers, in which case it might make sense to take over a business that already has a thriving framing department with employee framers who have worked there for several years.

A potential problem can be that the original owners, are, in fact, the business. Their skills and personality are key and without them there would be no customer loyalty, so the customerbase would be worthless. This scenario is most likely with small businesses run by sole traders and husband-and-wife teams. It is very important to evaluate the public perception of the owner and the extent of the owner's role. Retaining good staff or the services of the existing proprietor can ease the transition.

Buying an existing business makes sense if one comes up for sale in a location that you particularly want. If retail outlets in that position don't come up very often, and you feel confident that the location could be a success for you, then this might affect your decision to buy.

Valuing a business

When you are considering buying a business you have to decide whether it represents good value for money. Countless books have been written about the best way of valuing a business, and people base their careers around their ability to do so, but there is no magic formula upon which everyone agrees.

It is important to understand precisely how the figure under discussion was arrived at, and what is included in the price. Don't be frightened to ask questions. Most pricing systems involve three component parts:

• Goodwill, meaning reputation, the 'brand' and repeat business
• Equipment and shop fittings
• Stock.

A few businesses are sold along with freehold premises, but most are leasehold so any down-payment to the landlord will be additional.

It is sensible to compare the price of the business you are looking at with other comparable businesses. The internet has made this task easier; a Google search for 'small retail businesses for sale' should bring up a number of relevant sites which should include small bookshops, art materials shops or gift shops, if not exactly what you are looking for. You should also look at the 'businesses for sale' section in the relevant trade publications and talk to local estate agents.

Valuation is what a company is worth, but ultimately there is no one formula for working this out. The business is simply worth as much or as little as a buyer will pay for it. Valuations are inevitably a rough estimate at best, or a talking point in negotiations. The value of a business depends not just on simple formulae and multiples, but also on market conditions, the specific economics of the business, location, brand, management team, balance sheet, customerbase and the negotiating skills of both parties.

There are four main ways of arriving at an initial valuation:

• Book value, the same as net worth, is assets less liabilities
• The total sum of one year's sales
• A multiplication of net profit by a certain amount (the amount varies enormously between valuers)
• Comparison with other similar businesses in the same market.

Some valuers suggest that 0.75 to 1.5 x annual net profit is a realistic way of pricing a small retail business, while others are more bullish and suggest multiplying net profit by three or four times. Whatever the formula, you should check the result by comparing the price with the sums being asked for other similar businesses. No two businesses are the same, so it is not surprising that different valuations for the same business might vary by 30 per cent, depending what method of valuation is used.

Typically, a small business owner might take their net profit and multiply it by 0.75 up to four, then add a bit for goodwill and stock. A few thousand pounds might be added for goodwill, then stock added in at cost and equipment at current market value. A bit of room for negotiation would probably be built into the asking price.

Your accountant should advise you on the value of a business by looking at all the established formulae and suggesting what you should pay. However, in the end, a lot of negotiations come down to what you can afford to pay and how urgently the seller needs to sell.

The accounts

Anyone selling a business should provide prospective buyers with the last few years' accounts. The buyer should seek advice from an accountant; the accountant will compare the business's profitability to alternative investments and advise whether it seems a good buy.

If your accountant advises that the business is insufficiently profitable, but you are convinced that the business has potential, you can try negotiating the price down. In some cases an accountant may dismiss a business as unprofitable, but the potential buyer may have additional information that makes them think that they could turn the business round (for example, they might have had previous business dealings with the owners and know that they have let the business slide because of personal issues).

An accountant may advise that a business is just about viable, but if you know that it is rundown and unloved, you might be able to make realistic projections for growth that make the business seem more appealing.

However, in most cases it is important that the business you want to buy has a strong balance sheet and authentic and sustainable figures,

as well as a good client database and proven repeat business. It is no good if the owner says 'We do much better than is suggested in the accounts...'; you can't rely on that kind of unsupported information, and you can't sell it on. If it's not in the books, then, in commercial terms, it does not exist.

As a buyer you should be looking for a business with professional record keeping. Ideally you should have access to computerised stock control records, all invoices, accounts, suppliers' details, a professional business plan and more. You must be made to feel thoroughly confident that the business does as well as the owners say it does. The owners must be completely open about their accounts.

Goodwill

Goodwill is hard to price and many buyers complain that they overpaid for it. The solution to this is thorough research; you need to check in every way you can that the business has the reputation that the seller claims. The worst scenario is that the seller actually has a bad reputation, so the buyer ends up changing the brand that they have paid for.

Ask other local businesses for their opinion. It is vital to visit the business as often as you can and at different times of day; watch how many customers there are, and how many come out with purchases. Talk to customers and use the service yourself. Also check that the business is not too reliant on a few major customers.

Estimate sales based on what you see: for example, if three customers leave the shop with purchases every hour and the average sale value is £100, work out how much revenue that will generate each month. If the seller reports a similar figure for monthly sales you can be reassured.

An efficient seller will have kept good records of all marketing activity and investment in the business brand. Check brand awareness; try asking directions to the business to find out whether it is well-known. Look at how often advertisements and other marketing activity occur, and assess their quality. Try searching for the business on the internet and see how often it crops up in search engines.

Stock and equipment

Too often stock is considered last, as it represents less than ten per cent of the price. Substantial amounts of time and money might have been invested in the deal by the time stock is dealt with, which puts the buyer in a weak negotiating position. Don't just take the seller's word for the value of the stock, and try not to leave it until the last minute.

One solution to this difficulty is to take stock from the previous business owners on a sale or return basis. Some sellers bundle the value of stock in with the rest of the sale to prevent buyers quibbling about the price; in this case, you might use the fact that you don't want all the stock as a negotiating tool at the beginning of the process.

Stock is generally valued in a business's annual accounts, where old stock is gradually depreciated. Some sellers ask for this 'book value' plus ten per cent extra to cover new stock. The problem is that stock may not be worth its book value; in reality it becomes unfashionable and therefore unsaleable at any price. 'Stock at value' is a very imprecise term; a framed picture on the wall may be priced at £400, so might be valued at £200 to someone buying the business, but in reality it may be dated, knocked about and unsaleable.

It may be worth having stock independently valued. The cost could be shared by both parties; if the sellers are not prepared to fund this then maybe they are not serious about selling.

Ideally the business you are looking at will have very thorough stock control procedures in place, which makes valuing stock much easier. For example, a computerised system that gradually marks down stock over time until it is sold at cost helps to make way for something that would make a profit.

Check that all equipment is in good working order and that spare parts and consumables are easily acquired. Try to find out whether equipment is the industry norm, or a small-brand that no one else really uses. Ask to see maintenance and servicing agreements; bear in mind that if the owners are selling they may not have bothered to maintain their equipment properly. Equipment should be priced at the current second-hand value, not replacement value. Technological developments have been considerable, so ensure that any equipment you buy is not out-dated.

Record keeping

As a buyer you should be searching for a business that is not only profitable, but has a professional business model and efficient retail and financial systems in place. You should have access to documentation that proves this, evidence of marketing initiatives and a realistic business plan. You should feel convinced that the seller has nothing to hide and that their goodwill is worth paying for.

The business plan should set out the commercial history and prospects of the business. However, remember that a seller's plan is drawn up to sell the business, not to manage it, so it is likely to be bullish. Question all the assumptions and wherever possible compare the seller's plan with past financial information. Do whatever reality checks you can think of and cross-reference financial data as much as possible. Don't rely on second-hand information. Growth forecasts are suspect: compare projected growth with past results. If the seller promises a rosy future, why are they selling? However, divorce, bereavement or retirement might mean that a business with good potential is for sale, so don't totally ignore forecasts.

Efficient record keeping is enticing to a buyer. Ideally the owners will have worked to a professional marketing and retailing model and will know how to present the business for sale properly. A good business model is really worth paying for, and there is no reason why much of it will not still be in place several years later.

Leases and freeholds

Leases can be fraught with complications and surprises. This important subject is dealt with in Chapter 4: Choosing your premises (p.48). The terms of the lease should be looked at immediately as these hinder many a sale from going through. Most retailers would prefer a freehold but this is not always possible, for financial reasons and because prime sites tend to be snapped up by landlords. Buying a freehold is also discussed in Chapter 4.

Where to look

Many art and framing businesses are advertised for sale through the classified pages of *Art Business Today* and all ads appear online as well (*www.fineart.co.uk/classifieds.asp*). See the section on Useful further reading (p.231) for details of trade magazines in the craft, card and gift sectors.

Business transfer agents charge around 2.5-5 per cent commission to the seller. A problem can be that framing businesses are unique in combining an element of manufacturing with retailing, and agents do not always understand this mix so may not be as effective at selling framing businesses as other types of retailer.

Online agents are a growing resource. Sites that list retailers including florists, card shops, sandwich bars, gift shops etc. can give you a good idea of the prices typically paid for small retailers. You can usually see asking price, turnover, net profit and other details, all of which can be useful when pricing a business you are thinking of buying.

Chapter 4

Choosing your premises

Art and framing businesses can be run from industrial units, prime high street sites or the owner's home. Choosing the right base is fundamental to the success of any business; your premises have a big impact on how people perceive the business, your financial outgoings and the extent to which you can rely on passing trade.

Whether you are starting a new business, moving premises or buying a further outlet, it is essential to choose premises that will reinforce your market position. A shop with a large window and lots of passing trade in a prosperous market town might be right for a retailer selling original artwork and upmarket gifts, while a framing workshop in a no-frills industrial unit might be right for a contract framer, or a bespoke framer whose clients value easy parking and low pricing. Your choice needs to reinforce your market position both in terms of the type of area you choose (wealthy suburb or town centre) and the type of premises (gallery with passing trade or by-appointment first-floor gallery).

The decision will, of course, also be influenced by economics. A more prestigious site should bring higher footfall and greater margins, which means that you will be paying higher rent and rates. You must feel confident that increased turnover will lead to worthwhile profits.

Many shop owners consider their rent, rates, service charges and repair bills and think that if they ran their business from home they might find it harder to win new customers, but their overheads would

plummet. The trick is to balance the benefits of premises against the costs, and be sure that the benefits outweigh the costs.

Planning

Begin by carrying out extensive research about any potential properties; something as simple as a 'for' and 'against' list is a good idea, as there are so many points to take into account. Location and premises are absolutely key to whether your business is successful, so time spent finding the right site will not be wasted.

It is essential to match the building and location to your business needs. Don't just go for the first premises which roughly suits your requirements; take the time to look around and be sure.

Below are some key points to consider:

Price

It is important to compare prices in a range of areas and be sure that you can afford your chosen site. You also need to be sure that you are not being asked to pay over the odds; talking to other independent shop owners, estate agents, solicitors, surveyors and business people will help you build up a picture of current market rates. Being a member of local business groups can be a great help at this point.

Demand for the site

If the premises are as great as you think they are, and they have been available for a few months, try to work out why no one has already taken on the space. However, taking on premises that have been empty for a while gives you negotiating power; you might be able to negotiate a rent-free period, get the price down or arrange to make your first rent payment in arrears.

Passing trade and demographics

If passing trade is an issue for you, you need to establish whether the passing trade is the right type of person for your products and services. You need to stand outside your prospective shop on a wet Wednesday afternoon, and a sunny Saturday morning, and look at the footfall and the type of customer the area attracts. Talk to other independent shop owners about business in the area. Passing trade will be of little value to you if the people passing by are not your target customer.

Use the internet and population statistics from the local authority to check that people living and working in the area should buy from you. Consider who the major employers are; if one big company or organisation dominates the area this could make you vulnerable if that organisation re-locates or closes.

Red tape

It cannot be emphasised enough that all legal documents must be thoroughly understood, however complex. It can be well worthwhile to pay a professional to help you get to grips with your lease or the terms of your freehold. Anything you do not understand, or do not agree with, should be questioned at an early stage, so that you do not find yourself caught out when it is too late. For example, framing is a manufacturing activity and you must check that this is allowable at your chosen site.

Parking and loading

Customers collecting framed pictures need to be able to park very nearby, and value shops with free or easy parking. Restrictions on delivery and loading times can also impact on your business. If you are happy with the current arrangements you should check that the local council are not planning to make any changes.

Layout and frontage

The width of the frontage is important for a retailer, not just the square footage, though you will pay a higher rent for a wide frontage.

Framers need space to operate machinery safely and efficiently, and frame shops need room to take delivery of and store mouldings, glass and other materials. A location, for example, in a pedestrian precinct could mean that the glass delivery lorry would have to park an impractical distance away. Low ceilings can make handling lengths of moulding difficult.

Refurbishment

You need to work out how much it will cost to fit-out the shop; the decisions you make can vary hugely in terms of cost. Bear in mind that the look of the shop needs to reflect your market position and appeal to your target customer. If you are a gallery and gift retailer selling a certain style then of course your fixtures and decorative scheme needs

to emphasise this. It is important financially to pin down your builders to a finishing date for the work, as delays can materially affect your projections and ability to cover fixed costs.

Planning permission

You must double-check that any changes you want to make to the premises would be allowable under the terms of your lease or freehold and with the local authority. If you are moving into a listed building there are likely to be restrictions on how you can change the look and structure of the building.

Once you have made an offer that has been accepted, try to get a 'lock out agreement' which means that the seller or leaseholder won't enter into negotiations with anyone else.

Grants

There are grants and loans available to businesses starting up in certain areas, such as within the confines of inner city renewal or rural development projects. Local authorities sometimes set up enterprise zones to boost local economies or help small businesses. Your regional Business Link should be able to advise you on any local opportunities.

Type of premises

Below are some of the types of premises that art and framing retailers typically operate from:

Secondary and high street sites

Very few independent art retailers are on prime high street sites; they cannot afford to pay the rents and rates that the chain stores can pay. Many of the most successful art and framing retailers are located 'just off the high street' in secondary locations, where they still benefit from a high percentage of high street footfall.

Art and framing retailers that do have high street addresses tend to be in small market towns or large villages. Others that do well are at the edges of towns, often positioned at traffic lights or other places where the traffic pauses, allowing people time to look.

Industrial estates and business parks

Some framing workshops can survive without much passing trade, as they are primarily 'trade framers' who market themselves to galleries and art groups, rather than the art-buying public, so many successful ones operate from 'by appointment' workshops. These are commonly based in industrial estates or business parks. Galleries tend to need passing trade, so this type of site only really works for framers.

If you are going down this route you do need to think very carefully about how you are going to attract sufficient business and who your customers will be (one strong advantage of today's marketplace is that your website can be your shop window). Framing is a specialist service, so a focused marketing campaign can bring you customers wherever you are located.

Galleries and art dealers are potentially good customers for framers, as they will provide repeat business. They are unlikely to be prepared to pay retail prices, so often use framers based in industrial estates whose low overheads mean that they can charge genuine trade prices.

Working from home

Working from home can be an option; some of the most respected framers in the industry work from workshops at home. This keeps overheads low and allows you to gradually develop a customerbase. However, in terms of annual turnover, home workshops tend to be smaller businesses than those based on sites with vibrant passing trade. Typically, businesses begin with the owner framing from home, then the owner may want to expand or diversify into art retail, so makes the decision to move to commercial premises.

If you are thinking of working from home, don't forget that you need to seek planning permission for change of use to business premises and pay business rates. Check that there is nothing in the terms of your lease or freehold to prevent you running a small business from home.

Art centres and craft markets

Positioning yourself among other businesses that are selling to the same target customer can work well. Be sure to check that the landlords are marketing the venue as well as they claim to be. Look at footfall into the venue and study the type, and price range, of goods that are selling. This type of venue may attract browsers rather than actu-

al buyers, for example people might be there to see a play or visit an arty bookshop; they may not be thinking about buying art and framing. So be sure to check how many people seem to be buying and leaving the site with carrier bags. You may need to adapt your product range to maximise sales in such a venue, for example portable products such as art books and craft jewellery might be good impulse buys for arty theatre audiences.

Online galleries

There are art and framing retailers who operate solely from the internet and through eBay shops. However, many began with bricks and mortar premises, then gradually began selling more and more online so found it would make financial sense and be viable to cut overheads and focus solely on the virtual gallery.

Some highly specialist art and print dealers find that they no longer need business premises, since their customerbase is increasingly global, thanks to the internet, and their target customer is not passing trade in a specific area. They therefore deal through a website, specialist internet auctions and eBay.

Renting

Renting does not tie up capital, meaning that any cash can be invested in the business. Leaseholders may not be responsible for all maintenance, insurance and health and safety issues connected with the premises, some of which might be handled by the freeholder.

The majority of independents would prefer to own their property, but this is not always possible, partly because property developers and landlords tend to buy up the best sites. And of course many do not have the necessary capital to fund the initial down-payment on the purchase.

Rents vary hugely according to square footage, location, the length of the lease, frontage and the calibre and volume of passing trade. A small shop in a quiet rural area might be £9000 a year, an equivalent-sized one in a busy town might be £15,000, or on an up-market suburban parade the cost might be £30,000, while it might be nearer £50,000 a year in the west end of London.

A problem with leases is that they tend to be open-ended documents,

making it hard to plan future finances. You cannot easily predict how much your rent will go up at each review. You also have less control over the finance and management of repairs and maintenance if you are leasing.

There is a big difference between taking on an existing lease and negotiating a new one. If you buy an existing lease there is little you can do to alter the terms and conditions.

It is essential to have a good commercial solicitor to look at a lease with you. They can be fraught with complications and surprises, so it is good to look at them early on in the buying process so, if necessary, you can walk away having wasted as little time and money as possible. Problems with landlords and leases prevent many sales from going through. Retailers are full of stories about landlords suddenly demanding a year's rent upfront, a bond of six months' rent or changing their terms at the last minute. And the small print is getting more and more complex.

Below are some points to consider before agreeing to the terms of a lease:

Lease length and renewal

Leases are typically between three and 25 years, though there is a current trend for leases to be on the shorter side of this time span. Consider whether the length of the lease fits with your plans for the development of the business.

A word of warning: when renewing your lease don't just assume that it has not been changed. Landlords may change the terms without drawing your attention to specific changes; it is up to you to read the lease, and ask your solicitor to do so, before signing it.

Consider using an agent to negotiate the renewal. A good agent could save you a lot of money.

Rent reviews

Reviews are likely to happen every three to five years. Bear in mind that landlords can generally increase the rent as much as they like at each review; your recourse is to go to a tribunal, but you have to be pretty sure of your ground if you don't want to end up paying sub-

stantial costs. Independent retailers have been heard to complain that landlords have put up their rent by 25 to 40 per cent at a review, frequently forcing them to close; this often means that there hasn't been a rent review for a long time. Some buildings have 'indexed rent' which changes in line with measurements such as the Retail Price Index. Be wary of 'upward only' rent review clauses; these are common, but should be treated with caution.

Valuation agents can be employed to negotiate rent reviews, as well as the terms of new leases. This tends to operate on the same 'no lose' basis, with the agent taking a percentage of money saved.

Deposit and payment terms

A deposit is generally due when you take on a lease, which is commonly three to six months' rent. If you are a new business with no track record you are more likely to be asked for a six-month deposit. Rent is normally payable quarterly in advance, so this means that your initial payment to your landlord could be for as much as nine months' rent.

Rent-free period

You may be able to negotiate a rent-free period when you take on your lease, perhaps two or three months to allow you to carry out refurbishments. If the property has been empty for a while it might be possible to negotiate longer. If you negotiate three months rent free and then finish your refurbishments in two months, then you would have one month's trading without paying any rent, which could be a great boost.

Break clauses

Consider how easy it would be to sell-on your lease, or hand the property back to the landlord. Try setting up 'break clauses' at regular intervals.

There is a difference between 'relinquishing' your lease, which means handing it back to the freeholder, and 'assigning' it, which means selling on the existing lease (with the freeholder's permission). Check which type of business you are allowed to assign your lease to, as restrictions can prevent you selling. Find out whether you would still be liable for the rent even if you assigned the lease to another tenant -

this is very often the case. It would be up to you to find another tenant of whom the landlord approves and, if necessary, you would need to apply to the council for change of use. An advantage of being able to assign your lease is that it may entice a buyer, as the buyer would pay the rent you had agreed to for a few years, whereas if a new lease was granted the rent would probably go up immediately. You may be able to relinquish your lease if you give, say, six months notice. This might be a lot less hassle than trying to assign it, though not all landlords will agree to it.

Personal guarantees

Many landlords require personal guarantees before accepting a tenant, which some tenants are understandably unwilling to agree to. However, personal guarantees are increasingly becoming the norm. There are still some landlords who are happy with bank and business references, but not many.

Repairs

A common area of dispute with landlords is which party is responsible for repairs and to what standard, so it is important that repairing obligations are clearly laid out in the lease. A Full Repairing and Insuring Lease means that the tenant pays for all repairs, which may be acceptable over 20 years, but is problematic for short leases where the tenant may only benefit from investment in repairs for less than five years. The landlord pays for insurance, but the cost is passed to the tenant. There are various other types of repairing lease, for example, the landlord's insurance may cover some repairs or the tenant may not be liable for repairs caused by poor design and sub-standard building materials. A Schedule of Condition at the beginning can help minimise disputes; photographs should be taken, and both sides' solicitors must agree the details of the condition. It is advisable to put some money aside annually in order to keep the property in the agreed condition.

Handing back the property

It is very likely that when your lease expires the premises will have to be re-decorated and handed back to the landlord in 'as new' condition. Landlords present tenants with a Schedule of Dilapidations towards the end of their lease, detailing the work they think needs to be carried out. This can seem unfair if the premises were not in a good state when you took them on. You may decide to ask a surveyor to detail the

condition of the building at the beginning, then agree that it will be handed back in the same state. This document is called a Schedule of Condition, and while a surveyor may charge around £500 to produce it, it could save you many thousands of pounds in repairs at the end of your lease.

Service charges

Service charges might be payable on rented premises; it is very important to check what these charges cover and consider whether they are good value for money. In many cases, service charges are much higher than they need to be to finance the costs and repairs that they cover, so be careful. Service charges sometimes cover insurance of the building, or sometimes the landlord insures it. You must be sure where responsibility lies. (Whatever the terms, you will also need to insure the contents of the building.)

Service charges can be contentious, and disputes between landlord and tenant happen all too often. The fact that service charges tend to be handled by managing agents does not help, as this means that you cannot actually reason directly with the landlord. If a particular landlord owns a whole block of shops it may be a good idea to ask other tenants if all is running smoothly, or if there are disputes about service charges and repair bills.

Negotiate

Finally, but importantly, don't forget that rents are negotiable. Don't feel you have to offer to pay the rent that is first asked for, especially if the premises have been empty for a few months. Independent shop owners can have negotiating power with landlords as they can argue that they are destination shops so will bring customers into the area, whereas people have a choice of which branch of Argos or WH Smith they go to.

There are specialist valuation agents who can help you negotiate the terms of your lease, and they are often very successful. They tend to be available on a 'no win, no fee' basis: if they win you a reduction they take 50 per cent of the money they saved you in the first year. These people work for estate agents with a commercial arm. Even if an agent does charge a fee it may be well worth paying it; check who else the person has worked for and ask their opinion, but these agents should be highly familiar with the complexities of leases and could potentially save you thousands of pounds.

Buying

Most retailers would like to own their premises, but this is not always possible. If you take on leasehold premises you will be paying several thousand pounds rent each year without ever owning the building. Some independents begin by renting with a view to buying if an opportunity comes up; many end up buying either the premises they were previously renting, or one a few doors down.

As well as ending up with an asset, you have more control over the finances if you own your shop; you would have more flexibility over repairs, maintenance and other property management issues, and you could hopefully sell the building at a profit. If circumstances change it would probably be easier to sell a freehold property than to extricate yourself from a fixed-term lease.

Commercial rents tend to go up, whereas interest rates, and thus mortgages, can come down, and it is quite likely that a mortgage will work out cheaper than rent. A big obstacle to buying is of course that you need capital to fund the initial down-payment. It may be worth seeking investors to help you buy a particularly desirable freehold.

It is important to remember that you are responsible for the safety of the building, so you need to keep up with changes in fire regulations, laws on disabled access and other health and safety issues. It is important that a surveyor tells you that the building complies with existing regulations before you agree to buy it.

Your accountant should advise you on, for example, whether the business should buy the freehold or whether you should buy this personally, then rent it to the business (if you are a limited company, this means that should you go bankrupt you may not lose the freehold). An accountant will also explain the advantages of options such as Self-invested Pension Plans, where you pay rent into your own pension plan when you buy a freehold. (Bear in mind that the government can change these schemes at any time, so different options may be available in the future.)

Finances

Obviously your accountant is going to play an important role here. However, once you have identified desirable premises the next step is

to do some 'broadbrush' mental sums to see if your plans are feasible. Are the mortgage payments going to be affordable? Or, if renting, is the rent (and its likely increases) realistic for your business?

Uniform business rates are a substantial overhead for a small business, whether leasing or buying. Your rates (which are the commercial equivalent of council tax) are set by the local authority based on the rateable value of your property, so the more upmarket your property, the higher your rates. The multiplier used to work these out for a small business in 2006/7 was 42.6p, meaning that a business with a rateable value of £10,000 would pay £4260 in rates per year. Check which services your rates will cover as some, such as rubbish collection, are extra.

As well as rent and rates, remember to factor in the cost of repairs to the building and, if renting, remember that there may be a service charge.

Stamp Duty Land Tax is payable when you take over a commercial lease, as well as when you buy a property. Your solicitor should advise you on the exact extent of this, but it is currently a sliding scale of between one to four per cent, with a percentage of the purchase/lease cost exempt from the tax. There are some further exemptions, for example, 'land in a disadvantaged area', so you need to check your liability. However, Stamp Duty is probably going to add several thousand pounds to your set-up costs.

Whether buying or renting, the cost of taking on new premises is likely to include fees for a solicitor, a surveyor, an estate agent, local authority searches and an accountant or financial advisor.

Chapter 5

The financial side of setting up

Accounting and book-keeping

All businesses need to keep accurate records of income and expenditure, both for tax purposes and for their own internal budgeting. Your cannot exercise efficient financial control without a basis of solid book-keeping, and you won't know how sustainable your profits are.

You will almost certainly need an accountant, particularly if you are a limited company. Accountants' fees vary; if your business and borrowings are straightforward you are unlikely to get value-for-money from a high-flying accountant. If you decide to delegate your day-to-day accounting, it may be cost-effective to employ a part-time book-keeper. However, if you are a meticulous person you may find it easy to keep your records up to date yourself, and you will mainly need an accountant just when it comes to submitting your tax return. An accountant should ensure that you are not paying more tax than you need to and should advise you on ways of avoiding (rather than evading) tax.

Some people use their accountant to handle national insurance and employees' tax, and to compile their VAT return. You may, however, decide to carry out these tasks yourself as they are mainly fairly routine. The Inland Revenue are generally very helpful if you call with specific questions; they can bring your data up on-screen and talk you through any problem areas. A telephone call to the Inland Revenue is

free, whereas accountants are most certainly not. You could ask your accountant to cast an eye over your initial efforts and offer advice, then you could carry out the work on your own after that.

Choosing your bank

You need to look carefully at the charges different banks will make as these can vary considerably, and banking is highly competitive. Small business can pay very high bank charges, so it is really worth shopping around. As well as general charges for managing your account there are fees for credit and debit card transactions (see below), and you may also want to borrow money (see below). It is essential to be fully aware of all the charges that your bank may make; business accounts are subject to many more than personal accounts.

Personal recommendation from other local businesses or from your accountant or solicitor can be extremely valuable. A bank with a good reputation among people whose opinion you respect should be considered early on.

Some banks pay interest if your account is in credit, which can be attractive. Try to find a bank that offers free banking for the first year, or maybe for two years. Look at the structure of charges, including whether these are levied per transaction or whether a flat monthly fee is payable. Think which option would be best for you. Some banks process direct debit payments and standing orders free of charge.

Don't just look at the high street banks; smaller, specialist and internet-based banks may have lower fees and offer better deals in order to attract customers. They do not pay high street overheads and tend to operate from inexpensive locations, so can afford to offer good deals. It may pay to be suspicious of little-known banks offering unexplainably high rates of interest, however, as they may not be sustainable (as was the case with the BCCI which was wound up in 1991 leaving many investors destitute).

A disadvantage of a bank without a local branch is that you may not be able to pay in or withdraw cash, so you may need to open a second account at another bank for this, and then transfer money over. However, some specialist and internet banks allow you to nominate a local branch of another bank and they make an arrangement for you to pay in and withdraw cash there.

If you don't have a branch, cheques can of course be paid in by post, should you decide to accept cheques; it's a good idea to keep photocopies or records of the cheques you send just in case they get lost in the post. Many high street retailers no longer accept cheques, as credit and debit card payments are automatically credited to your account, and no slips need to be posted to the bank.

Remember that once you have chosen your bank you do not need to stay there forever. Keep an eye out for what deals are on offer; the internet makes comparisons relatively easy. If you have benefited from free banking for a couple of years make sure that the charges at the end of that time are not too high; if you go to your bank saying that you are going to move, you may find that they lower their charges. Banks seem to rely on the fact that people are too busy to change, and even when they have deals that would benefit their customers they may not alert them to this fact.

You need to keep a strict eye on your bank charges over time and ask the bank to explain any charges you were not expecting. You need to work to keep this to a minimum by automating as many processes as possible, using online banking and sticking to the terms and conditions of your account.

Borrowing money

Many people need to borrow money to fund their start-up business. The ideal scenario is an interest-free loan from family or friends, but most people do not have this opportunity. The alternatives are borrowing from banks or investors. (Grants are discussed separately; see below.)

Framing, in particular, often attracts people leaving the police force or military service, and others with redundancy payments to invest in their own business. A basic professional framing service has relatively low start-up costs and may provide the platform for later growth into a gallery or artshop.

Most lenders, banks and other investors want to see you invest some personal equity in the business before they lend you money. It may be necessary for you to mortgage your house in order to do this, or take out a second mortgage on it. They may also require security against the loan such as a personal guarantee. They would want to see a business plan, including a plausible budget and cashflow scenario. Part of

your business plan (see Chapter 7: Writing a business plan on p.81) will include your CV, and the better the business credentials you have the more likely people are to invest in your business.

While taking out a personal loan or investing your life savings is a big step to take, outside investors can ask for their money back at any time and will expect a good return on their investment. If your business fails you could lose your house and big personal loans can be very worrying.

If you do not have the necessary collateral to secure a loan you may qualify for the government's Small Firms Loan Guarantee Scheme. The government guarantees 75 per cent of the loan and charges an additional interest rate for the service.

You need to begin by working out how much you need to borrow. Be careful not to borrow money unless you really need to do so; banks are very keen to lend money, as they earn interest, but try to resist their offers if possible and keep your debts to a sensible minimum. You need to calculate the amount you will need to cover your initial start-up costs; the list below is designed to ensure you do not forget any of these. You also need to finance your running costs; it is sensible to begin with enough capital to cover your on-going overheads (see list below) for at least six months.

It is critical that you do not sign on the dotted line for any loan, whether from family members, a bank or a private investor, before you have carefully read and understood all the small print, and you are 100 per cent certain that you are happy with the terms of the loan. Do not hesitate to seek professional advice; there may be a fee for this, but it could save you a lot of money and heartache in the longterm. A realistic, prudent business plan should show that, even in the worst case scenario, you will be generating sufficient surplus to cover the costs of repayment.

1. Bank loans

You can begin by searching the internet for small business loans and see which bank has the best deal. Interest rates vary, they may be fixed or variable and are sometimes negotiable; the interest you are asked to pay on a loan will be affected by the 'credit risk' of your business, i.e., how risky the bank assesses the loan to be. Some lenders do not levy bank charges for the first year or two, while others pay interest on surplus in your current account.

There are two main ways of borrowing from a bank, and you need to decide which is most appropriate for your needs:

Overdraft

You agree an overdraft limit and only pay interest on the amount you are overdrawn, but your payments may not reduce the loan. This method minimises your monthly payments, but may not be such a good long-term solution. If you only want to utilise funds for a short period then an overdraft is the better way of borrowing.

In addition to interest you will probably also pay an 'arrangement fee' at the outset – this may be around 1.5 per cent of the amount being borrowed – as well as 'annual renewal fees'. If you exceed your overdraft limit you will have to pay either a set penalty amount or an extra fee per day you remain over your limit, plus additional interest, and the bank will also charge you for letting you know that you have exceeded your limit; you must be clear about potential penalties. Overdrafts attract higher rates of interest than bank loans.

Overdrafts are a flexible way of borrowing money, in that you only use it when you need to, therefore you only pay interest at those times.

Loan

You repay both capital and interest in regular instalments, so the loan gradually reduces, which may be a better way of managing your borrowing. Loans are better than overdrafts for buying fixed assets. The length of the loan might be anywhere between one and 25 years, depending what you are seeking finance for; it would not be sensible, for example, to seek a 25-year loan for framing equipment and computers which would probably not last that long. An arrangement fee of around two per cent might be payable.

Loans are less flexible than overdrafts in that you may find you no longer require the loan, but you will still be tied into paying for it. However, they tend to come with lower rates of interest than overdrafts.

2. Investors and shareholders

A major difference between bank loans and investors is that the latter are generally prepared to lose their money if your business fails, while banks tend to require personal guarantees. Some business owners choose finance from investors specifically because they are not pre-

pared to put their house on the line. On the other hand, if you make a profit, your investors are entitled to their share of it.

Investors who are prepared to take shares in the business, rather than interest, can be useful if you don't feel you will be able to afford to pay interest at the beginning. (Share capital is also called 'equity finance'.) However, paying interest is a more straightforward arrangement and you may not like the idea of shareholders owning part of your business and having a say in it (you need to consult your shareholders before making important decisions that will affect the business). Drawing up agreements with shareholders can be time-consuming and involve complex negotiations, while taking out a bank loan is straightforward. While you only pay dividends to shareholders when you make a profit, whereas interest on loans has to be paid at fixed times regardless, this does of course mean that your share of the profits is smaller.

Many small businesses look to friends, family and social contacts for investment. However, borrowing money from people you know personally can be highly stressful, as you know they will lose their money if your business fails. It is therefore a good idea to limit investment from such people to an amount you know they could lose without it really affecting them.

'Outside investors', those who are not personal contacts, might invest in your business because they would get a better return on their money than they would if they put it in a high interest bank account. The risks would inevitably be higher, but, so long as your business plan seems plausible, investors may see it as worth taking this risk.

Outside investors are sometimes referred to as 'business angels'; these tend to be individuals with money to invest, rather than 'venture capitalists' who invest millions of pounds at a time. Business angels might typically invest sums between £10,000 and £100,000. Look on the British Business Angels Association website for more information (*www.bbaa.org.uk*).

Outside investors may want a controlling interest in your business, i.e., more than 50 per cent of the available shares, before they are prepared to hand over their money. Most small business owners would like to avoid this, but it is not always possible. However, an advantage of outside investors is that they may have expertise in your type of business, which explains why they feel confident to invest in it, so their advice

could be extremely useful. You and your investors have a shared interest in the success of your business, so they should willingly give you the benefit of their expertise.

The proposed return on investments needs to be finalised, and when this will be paid. You also need to decide whether your investors will receive an annual cash dividend, a share in the business or both. Many investors expect a moderate annual dividend plus a good return when they sell their shares.

You need to sort out at the start what happens if your investors want their money back, which might entail a notice period and a schedule of payments.

You should seek professional advice, probably from both an accountant and a solicitor, before issuing shares, as it is a complex area surrounded by legal requirements and tax implications. You need to work out how much share capital you have, which might be the total of your assets and cash (including loans). This needs to be divided into shares. For example, if your share capital equals £100,000 then you might choose to issue 100,000 shares worth £1 each. You then need to decide how many shares each investor is entitled to own.

Make sure that you fully understand the tax implications of your loan arrangements. This is particularly important when friends and family are investing, as tax may mean that their dividends are smaller than they thought, which could lead to ill-feeling. Stamp duty may be payable when you transfer shares and capital gains tax may be due on any profits. Dividend payments are taxable, but no national insurance is paid on them.

3. Credit with suppliers
Most suppliers offer 30 days' credit, and some as many as 60 days. Utilising these terms is another way of 'borrowing'. See Chapter 8: Cashflow (p.91) for more information.

4. Hire purchase, leasing and borrowing to buy equipment
You can buy office and framing equipment via a 'hire purchase' arrangement, which means that you pay for it in monthly instalments, often with competitive interest rates or an interest-free period. This means that you do not need to invest capital at the outset and the equipment is earning its way as you pay. Most suppliers offer financing terms.

You can also lease equipment, which normally gives you the option to buy it at a favourable rate at the end of the loan period. Leasing can be tax efficient as the cost is a tax deductible business expense. It also means that you can upgrade your equipment at little extra cost.

You should research which suppliers are offering the best leasing and hire purchase terms, then seek advice from your accountant as to which, given your particular financial circumstances, would be the most tax efficient way of acquiring new equipment. This will depend upon whether your business is currently making a profit, whether you would need to take out a loan to buy the equipment outright and how well the piece of equipment would hold its value over time (e.g., a mitre guillotine for cutting frames has a longer working life than most IT equipment).

There are certain types of pension schemes that enable the directors of small limited companies to borrow money from the scheme to buy capital assets. These schemes are called Small Self Administered Schemes; there are terms that have to be adhered to but this is a beneficial way for such pension holders to borrow money.

Grants

The key benefit of grants is that they often do not need to be repaid (so long as you abide by the terms of the grant), though some 'grants' come in the form of interest-free loans. Grants are not always paid as cash, but instead might be free training or business advice. Grants are often intended to fund specific projects, so you can't choose to spend the money as you see fit, as you could with a bank loan. They also tend to be paid for future projects, rather than for projects that you have already started.

Business start-up grants are sometimes available, for example if you are based in an inner city regeneration area or a deprived rural location. There are also grants available to people who have been out of work for several months or are returning to work after caring for children. There may be funding for specific areas of your business development such as training, setting up a website or developing export opportunities. Grants may come through the government, the EU, your local authority, enterprise agencies or via local business groups and trade associations.
Your local Business Link and the Department for Business, Enterprise and Regulatory Reform are the best places to find out whether you are eligible for any grants (in Scotland, Business Link is called Business Gateway, in Wales it is Business Eye and in Northern Ireland it is called

Invest Northern Ireland). Search their 'grants and support directory' to find out about any grants, subsidies and advice available.

It also helps to be actively involved in local business groups and trade associations, as these may publicise information about grants in their newsletters and may negotiate grants for specific purposes (for example, local shops may win local authority funding for a street party).

The terms of a grant may require that the business invest at least 50 per cent of the cost of the initiative to be funded, though this percentage varies according to the nature of the project. In order to qualify for a grant you need to meet certain criteria, for example you may need to have been trading less than a certain number of years, turnover less than a certain amount or be located in a specific area. Applying for a grant can be time-consuming so you want to be reasonably sure that you will get it before you begin the process. However, your business plan should go a long way to answering many of the questions.

Credit and debit cards

It is important to accept credit and debit card payments if you want to capitalise on impulse buys, which retailers of luxury goods need to do. Banks offer different deals on processing 'plastic' payment, and these are negotiable, so you need to shop around for the best one. Again, this is where trade association membership can help; associations can use the buying power of their total membership to negotiate highly competitive rates for individual businesses. The Fine Art Trade Guild has achieved this for art and framing businesses.

When searching for the best deal you need to look at each component of the package:

• Joining fee
• Cost of renting terminals
• Monthly service charge (and whether there is a minimum charge)
• Charges per transaction
• The minimum length of your contract
• Check whether there is a freephone number for authorisation calls.

There is usually a flat fee for each debit card transaction and transaction charges operate on a sliding scale for credit card payments. If your average transaction value is several hundred pounds you will pay a

lower rate than if your average sale is less than £50.

When you find that your average transaction size grows, or if it is larger than you first expected, remember to call the bank and renegotiate your fees. The same applies if you find that you are taking much more 'plastic' money than you initially anticipated. You need to regularly check that you are getting the best deal and try to renegotiate with your bank as often as necessary. With the endless pressures on your time you may forget to do this, but it really can be well worth your while. Remember that banks tend to rely on their customers asking them for better deals; they are unlikely to call up and offer them without prompting.

Tills, barcodes and forgeries

Your till should do more than just add up. It should allow you to enter a code for each product type, so that you can easily see which products are selling best at the end of each day. It should also provide summaries of how goods were paid for (cash, card or cheque), how many refunds were given, the value of each sale and the number of items sold.

Your till must also provide customers with VAT receipts (if you are registered), which must be kept by customers who may want to return items. This last point is important, as people may try to return stolen goods to you and insisting on a receipt prevents this. If customers' purchases are for business purposes they will need receipts for their records. Some tills have two till rolls, so a copy of each receipt handed to a customer is stored in the till. This can be a useful back-up in case of a query.

Few independent framers and galleries use barcodes; these are mainly used by retailers selling art materials, large quantities of greeting cards, gifts or art books. Bespoke frames are by their nature difficult to code, as each one is unique, and artists are unlikely to supply their paintings with barcodes on them. A till with a barcode reader need not be a big investment, and can often be bought secondhand. Barcode readers are an essential part of stock control when selling a good range of art materials, as you can easily find yourself stocking 3000 items (many paint ranges include 80 colours). A barcoding system alerts you when particular stocks are running low and can produce detailed sales analyses. You can use your till to ring up sales where part of the sale is barcoded and part of it is not.

There are cash forgery detection gadgets and pens that are inexpensive and can save you money, as your bank will not accept forgeries so you will lose out. It is a good idea to scan all notes, but particularly £50 ones.

Art loan schemes

Art loan schemes enable galleries to offer credit to customers to purchase art, which is then paid back over an extended period. Most schemes offer the buyer interest-free credit, though the gallery does pay for the service. Art loan schemes put art on the same footing as furniture and cars, helping galleries to compete on equal terms for discretionary disposable income. The credit option helps overcome what is often the main barrier to completing a sale: price. To ensure that profits don't suffer, loan schemes should be used to trade customers up to more expensive purchases and to secure additional sales.

Loans can clinch a sale: whereas £650 seems a lot of money to spend, a little over £100 spread over six months, with no interest payable, might seem much more manageable. Art loans should cost the gallery less than the discount they might otherwise need to give to close the sale.

Certain art publishers, the Fine Art Trade Guild and others make publicly and privately funded options available to retailers.

While the customer is offered interest-free credit, the gallery nearly always has to pay. Interest rates vary widely, as can terms, which may limit buyers to original art. Rates tend to be higher the longer the period of the loan.

Before selecting a scheme check the small print. Find out if customers are expected to pay a deposit and how much they are allowed to borrow. A minimum level of turnover may be required before you can join a scheme and lenders also seek approval of galleries from credit agencies before accepting them. Find out how quickly credit checks on customers can be carried out and how quickly galleries are reimbursed. There are sometimes rules surrounding how quickly the artist must be paid, and confirming that the cost of the loan is borne by the gallery and not the artist.

Any business wishing to offer credit must hold a licence from the Office of Fair Trading enabling them to trade as credit brokers. A Consumer Credit Licence costs between £120 and £300, depending on

whether you are a limited company or a sole trader, and it will last for five years.

Overheads

Below are the overheads that retailers might typically have to pay. These are divided into start-up costs, expenditure, the direct cost of sales and occasional expenditure.

1. Start-up costs

- Refurbishment costs – Building work before you start trading, including sign writing. This is often the highest start-up cost and if work is not completed to schedule, the costs of lost business can cripple cashflow projections with severe consequences
- Stamp Duty Land Tax – See Chapter 4: Choosing your premises (p.48) for further details about this one-off tax which is payable when you take on a lease or buy a commercial premises
- Surveyor's fee – When taking on a lease you may pay a surveyor to produce a Schedule of Condition (see Chapter 4 p.48), and when buying a freehold your mortgage company would require a survey. (Some people also use a surveyor to act as agent when negotiating a lease or sale, but the surveyor should save you more than their fee)
- Solicitor's fee – A commercial solicitor would need to advise you on matters such as the terms of your lease, your Partnership Agreement and setting up as a limited company
- Accountant's fees – An accountant should look at your business plan and advise on the feasibility of the financial side of your projections
- Local authority searches – Some of these are standard when you take on a property, and your solicitor should advise you. There may be slightly higher fees if the property is a listed building or in a conservation area
- Companies House – If you set up as a limited company or limited liability partnership you have to pay a fee to Companies House, whether you register a new company or buy one 'off the shelf'
- Fixtures, fittings and furniture – Items including a new fridge, framers' workbench, office desk and chairs, poster browsers and display and storage equipment
- Security system – You may need to install a new burglar alarm, panic alarm or system for 'buzzing in' customers
- Framing equipment – See Chapter 9: Which services to offer (p.96) for details of which equipment is essential at the outset
- Printing equipment – See Chapter 9 for details of which equipment to buy if you will be offering a printing service

- Computer and electrical point-of-sale equipment – See Chapter 12: The role of computers (p.131) for an idea of what to buy at the start
- Design – You may do this yourself, but many people pay a professional to design their logo and brand to ensure that it is effective
- Registering your domain name – Small fees are due when you register a website domain name
- Website design and launch – You may not be focussing on e-commerce immediately, but many businesses launch a website at the beginning. There are set-up fees if you offer secure shopping to online buyers (see Chapter 12: The Role of Computers).
- Car or van – You may already own a car suitable for delivering framed pictures, or you may need to buy one
- Consumer credit licence – You will need to buy one if you want to be part of an art loan scheme (see above).

2. Expenditure

- Rent or mortgage – See Chapter 4: Choosing your premises (p.48)
- Salaries, health insurance and pension plans – You may choose not to draw a salary to begin with and you may not have staff. Once the business is established you may buy health insurance and pay into a pension plan
- Tax and national insurance – See Chapter 2: The formalities (p.24)
- Uniform Business Rates – See Chapter 4. In some areas services such as rubbish collection are charged separately
- VAT – See Chapter 2
- Service charges / maintenance – Some tenants and multi-occupancy freeholders pay an annual service charge, while other freeholders need to keep money aside for repairs to the structure of the building
- Loan charges – Separate from your rent or mortgage you may be repaying a bank loan or borrowings from other investors (see 'Borrowing money' above)
- Bank charges – Including fees for processing debit and credit card payments and renting your PIN terminal, as well as fees to your e-commerce provider (if you offer secure online shopping)
- Hire purchase or leasing costs – These apply if you have chosen to acquire office and framing equipment in these ways
- Marketing and advertising costs – See Chapter 13: Effective marketing (p.139). This overhead might include advertising, printing, posting and distributing leaflets, window dressing, PR, buying a mailing list, contributing to a street party etc.
- Art loan scheme fees – If you are part of an art loan scheme, there

will be fees to pay (see above)

- Artist's Resale Right or Droit de Suite payments – This will only apply if you are selling original art on the secondary market or bought outright from publishers, see Chapter 2
- Insurance – See Chapter 2
- Utilities – Electricity, gas, water and telecommunication bills
- Website fees – You will need to pay a host for your website, and you may also pay for the site to be up-dated, maintained and kept at the top of the search engines
- Stationery – This includes carrier bags (maybe over-printed with your logo), packing supplies, letterhead, business cards and invoices
- Car or van – The running costs of your delivery vehicle, and maybe also monthly hire purchase payments
- Accounting fees and financial advice – Even sole traders and partnerships tend to spend some money each year on book-keeping, accountancy and financial advice
- Companies House – A small fee is payable each year if you are registered as a limited company
- Trade association membership, magazine subscriptions and donations – Professional art and framing retailers join the Fine Art Trade Guild, see Chapter 2. You may also subscribe to trade and art magazines (see Useful further reading on p.231), pay donations to local business groups and make charity donations
- Security system servicing – Most burglar alarm systems need servicing annually. You may also need to pay a key-holding company or pay a fee to cover the cost of call-outs
- Auction house charges – These obviously only apply if you buy and sell at auction or via on-line auctioneers
- Cleaning and window cleaning – You may do this yourself at the beginning
- Shoplifting and damaged stock – You need to make an allowance for stock that gets damaged, is used for display purposes or is stolen. Shoplifting is more of a risk for gift and art materials shops than framers who only display chevrons and print catalogues, or galleries whose pictures tend to be in large frames
- Bad debts – Most retailers do not sell on account, so a few uncollected framed images might be the worst scenario. However, contract framers and those supplying corporate art need to manage credit control and debt collection to minimise bad debts.

3. The direct cost of sales

The direct cost of sales refers to costs involved in actually making the products you sell, such as frames and digital prints. For accounting purposes this includes the proportion of wages that paid for framing and printing, the cost of machinery and equipment and the cost of loans taken out to buy equipment. Include:

• Stock for re-sale
• Framing materials and printing consumables, if you carry out these services
• Framing – this can be a considerable cost for galleries that choose not to do framing in-house
• Picture restoration – this should only apply if you are buying artwork on the secondary market. Brand-new artwork should be in mint condition.

4. Occasional expenditure

Some overheads will crop up occasionally, rather than each quarter or annually, but must still be budgeted for.

You also need to consider the depreciation of machinery, equipment and vehicles. While this is not exactly an overhead, your audited accounts will include figures for depreciation. Include:

• Replacing or upgrading computer equipment and software
• Replacing or upgrading framing equipment (if you offer this service)
• Replacing or upgrading printing equipment (if you offer this service)
• Staff recruitment and training costs
• Maintaining your building – if you pay service charges look at what these do not cover
• Replacing display equipment, fixtures and fittings
• Renewing your Consumer Credit Licence – this licence is renewable every five years and is a necessity if you are in an art loan scheme.

Broadbrush financial scenario

Before you go out and look for premises or invest much time at all in your new business idea, you need to do a broadbrush financial scenario to check that your idea is viable. This will form an important part of your business plan (see Chapter 7: Writing a business plan on p.81).

This involves budgeting your anticipated takings for a fixed period

against your expenditure (see above), including the cost of stock and materials, to produce an estimated gross profit. Do not forget to include your tax liabilities and a realistic salary for yourself.

While this financial scenario can only be estimated, you must try to make the most informed estimates possible. Begin by making sure that you don't leave any overheads out and that you are not over-optimistic about how much stock you will sell and at what price. Your financial scenario needs to be realistic rather than optimistic and you must demonstrate that careful analysis and research has gone into it.

Your business as pension

Many retailers do not make proper pension provisions on the basis that they will sell the business when they want to retire. The problem with this is that many art and framing businesses are highly personal, so are hard to sell as going concerns. Potential buyers do not always attach much importance to sellers' goodwill and may not pay more than a few thousand pounds for it. A quick look at the classified ads at the back of leading trade magazine *Art Business Today* shows that the same businesses are offered for sale issue after issue, many never finding a buyer at all. And many are offered at very low prices considering the long hours put in by their owners.

There are various ways to maximise the price you can get for your business, however. Limited companies are easier to sell than sole traders and you need to ensure that the business model is efficient, well-documented and running smoothly. You need to keep records going back as far as possible, show good investment in marketing and brand-building and be able to prove that you have good rates of repeat business. You also need to demonstrate that the business is not dependent on the owner's presence, which involves having a strong staff team.

Rather than relying on selling the goodwill of your business for your pension, it is advisable to gradually invest some of your profits as these are generated. Many retailers seek to make capital investments such as buying their premises after they have been established a few years, even if this means moving to a new shop (which it quite often does). There are tax-efficient ways of buying a freehold, such as through a Self-invested Personal Pension, which your accountant should advise you about.

Once profits are sufficient, many chose to pay into their own pension scheme, and the government offers tax incentives to people who do this.

Chapter 6

Assessing your progress

There are various ways of assessing how your business is doing, which all involve efficient and regular record keeping.

Budgeting

If you don't budget properly you are unlikely to make a profit. You must be in control of your costs, fully aware of your income from sales and must be pricing effectively (see Chapter 11: Pricing on p.123). You need to update your records daily. If you do not budget properly you may end up working a seven-day week without making a profit; you may feel under such pressure to, for example, fulfil all your framing orders that you lose the grip on your finances, which could prove fatal to your business.

Budgeting is different from book-keeping in that the latter is to do with accurate record keeping, while budgeting is to do with financial projections and targets. You need to compare your actual figures with your projected figures each month.

You need to pay particular attention to the percentage of your sales revenue that is offset by costs. If costs are offsetting an increasing percentage of revenue, and thus eroding your profit margin, you need to know why. For example, if a supplier has increased prices significantly you need to look at alternative sources of supply.

You can only control costs properly if you have a clear picture of whether they are rising. You need to regularly assess your highest overheads and see if these can be cut in any way. Costs such as printing catalogues and direct marketing material, for example, can vary hugely, so it is always worth getting several quotes, which is quick and easy now that it is just a matter of emailing your requirements to several printers at once. The internet makes comparing prices easy, so you must never be complacent about this.

Cashflow is an important aspect of budgeting, which is discussed in Chapter 8: Cashflow (p.91).

You must constantly monitor your financial position through cashflow analysis, your profit and loss account and your balance sheet. Computerised accounting packages such as the market-leader, Sage, make this task a lot quicker than it used to be.

Balance sheets

Balance sheets, which summarise the financial position of your business at a particular time, are an important part of budgeting. Balance sheets are closely linked to profit and loss accounts, but each focuses on slightly different aspects of the business.

If you are a limited company or limited liability partnership it is a legal requirement for your annual balance sheet, which is submitted to Companies House and the Inland Revenue, to include the following:

- Fixed assets – your premises, equipment, machinery and vehicles, plus the value of your 'intangible assets' i.e., your goodwill and your brand. Equipment and items that will depreciate in value must be included at their current re-sale value
- Current assets – stock, cash and money owed to you
- Current liabilities – money that you owe and outstanding bills, including tax
- Long-term liabilities – capital that has to be re-paid in the future
- An analysis of your profitability, i.e., how big a surplus or deficit you have generated.

Balance sheets help you run your business by showing which areas are doing well and which need to be focused on. Comparisons between balance sheets from different periods are particularly useful; you may decide to create balance sheets once a month for internal management

purposes, even though this is not a legal requirement. Investors like to see balance sheets as they quickly reveal how a business is doing.

The total value of your assets should always appear as the same as the total value of your liabilities, hence the term 'balance sheet'.

Profit and loss accounts

Profit and loss accounts are another important way of assessing the progress of your business, and are a legal requirement for limited companies and limited liability partnerships. This type of record is a summary of all the buying and selling you have done over a period of time, including how much profit, or loss, you have made over that same period. This differs from a balance sheet in that is concerned with trading patterns, rather than the wider picture of the business as a whole.

When working out your profit and loss you need to deduct the direct cost of sales (stock, materials and the cost of making products) from your overall sales total, which gives you your gross profit. You then deduct all other overheads from your gross profit, to reveal your pre-tax profits.

Fixed assets (premises, machinery, etc.) are not deducted from your taxable profits in the same way as other overheads, but the costs are depreciated over several accounting years.

Accounting ratios

There are various accounting ratios that can be used to assess how your business is doing. Accounting ratios make sense of the financial data you are constantly collecting and flag up potential problems and which areas of the business are performing particularly well.

The current and quick ratios are the most commonly used, and they assess your short-term liquidity. As well as liquidity ratios, there are capital ratios, which relate your funding to the payment of your long-term debts. Efficiency ratios look at the operating efficiency of the business, and profitability ratios focus on whether or not you are making a higher-than average level of profit. Some accounting ratios are discussed below, and many more are readily available in business management books and websites.

Current ratio

The current ratio analyses the extent of your working capital, which in practice means whether you will be able to pay your bills as they fall due. You need to calculate your working capital requirement regularly if your business is growing quickly, otherwise you might run into cashflow problems.

This ratio takes your current assets (stock, cash and money owed to you) minus your current liabilities (money owed to the bank, suppliers and the tax office). Fixed assets, such as your premises, are not included in this equation; only assets that could be quickly and viably liquidated. Nor is goodwill or the value of your brand included. Similarly, long-term debts, such as to shareholders, are not included; only debts that you will have to pay within a year. The ratio is called 'current' as it looks at your business's ability to pay at the current time, rather than in future years.

Some working capital is necessary to run a business, and this may be more during some months than others, depending when bills are due and on your stock-buying patterns. Accountants commonly suggest that you should have a ratio of 2:1, i.e. your current assets should be double the size of your current liabilities. If you are working with a ratio as low as 1:1 you need to keep an even closer eye on your financial situation, as a cashflow crisis could develop very quickly.

Quick or liquidity ratio

The quick ratio involves dividing your current assets, excluding stock, by your current liabilities. This highlights your ability to pay bills, i.e., your liquidity, even more starkly than the current ratio since it focuses just on your cash situation, uncomplicated by the value and saleability of your stock.

In this instance, a ratio of 1:1 shows that you have a good liquidity level and your business is doing well.

If your business has a healthy current ratio, but a less healthy quick ratio, then you may be over-stocked. The danger here is that it takes time to sell stock and, inevitably, not all your stock will be easily saleable.

Defensive interval

You should also work out your defensive interval, which refers to how long your business could survive without any money coming in. You take your current assets, again excluding stock, and divide these by your daily operating costs. This exercise should ideally show that you could survive between 30 and 90 days.

Gross profit margin

This analyses your profits as a percentage of your turnover. The equation takes the ratio beween your gross profit and your total sales for the same period and multiplies the figure by 100. For example, if your turnover is £150,000 of which £50,000 is gross profit, your turnover is three times your profit, so you multiply this by 100 to give a gross profit margin of 30 per cent. In other words, for each pound you take, 30p is gross profit.

Gearing

Banks and other lenders will assess your gearing to see if you are a high or low investment risk, and how secure their loan would be. This ratio is the relationship between your borrowings and the net worth of the business, as shown on your balance sheet. Ideally the net worth of your business should be three times that of your borrowings, though your bank may only have serious concerns if the ratio falls below 1:1.

Chapter 7

Writing a business plan

The best way of showing potential investors that your business is worthy of their financial support is to present an effective business plan. Many lenders see a business plan as mandatory, however, the uses of a business plan extend far beyond the need to attract investment. It should be a map to guide you through the day-to-day running of the business and a benchmark against which to assess your progress.

A good plan must be clear, focused and realistic. It needs to show that you have the tools, team and talent to make the business successful. It should outline your goals and show that you have systems in place to make these a reality. It must show that your business will generate sufficient revenue to cover your costs and make a profit. A good business plan helps managers plan for and focus on the future and ensures that everyone is working with the same objectives in mind. The process can help you allocate resources and foresee problems.

Businesses with more than one partner (even family members) need a business plan to ensure that the partners have the same goals; even if you have a pretty watertight partnership agreement (see Chapter 2: The formalities, on p.24), a business plan can provide checks and balances to ensure on-going mutual focus and direction.

When it comes to selling your business, a sound business plan, along with evidence that you continue to be guided by it, can go a long way towards persuading potential buyers that your business is worth paying for.

The contents

A business plan with the prime aim of securing investment will have a different emphasis to one that is intended for internal management purposes. Investors are looking for profitable investment opportunities, while managers may be looking more closely at long-term security and sufficient steady growth to pay their salaries.

Most business plans tend to follow these basic guidelines:

- Summary – a one or two-page outline of your plan and its highlights
- Business description – the business and its aims, including its ownership and history
- Products and services – describe these and explain their unique selling points (USPs)
- Your market – analysis of your customerbase, the competition, potential market and projected growth
- Marketing and sales – how to position your business, tell people about your product and sell it
- Operations – how the business is structured and organised
- Management – CVs of your decision makers
- Financials – details of capital, projected cashflow, sales, overheads and profit.

In addition to the sections listed above there should be a title page and a list of contents. The title page should catch the eye and make you want to read more. It should say 'business plan', along with the business name and logo, the author's name, business contact details and a date. Each page should of course be numbered.

Business plans vary considerably in length with many ending up between 15 and 40 pages, but length is not an attribute in itself. It is far more important to keep it clear and concise; this will help convey the idea that your business will be run in an efficient and professional manner.

Photographs, designs for advertisements and promotional material and other graphics can be included in an appendix at the end of the business plan. Since art and framing are visual products this can be a good idea.

Making it easier

There are consultants who will help you write your plan. Bear in mind that you will still need to invest considerable time in the project yourself and work closely with the consultant to ensure that it properly reflects your business and your ideas. However, the style in which a business plan is written and the manner in which the information is presented can make a great difference to its impact.

There are many books, magazine articles and websites that will help you research and write your business plan. Your bank should also have a useful information pack on the subject. Business Link has guidelines and templates for writing a business plan.

There is business planning software available to give you an outline to work with. However, don't think that software will do the job for you; you still need to supply the right data and ideas. Software should provide initial structure, ask you important questions and prompt you to provide the right information. It should also include lots of sample plans for you to reference. Beware of letting software dictate the form of your plan to a great extent, as this will detract from its individuality and make it look the same as everyone else's.

Summary

Ideally your summary should only be one page long, and can be adapted if you want to use the plan for different purposes. Getting it right is critical for investors; many will only look at this section and the financials, and will make their decision based on these. The most important points of your plan should be distilled in this section and your strengths should be abundantly clear. If this part is weak, then many investors will not bother to look further. It may be a good idea to write the summary last, taking key phrases from other sections as you progress.

Business description

Function

You must begin by explaining what your business does, or will do; outline your idea, then explain why it is viable and how you are going to turn it into a profitable entity. It is a common mistake to enthuse about the idea on which your business is based, without sufficient emphasis on its viability and profitability.

Market position

This is where you explain your 'mission statement', or what your company aims to provide. This is not just a description of your products (which comes later), it includes how you will do business and the benefits to your customers of dealing with you. You need to explain the principles on which your business is founded. For example, your plan might be to run a gallery selling quality original art and handmade prints at under £2000 in a deliberately unintimidating environment. Or you might want to be dedicated to selling prints, paintings and decorative objects featuring, for example, birds to both local bird watchers and through a specialist network of trade shows and publications.

The industry

Include an overview of your industry. This description will show that you have properly researched the industry and that it is one offering good business opportunities. The more relevant supporting facts and figures you can supply, the better; your business will not be operating in isolation. Search the web, use trade magazines, local authority statistics, etc., to find information that will demonstrate that you have properly researched this business opportunity.

The facts

Include facts about the company, such as when it was founded, its legal status and who owns it.

The future

Explain how you plan to develop the business in the future. Ideas for future growth appeal to investors and show that you have considered future challenges and changes in your marketplace. This will also help you develop the business and give you guidance and benchmarks against which to assess your progress as the business grows.

Products and services

As well as describing your product mix, you need to show that there will be a strong demand for your products and services. However brilliant your idea, if there is no real demand for it, your business will not be viable. You need to show that you have hit upon an idea that can be exploited profitably.

Explain the unique selling point (USP) of your products and services. This is very important as your USP is what will make people buy from you rather than spend their money elsewhere. There must be no confusion about your USP; it should be at the core of your business.

See the section entitled 'Is your business idea viable?' in Chapter 1: Getting started (p.12) for inspiration when writing this section.

Your market

This section of your plan should be an analysis of your customerbase, the competition, the potential market and projected growth. You need to show that there are sufficient customers to make your idea viable. See the section entitled 'Is your business idea viable?' in Chapter 1: Getting started (p.12) for some ideas.

You need to clearly explain who your target customers are, otherwise you cannot plan how to reach them. Many entrepreneurs have an idea that they have fallen in love with, but fail to properly think through who is going to buy it. As this is such a common mistake it is absolutely essential to stress that you know who you are selling to, and that you have researched their perceptions, values and retail expectations.

You need to quantify your market, i.e., find out its size and demographics, and explain its key features. For example, a retail gallery and framer in a middle-class suburb might be primarily targeting women within a three-mile radius. Give evidence that you have researched the buying habits and spending patterns of these people.

There are a number of websites that provide free demographic information, which can be useful when describing your target customer. These should help you put together a picture of the local population and a profile of the type of community you will be serving. Your local library and town hall should also hold relevant information. If, for example, you are starting a gallery selling collectable limited editions you can provide information on local house prices and local businesses selling antiques and home furnishings, to justify your opinion that there is a wealthy local clientele hungry for your type of product.

Part of your strategy has to be how you will deal with the competition. It is a common mistake to think that there is no competition, because no one else in your area has a business like yours, but there is always

competition in terms of other ways for people to spend their disposable income. Art and framing are luxuries; you will be competing against fashion retailers, home furnishers and restaurants, among others. You need to discuss direct competitors as well, e.g. other galleries and frameshops, and how your business differs from them and will take some of their marketshare.

Marketing and sales

This section should look at how you intend to position and brand your business, as well as marketing and selling products and services. Though your idea may be brilliant, it won't be a success if you can't sell it. You must show that you can reach potential customers in a cost-effective way that will generate revenue.

Explain how you will convey an image that will help sell your USP to your target customer. For example, a bespoke framer could opt for the feel of a Florentine gilding atelier, to convey timeless craftsmanship and expertise, or emphasise the design-led aspect of framing with a more funky look. The choice will depend on your target customer and your USP. Your branding, packaging, promotional material, website etc. will all be designed to reinforce your chosen market position.

It is a common mistake to neglect to address how you will tell your target customer about your services (marketing) and how, once they are in your shop, you will sell to them. Both marketing and sales need to be addressed, and the two mustn't be confused.

Marketing

Details of planned marketing activities should be given; see Chapter 13: Effective marketing (p.139). Explain how you will use your chosen activities to convey your message, and why particular methods will work for you. You also need to explain who will handle marketing, estimated costs, timescales, how you will handle the response to marketing initiatives and how you will monitor success. You need to set targets for each initiative.

Sales

You must consider sales techniques, i.e., how you will convince customers to buy once your marketing has brought them into the shop. Explain your sales strategy, staff training and how you will close a sale.

Pricing

Pricing is a key component of marketing and closing a sale. You need to explain your strategy for pricing and give examples. Explain how your level of pricing compares with the rest of your industry, with other local traders and with your target customers' ability to pay. Whether your prices are higher than those of competitors, or lower, your choice of price point needs justifying.

Suppliers

Explain your supplier strategy; for example, you may be buying from a particular arts and crafts co-operative so you can offer goods that no one else in your region has access to. Your chosen greeting card publisher may supply cards featuring work by early 20th century artists that complements the work of your living artists. Show that you plan periodic checks to ensure cost competitiveness, and that you will be regularly assessing new suppliers and supply options.

Operations

Location

Your choice of location should be explained and justified. The plan should include a rationale for why you are going for a secondary position, a first floor shop, an industrial unit or a prime high street outlet.

Staffing

Explain why you don't plan to employ anyone or justify your requirements for employees, and which functions they will be carrying out. Include how you will recruit and train staff, as well as how easy it will be to find the right people, and their projected job descriptions and salary levels (salaries should be compared with those paid for similar local jobs).

Suppliers

You need to have a sourcing policy and give details of suppliers, and show why you think they will deliver to specification, timeframe and cost. Suppliers need to be addressed under 'operations' as well as 'marketing and sales'.

Equipment

Explain why you need certain pieces of equipment, for example framing machinery or large-format digital printing hardware. Justify your expenditure if you are planning to invest in, for example, a computerised mountcutter rather than its less expensive manual equivalent.

Management

If the aim of your plan is to attract investment then managers' CVs are important. If your plan is designed to help with internal decision-making then your focus will be on the role that each manager will play. But remember that if you want to sell the business potential buyers would want to see the CVs of the people who founded and run the business. Effective managers can make or break a business, so you must stress the relevant skills that each will bring. Show that these complement each other and combine to form a winning team.

The closer the skills, qualifications and experience of staff match the job they are expected to do, the better. The business plan needs to show that the tasks, workload and management of the business can be carried out by the owners and their staff team.

Financials

You need to provide financial forecasts for at least three years. Your projected finances need to be plausible, properly explained and consistent. If you cannot justify your figures properly then your plan seriously loses credibility. Your financials should be optimistic, readers will expect that, but not excessively so; a common mistake is to feel compelled to make exaggerated financial claims. It is important that your accountant should look at your financial projections.

Your figures must demonstrate that you will have sufficient cashflow to keep the business running. Start-up businesses may expect to make a loss for a few months, but you need to show that you have planned for this with an agreed bank overdraft, grant, loan, financial investment or capital in hand.

An understanding of cashflow is essential, and this understanding needs to be demonstrated in your 'cashflow statement'. Many perfectly good businesses go under because, although they have a full order book, they do not have the cash in the bank required to pay their bills.

Your plan needs to show that you have considered when money is likely to come in, and when bills are going to come due. You need to demonstrate, for example, that money from vibrant pre-Christmas sales will be available to pay January's rent and wages. Explain when you need to pay artists who have provided work on a sale or return basis, as well as your main suppliers' payment terms.

A break-even analysis helps show how much you need to sell at what price in order to cover costs and start making a profit. Your business plan can include 'best case' and 'worst case' scenarios. A profit and loss forecast helps you see when a new business should start to make a profit, or assess the profitability of an existing business. It provides a benchmark against which to assess progress.

Your financial projections need to include all overheads, including the owners' salaries. There is a tendency to leave this last expense out, on the grounds that the owners will just 'take what's left' at the end of the month. This shows woolly thinking; either the owners' salaries need to be included, or if they have sufficient capital to live off for the first few months, then this needs to be stated. Your financial forecast must be as comprehensive as possible to enable you to understand the trading position of your business.

Your overheads can be divided into:

• Operating costs – utilities, wages, rent, print, admin, etc.
• Capital investments – computers, printing and framing equipment, till, etc.
• Stock – products that will be sold on and materials you need to produce finished goods.

Estimating revenue can be difficult for a start-up business; the main thing is to be able to explain how you arrived at your projected revenue. Evidence of extensive research and planning is what is required.

Work out an average spend per customer transaction and calculate the number of customers you might reasonably expect in a typical day, allowing for seasonal fluctuations. For example, a gallery and framing business should find out what other businesses in areas with similar demographics might charge for a framed image. Also look at surrounding shops and restaurants and the prices that people seem prepared to pay. Count how many people go into these shops.

If investment is sought, then the proposed return on the investment needs to be included, and when this is likely to be paid.

All businesses face risks and situations can change. You need to address some 'What if...?' scenarios and explain how you will deal with their financial impact. A frank discussion of your risks and threats shows that you are approaching your business realistically, and assessing these before they become problems can help minimise their impact later on.

Chapter 8

Cashflow

Cashflow is the lifeblood of any business, and disrupted cashflow is a major reason why perfectly viable small businesses go under. The term cashflow refers to your ability to manage the flow of money in and out of your business; this might sound simple, but it can be very easy to stop focusing on this critical element of staying in business when there are myriad demands on your time. It is essential that you are on top of this element of your business at all times.

Profit and cash are not the same thing: you can get away without making a profit for a while, but running out of cash is another, often terminal, matter. Cashflow refers to your ability to pay your bills each month, which is linked to the amount of cash flowing in and out of your business. You may be owed a lot of money by reliable customers and have a full order book, but still be unable to pay your staff and suppliers because you do not have cash sitting in the bank at a particular time. Managing cashflow means ensuring that this does not happen.

Profit and loss accounting differs from cashflow forecasting in that the former aims to show all revenues against all outgoings. Profit and loss accounting looks at the wider picture for a business, not just its immediate ability to pay its bills.

Retailers have an advantage in that the norm is for customers to pay before taking their goods. Providing the business has good stock control, this means they may even be taking payment for goods before they have had to pay their suppliers, which is good for cashflow. However, corporate art suppliers and contract framers may have to offer 30 days credit, or more, so cashflow can be harder for them to manage.

Retailers need to have a policy on stock turnover and ensure that stock is sold at a reduced profit, if necessary, to ensure that cash keeps flowing. Some framers choose to buy mouldings ready cut to size, which is called 'chop service'; while this reduces profits slightly it minimises the money tied up in stock.

Planning and forecasting

Key advice is to store away money for the lean years, get a good accountant and remember about the taxman. It is all too easy to use stored cash intended for the Revenue to cover a lean period, but this can have disastrous consequences.

Tight cashflow controls should quickly highlight problems such as falls in repeat orders and rising raw material costs.

It is important to have a cashflow forecast, which is essentially details of when money is likely to be paid in and when bills come due. Your accountant should help you integrate this with a budgeted profit and loss account and balance sheet. This may sound complicated, but the principle is quite simple. The point of a cashflow forecast is to help you spot cash shortfalls in advance so you can plan ahead to mitigate these. Potential cashflow problems quickly become cashflow crises if they are detected too late.

Cashflow forecasting can be incredibly difficult for new businesses, as you have to make projections without any past history to base them on. The best way to build a cashflow forecast is to start by making a spreadsheet of regular fixed outgoings based on when these fall due (rent on the first of each month, wages at the end of each month, utilities quarterly), then note revenue-generating activities alongside these and when you expect to be paid.

Receipts from shop sales must be predicted, based on the sales budget in your business plan and receipts from previous years. This should

help you work out how much stock is needed to meet demand, so purchases can be planned allowing for order lead times and the need for buffer stocks. Retailers typically have fluctuating demand patterns and judging what stock is needed at different times of year can be a tricky juggling act, but without the right stock on display you won't make the sales to generate sufficient cash reserves. Too much excess stock, on the other hand, is tying up capital unnecessarily and can put strain on your cashflow.

It is important not to pay for goods earlier than you have to, or to arrange delivery of goods earlier than you need them. Note your main suppliers' payment terms, which are likely to be between 30 and 60 days after delivery, and integrate these into your cashflow forecast.

One of the easiest ways to monitor cashflow is to compare unpaid purchases with sales revenue at the end of each month. If unpaid purchases are greater than sales, you will need to spend more cash than you are likely to receive next month, indicating a potential cashflow problem.

Many small business owners find that online banking helps the management of cashflow, as they can check their balance and check on payments at any time of the day or night simply by logging on.

Contract framers and corporate art suppliers can be so grateful to win new business that they rush in without proper contracts with their clients, which is a big mistake. It is essential to ensure that a proper schedule of payments is in place before you start trading with a new customer, and that details such as deposits, penalties and the shared costs of raw materials are sorted out.

Paradoxically, it is commonly a business's success in winning a big new order that turns out to be its downfall. For example, the business might neglect its small regular customers in order to fulfil a large order; the large order incurs raw material and labour costs while payment is not received for several months from the date the order was taken. The cashflow problem is exacerbated by the lack of income from the small regular customers. It is therefore essential that any expansion is based on a solid business plan and cashflow forecast.

Balancing act

The key to healthy cashflow is to try to get money in as quickly as possible and, within the limits of good practice, pay money out as late as

is legally allowable. Make sure that your system for chasing payment is as efficient as possible and do not supply customers until you are fully satisfied that they can pay.

It is important to manage your suppliers; check that they are not over-charging, taking too long to deliver or enforcing unreasonable payment terms. Make sure that you are not settling invoices earlier than you have to and that you are not over-stocked. Check suppliers' terms carefully and consider discounts for early payment; for example, a two and a half per cent discount for paying 30 days early typically saves three times the cost of the borrowing. Consider a draw-down ordering system from suppliers prepared to offer it. You agree to buy at a given price and quantity, but dictate when you want delivery as the year goes on, only paying for what you use as you use it.

Some suppliers offer as long as 60 days' credit. Be sure that you are aware of suppliers' terms and are utilising them to your advantage (without abusing them). If you can sell goods before you have to pay for them, then you are generating cash for your business. But bear in mind that if you take too long to pay suppliers they can withdraw your credit facility.

If you are selling goods on credit, be sure to invoice customers as soon as they take delivery of the goods. If you wait to prepare invoices until the end of each month, you may be adding as many as 30 days to your cash-flow conversion period. It might be effective to offer customers a discount for paying their invoices early; if your normal payment terms are 30 days, consider a two per cent discount for customers who pay within 14 days.

Most framers ask their customers for a deposit when they take on a job. This of course helps with cashflow and framers should feel confident that they are requesting the maximum deposit that their customers will feel happy to pay.

Make sure that you regularly assess your outgoings: are some of the deals available for telephone and internet connections worth taking advantage of; should you lease rather than buy certain equipment; are you buying services such as printing, shipping and framing from the most cost-effective source? It is worth getting quotes for these services on a regular basis; don't just assume that the supplier who gave you the best quote five years ago is still offering the best value for money.

Buying major items towards the end of a VAT period, rather than at the beginning, can also help with cashflow.

Get paid on time

Small firms are three times as likely to wait for payment than larger firms, according to the Credit Management Research Centre. The Better Payment Practice Group has published a 12-step guide to the essential elements of an effective credit management policy:

- Check new customers' credit worthiness before drawing up contracts
- Refuse orders if a customer has an unacceptable payment record, or ask for payment in advance
- Set strict credit terms and be sure to stick to them
- Make sure that you and your customer agree unambiguous written terms and conditions of trading
- Make sure your sales force understand and agree with your trading terms and are prepared to discuss them with customers
- Make sure that you understand and comply with procedures used by your customers' accounts departments
- Develop a rapport with customers, particularly the people responsible for paying invoices, so that even when money is tight you will be top of the list to be paid
- Carry out regular credit checks on existing customers
- Ensure that despatch notes and invoices are accurate and are delivered to the right customer at the right time
- Put a stop on supplies to customers who are not paying and use their desire for further supplies as a spur to payment
- Chase payment persistently and at regular intervals
- If all else fails, put the debt in the hands of a debt collection agency or solicitor.

You must of course track overdue accounts and actively pursue collection. Most accounting software helps you to track past-due accounts, but you also need a clear process for chasing payment. Such a process would probably involve regular letters and telephone calls in order to find out why the customer has not paid and to remind them of the steps you will take if they do not pay, such as turning the account over to a debt collection agency or issuing a Court Order. (Many businesses find that this last threat is what is needed to make people pay.) You need to keep records of all conversations and correspondence, delivery notes, etc.

Chapter 9

Which services to offer

There are several services that art retailers can offer as well as selling artwork, gifts and art materials. Four of the most popular are discussed here. Some businesses find diversifying into a range of products and services useful, partially because each aspect of the business brings in customers for the other parts. For example, artists may go into a shop to buy art materials and end up buying their framing there as well, and getting their artwork made into digital prints.

Many galleries frame in-house, while others out-source it and add on a profit margin. Increasingly, galleries are investing in wide-format printing equipment and producing prints that they sell themselves, as well as offering a printing service to local artists and art groups. Others act as agents for the artists they represent, negotiating licensing and publishing deals on their behalf. Some galleries set up 'corporate art departments' supplying art to local businesses, either direct or through interior designers.

Each business person has to make decisions about how best to allocate their time, available finances and physical space, and the factors affecting these decisions inevitably differ in each case.

Framing

When times are hard in retail it is common to hear shop-owners remark that print and gift sales are down, but framing is steady. It seems that people tend to see framing as less of a luxury than buying art, so are more likely to still get things framed in tough times.

Framing is another way for retailers to attract customers: people may come in to have their child's first drawing framed and walk out having bought a print, and if it wasn't for the framing it may never have occurred to them to go into a gallery. Framers can market their services to local art groups, photographers, schools (for photographs) and businesses; a framing service can be a lucrative profit centre if marketed and priced properly.

However, competition is stiff at the price-conscious end of the framing market, with chain stores, out-of-town retailers and photographic shops selling attractive ready-made frames at low prices. Most successful frameshop owners will tell you that you can't compete on price nowadays, you have to offer something that the chain stores can't, which means positioning yourself as a professional who can offer expert design and conservation advice and provide the type of frame that can't be bought off-the-peg. You need to have the courage to charge a decent price, because there will always be someone cheaper than you, and be confident that the service you are offering is still value for money.

You may be attracted by the idea of providing a framing service as the initial financial investment in equipment is relatively small. The basic technical skills required can be learnt relatively quickly, courses typically take three days, though there are a host of more advanced techniques that add value to a framing service and take longer to learn.

Framers' skills lie primarily in having a good eye for what will flatter artwork, the ability to communicate effectively with customers and in pricing and marketing their services properly. Framers need a good sense of colour and the ability to quickly understand which frame designs will look best. These skills can be learned, but an inate flair is a positive bonus. You need to be aware of changing trends in interior design. Many framers are frightened to charge enough for their work and end up working hard for minimal profit, which is not good practice.

Some aspects of making a frame no longer require the skill they did 50 years ago, because of technologically advanced equipment, but the most profitable work does require considerable skill and up-to-date product knowledge. The term 'conservation framing', for example, refers to materials and techniques that will help preserve and protect artwork over time, and framers need to understand the principles of this concept if they are to avoid causing irreparable damage to customers' artwork.

Other specialist, and potentially profitable, techniques include:

- finishing raw timber frames
- gilding
- handling textile art
- dry-mounting
- framing 3D objects
- frame restoration
- cutting and decorating windowmounts.

While a frameshop need not offer all of these services, this is the type of business that the chain stores cannot generally handle, whereas they can probably supply a tasteful photo frame in a standard size at a lower cost than you can.

Framing courses are available across the country, mainly offered by experienced independent framers and tailored to suit the student's requirements. Two-day courses tend to cover the basics, while a week's course will teach more specialist skills. The Fine Art Trade Guild lists accredited training providers, along with details of what they offer, and a summary of this list is included at the end of this book (see Appendix: Useful contacts on p.222).

The Guild Commended Framer vocational qualification programme is run by the Fine Art Trade Guild and is the benchmark qualification that all framers aim to achieve. The GCF Study Guide is an essential training manual which employers use to ensure that their framers are working to the required standard. Framers who qualify are able to market themselves as committed professionals to their customers; the qualification is at the core of professional framers' marketing plans, and it gives them the edge over the competition. Qualified Guild member framers display the GCF logo on their stationery, in their shops, on their clothing etc., which promotes their superior status to customers.

Specialist GCF modules are available in Textile Framing, Mount Design & Function and Conservation, with further modules in the pipeline.

The cost of setting up a framing workshop is beguilingly low, probably under £5000, depending upon the equipment you select. There are three essential pieces of equipment:

1. A guillotine for cutting mitred frames (this is often called a 'Morsø', which is in fact the name of the market leader)
2. An underpinner for joining frames
3. A mountcutter for cutting apertures in windowmounts.

On top of this there are essential hand-held tools (such as a glass cutter) and supplies of materials. The Fine Art Trade Guild's website and annual Directory include lists of suppliers of framing materials and equipment, and sources for each type of product.

Of course lack of space might prevent some retailers from offering a framing service, as a framing workshop needs to accommodate the three pieces of equipment mentioned above, as well as areas for cutting glass, assembling frames, storing bulky materials and storing artwork.

Not all retailers want to divert their already stretched resources into framing. Such galleries may choose to use trade framers who work from industrial units and other relatively low-cost premises; they then add a percentage onto their framer's charges when selling on to their customers. Galleries which sub-contract framing often only handle framing for the pictures they sell, or else they offer a deliberately limited framing service; acting as middle-man becomes too complicated when handling a wide range of general framing work. Nor is it worth training gallery staff to sell complicated framing services, when framing is a sideline and selling pictures is the core business.

The percentage a gallery can add to sub-contracted framing work is the difference between the price your customers will comfortably pay and the price the framer charges you. This could be anywhere between ten and 50 per cent, and is likely to be on a sliding scale, with a smaller percentage added to expensive frames. What you can charge depends whether or not you are in a premium location with a wealthy clientele. The prices you are charged by your framer will depend upon factors such as the volume of work you generate for the framer on a

regular basis, and how much hassle that work causes (for example, you may get a better rate if you always order the same few frame profiles and mount designs). It is, of course, important to regularly assess whether you could reasonably be charging more and paying less.

Printing

Since the turn of the 21st century a digital printing revolution has been going on, which means that it is now possible for many gallery owners to operate and finance the purchase of a large-format printer. This can be used to publish prints that gallery owners sell themselves and some also offer a printing service to local artists and businesses.

Many galleries sell original work by local artists; those with digital printing facilities can quickly respond to market trends and produce prints of popular images that can, of course, be sold to those who do not want to pay the price of an original piece (and people who buy prints may gradually trade up to an original). If you own the means of production you have great flexibility; you can test the market for an artist's work, you can alter colours or print at different sizes at the push of a few buttons. If you produce a print that doesn't sell you have lost very little in terms of either time or money, as little capital is tied up in stock.

If there is competition for a local artist's work, a gallery that can offer a fine art printing service has additional negotiating power and may win an artist's favour over a competitor. A printing service will attract artists to a gallery, which may be a good way of finding new talent and it may bring in business for framing and artists' materials.

A print produced digitally is known in the art trade as a *giclée* print (*giclée* is the French word for 'squirt', which is how the ink is applied to the paper). Prior to the digital printing revolution, fine art reproductions were mainly offset lithographs that can only be produced on large-scale expensive equipment and are only financially viable in large printruns. However, once the machine is set up offset lithos can be printed very quickly, so this method is still generally used in the art print trade for large printruns. Digital images are stored on a computer and *giclées* can be printed out on demand.

The down side is that the print market is more competitive than ever now that it is relatively easy to produce prints. Framed prints are

available in abundance all along the high street, on the internet, in catalogues and through special-interest retailers. Convincing people to buy therefore requires better marketing, branding and sales skills than ever before.

Similarly, an increasing numbers of graphics firms and photographic labs are diversifying in a similar manner, offering printing services to artists, as well as galleries; competition is likely to increase as the price of the hardware continues to fall. Effective marketing is required to retain the competitive edge by promoting galleries' knowledge of the art industry and its standards.

A disadvantage of offering a printing service to artists is that this can be very time-consuming; artists may be highly particular about how their artwork is reproduced, which means that many proofs will be required, along with long conversations about their requirements. The gallery offering the service will therefore make most profit from re-orders of a print, rather than from the first few that are ordered, even if a set-up charge is levied. In reality, many artists do not re-order prints as they do not have established distribution networks.

Though publishing prints is easier than ever, do not be misled into thinking that anyone can do it without training. There are pitfalls involved in the production of fine art prints: you don't want irate customers coming back to you in a few months muttering about Trading Standards and waving prints from which all the yellows have faded, leaving ghostly blue landscapes. Bear in mind that reproductions on paper range from photocopies intended for short-term use to quality prints that are almost indistinguishable from originals; you don't want to ruin your hard-earned reputation by producing prints that leave customers dissatisfied.

The Fine Art Trade Guild's standards for fine art printing have been the industry norm for decades; these require prints to be on paper at least 250gsm thick, with a pH balance of between 7 and 10 and with lightfast qualities of 6 or greater on the Blue Wool Scale. And it is more complicated than just buying good inks; for example, certain combinations of paper and ink may undermine the lightfast properties of the colours.

As well as acquiring a good understanding of printing consumables, you need to master image manipulation software such as Photoshop.

Colour management and calibration can be complex and time-consuming. Manipulating colours on-screen and ensuring that the printed image is the same as the original requires experience and skill. Time must be spent in keeping abreast of rapidly changing, and often complex, technological developments.

Your initial investment would include a large-format digital printer, computer, scanner and colour management software. To this must be added relatively costly consumables and maintenance. There are many choices of equipment on the market; there are clear advantages to buying from a specialist fine art supplier who understands the requirements of the marketplace, rather than from an anonymous source on the internet or high street. Servicing and back-up are important issues, so look at the maintenance deals being offered. The Fine Art Trade Guild website includes details of specialist suppliers.

There are ethics involved in publishing prints as well as technical specifications. It is important that the size of the edition and any variations within this are comprehensively disclosed to buyers (variations refers to differing sizes, colours, added embellishments). Guild print standards dictate that if an image has been used for a limited edition it cannot be used in any other form such as a jigsaw, greeting card etc. For further information on Guild print standards see the website.

There is a British Standard for fine art printing (BS 7876:1996); this focuses on the level of involvement by the artist in the printmaking process. Requirements for paper and ink quality have been aligned with Guild standards.

When charging artists to print their work many galleries have a charge for scanning and colour balancing, then a further charge for printing the work. If an artist simply wants an image scanned, with no re-touching or colour balancing, a gallery might charge a lower fee. This first fee would not apply at all when the gallery is just out-putting from a digital file provided by the artist. Many galleries charge a price per square metre of printed paper, generally with discounts for quantity. Artists can therefore work out their costs by multiplying the length by the width of their desired image size. Your fees must reflect the cost of consumables, wear and tear of equipment, a margin for wasted materials, your labour and physical overheads. You also need to check what other businesses are charging for the same service; remember that artists can easily email images, so you are not just competing against local businesses.

Acting as a licensing agent

Galleries may be able to act as agent for their artists, interfacing with image libraries, card publishers, gift manufacturers and ceramics firms. If a gallery owner develops a rapport with a particular company, he or she may begin to contact the company when new art becomes available, whereas the company may be less receptive to a 'cold' approach from an unknown artist. Licensees may like a particular gallery's style and start to rely on them to provide new artwork. But be aware that some companies do not like dealing with middle-men and will only work directly with artists.

Artists sometimes dislike selling their work and find that a third party can negotiate better prices than they can. It may be worthwhile for gallery owners to invest time in familiarising themselves with the complexities of the licensing market, as they are negotiating deals on behalf of a collection of artists, whereas an artist would be working alone.

Gallery owners acting as licensing agents need to familiarise themselves with typical fee structures; which product types generally pay a flat fee and which pay a royalty. The fees paid for images vary enormously, which is where the gallery owner's professional negotiating skills and acquired experience come in.

Greeting card companies tend to pay a flat fee of a few hundred pounds per image, while fine art print publishers tend to pay a royalty of around ten per cent of the selling price. Ceramics manufacturers pay either flat fees or royalties; royalties tend to be a low percentage, between five and seven per cent is common, as the volume of sales is high. Giftware companies – just like those that make jigsaws, tablemats and playing cards – often pay a flat fee of several hundred pounds. Where royalties are paid in the gift sector, they tend to be well under ten per cent as the artist's image is only one aspect of the product and its design.

As a general rule, artists are paid a low percentage for images that will appear on low-value products to be produced in high quantities. For example, the food industry might only pay one or two per cent for images to appear on children's food packaging, since projected sales are high. For more specialist, or upmarket, foods such as celebration cakes, an artist might expect five or ten per cent.

If you are acting as agent you need to understand the difference between selling copyright and selling a licence for specific limited use. Reproduction rights are sometimes sold for a limited number of years: two, three, five, seven and forever are commonly used. It is common for licensees to buy 'exclusive worldwide rights' to use a given image for a given purpose. Licensees do not want copyright holders to sell licenses to, for example, several other dinnerware manufacturers, so they might state, 'The artist will retain full copyright in the artwork, and she may use the same image in fields other than dinnerware as she wishes'. Territorial rights are also common: UK rights, world rights, world rights excluding the USA etc. You may also sell the right to use an image measuring less than, for example, 20x10 cm.

The commission rates charged by galleries to their artists of course vary enormously. A gallery owner who is a good negotiator should be able to earn more money for an artist than the artist could alone, even taking commission into account. The gallery owner may retain any-where between 30 and 70 per cent of the licence fee, though when bro-kering deals worth thousands of pounds their commission rates might be less than 30 per cent. The percentage will be affected by the artist's reputation, level of fame and popularity.

Corporate art and art rental

Some art retailers also act as 'art consultants' supplying art to compa-nies as an appreciating asset, a way of improving a company's profile and to improve the working environment. Art consultants commonly supply work for a wide range of projects, including hospitals, show homes in new developments, hotels and bars and passenger ships.

Art consultants see companies of every size as potential customers, not just large corporations with museum-quality collections; many also cater for mass-market tastes, putting together packages where the frame may be worth more than the artwork. A lot of businesses just need 15 to 20 framed images for their reception and boardroom areas.

The main role of the art consultant is to interpret a brief from a client, then to source the appropriate art. A selection of art in the right style and within the budget will then be presented to the client.

Companies want art that complements the style of their building and décor, but also that reflects their corporate values and culture. Part of

the art consultant's job is to interpret this and translate it into art. The consultant needs to be good at listening to clients' needs and quickly understanding what style of artwork would be appropriate.

Art consultancy is highly competitive so art consultants need to be proactive in finding new business, and generally do lots of research and cold calling. They develop working relationships with architects and interior designers, approach companies direct and keep abreast of which businesses are moving to new offices in the area. They do presentations to companies and pitch for business, which makes art consultancy different from conventional gallery sales to individuals.

A good rapport with interior designers, architects or property developers can result in substantial repeat business. They need consultants who are reliable, professional, work to budget and meet deadlines, as well as supplying a good range of art.

Some businesses want to rent pictures, maybe because they want them changed regularly or because they want time to decide whether to invest in art and renting is a way of deferring payment. Art rental can be profitable once you have built up a good range of framed art to offer, but it requires considerable investment in artwork and framing at the beginning.

Rental is normally based on a minimum 18-month contract, renewable at three-monthly intervals thereafter. Rental is generally charged at one per cent of the purchase price, which is charged weekly and collected quarterly. In other words, the picture would be paid for in just under two years. The fee includes insurance, installation and collection. Advertising agencies and film makers may want to rent artwork by the week or day, which would be charged at a higher rate.

Chapter 10

Sourcing and buying

It is essential to offer products that will appeal to your target customer, and these must generate sufficient profit to pay your overheads.

Most independents' market position is to stock goods that are 'a little bit different' from the chain stores. Their customers are not primarily concerned with price; people who buy luxury goods from independents generally know that there are discount stores which would be cheaper, but they are looking for something that isn't available everywhere and is of high quality. They may also be 'buying into' a particular style that your shop conveys; it is hard for chain stores to compete with the feeling of stylish intimacy that the owners of some independents can achieve with their stock and shop design.

In today's market design and fashion are changing faster than ever, so staying ahead of the trends is a challenge. You need to read the right trade and consumer publications, visit trade fairs and exhibitions and look at a wide range of suppliers' publicity material. You also need to visit the shops and websites of other outlets similar to yours and familiarise yourself with the type of stock they are selling and their pricing levels. You need to choose suppliers whose style reflects your commercial position, and who will help you predict the trends. Some independents feel that one of the ways they can maintain an edge over the chain stores is that they can react more quickly to changes in fashion, with a minimal paper trail and no office pol-

itics or internal decision-making hierarchies to consider.

You need to continually assess how much space each product group occupies and how much profit that square metre of space generates; that way, you can keep refining your product mix and levels of pricing. There are various accounting ratios that can help you see if you might be over-stocked and if you are generating sufficient profit to keep operating safely. Some of these are discussed in the section called 'accounting ratios' in Chapter 6: Assessing your progress (p.76). Detailed monitoring of your cashflow would also indicate whether your prices might be too low, which products are selling best and whether you are holding too much stock.

Different categories of stock are sourced from different places, and the main ones are discussed below. Whether you are buying from trade shows, following leads in trade magazines, buying direct from artists or buying from sales reps, you must check that your chosen supplier is reputable and reliable. Your reputation will suffer if you promise a customer to have a particular item in stock, and then your supplier lets you down. And you don't want to stock items that break or deteriorate.

Many independents strive for originality so want to buy from small little-known suppliers. A problem with this strategy is that small suppliers can disappear very quickly if they have cashflow problems, which is, unfortunately, all too common. Self-employed sales agents may promise the world, but as they invest little in their businesses, they can give up and find another job at a moment's notice. Check that small suppliers hold sufficient stocks to fulfil repeat orders; if an item sells well and you develop a demand for it, you need to be able to capitalise on this by re-stocking.

Large established suppliers may have better insight into current trends, as they invest substantially in predicting these and are experienced at it. The problem is that their stock may be all over the high street.

The only solution is to choose your suppliers carefully, find out how long they have been in business and who else they supply. They should have no problem with telling you who their other customers are and it is perfectly reasonable to ask.

You can gauge how professional suppliers are by talking to them about their payment terms, minimum order quantities and delivery times. Check that stock is held in a warehouse in the UK, otherwise it may take

a long time to arrive, whatever they promise. A salesperson may say that it will only take two weeks, for example, for the items to arrive from China or India, but they cannot guarantee the performance of their shipping agent and international customs officials and with the best will in the world your products may arrive too late to be of use to you. If a business has not invested in UK operations it may mean that they are not properly committed to supplying their UK customers and will let you down.

Also ask them which items sell best, and in which type of shops, as inevitably some items will sell more quickly than others. Some suppliers provide free point of sale and display equipment if you take on their full ranges, which is always worth finding out about.

As discussed below, framing materials, prints, gifts and greeting cards are often bought from travelling sales reps. Sales reps can be a refreshing lifeline for retailers who feel they are working in isolation; they know the trade gossip, how business is going for others, as well as what is selling well and in which types of shop. However, as with any other supplier, you need to feel sure that a particular rep is reliable before you do business with him or her. They may exaggerate how well a product is selling in order to make a sale, though good reps who are in it for the long-term will know that this is a short-term strategy.

Some sales reps are employed exclusively by one company, while others are self-employed and hold stock for several companies, often up to six (be cautious of reps who represent too many different businesses, as they may not have a strong working relationship with them all). It doesn't cost much to set up as a sales rep, so they can come and go quickly, therefore it is important to check how long they have been in business.

Don't let reps walk in at busy times and dominate your shop. Make appointments to see them at times when you will be free to concentrate, maybe before or after your normal hours of business.

Frames and framing

The main UK trade show for retailers to source frames, framing materials and equipment is Spring Fair Birmingham, which dedicates a whole hall to art and framing. (Internationally, Quadrum SACA in Italy is the dedicated art and framing exhibition that is most useful to high volume buyers, including UK distributors.)

The Fine Art Trade Guild website has a list of framing suppliers and their annual Directory also contains detailed product and equipment sourcing information. The leading trade magazine in the field is *Art Business Today*. As with most other sectors, once you are established framing suppliers will start to target you with visits from sales reps, marketing material and catalogues.

The type of framing you buy of course depends upon the tastes of your target customer; for example, black and gold frames appeal to those with traditional tastes, while wide white frames are currently popular with buyers of contemporary art. Competition between suppliers is fierce; similar products may be available from several suppliers, but there will be differences in quality, price and levels of customer service (delivery times, the amount of stock that arrives damaged, minimum order charges, payment terms).

Most framing suppliers will sell on account once they have followed up satisfactory references, though it may be necessary to pay cash-on-delivery at the beginning.

Frames are now available on every high street, so most independents find it hard to sell simple black or gold photo frames, as someone else can always supply similar goods at a lower price. The solution is not to try to compete on price as chain stores have more buying power and can always be cheaper, but to offer stylish specialist goods that pound shops and photo processing shops don't stock.

Most suppliers offer picture frame mouldings via the 'chop service', which means the moulding is cut to the size your customer requires. Mouldings ordered this way are a bit more expensive than mouldings bought by the length, but there is no waste, no storage problems and the framer doesn't tie up money in stock that may or may not sell. A disadvantage of the chop service is that you cannot respond quickly to customer orders. A lot of framers order wide mouldings that cannot easily be cut on their guillotines, and aluminium frames, via the chop service. Some keep a core stock of best-selling mouldings by the length, but offer more specialist designs via the chop service.

As well as deciding which types of framing to go for aesthetically, you need to consider specialist products such as non-reflective glass and conservation mountboard. These can reinforce your market position as a specialist and an expert, and can add value to a framing job. For

example, suppliers argue that it takes the same amount of time to make a frame with non-reflective glass that also filters out an element of damaging UV light, but that customers are prepared to pay up to eight times as much for this type of glass. Therefore, specialist products can be a good profit centre. Discount and chain stores are unlikely to want to get into selling such products, partly because they are relatively complicated to explain to customers, and sales staff in non-specialist stores are unlikely to have this level of specialist knowledge.

See also the sub-section on pricing framing in Chapter 11: Pricing (p.123).

Reproduction prints

Reproduction prints are photo-mechanically or digitally produced copies of original artwork. Some independents that have chosen to position themselves as upmarket may not stock these, though others would consider certain limited edition prints as acceptable.

An enticing range of reproduction prints can of course boost framing sales, which may be where the real profits lie. Retailers sometimes order in a print for a customer at very little profit, knowing that they will make money from the framing.

Prints produced digitally are called '*giclée* prints'; the name refers to the French word for squirt, as this is how the ink is applied to the paper. Not all *giclée* prints are reproductions as some printmakers work on a computer and produce original or artists' prints digitally (see below). Quite a few independents own digital printing equipment and produce their own *giclées* (see Chapter 9: Which services to offer on p.96).

Digital printing dispenses with the need to produce film and set up a printing press; the image is stored on a computer and can be printed out at the push of a button. This means that *giclées* can be printed on demand, which provides great flexibility and means that publishers and artists do not need to tie up money in stock. Digital printing is still slower and more expensive than offset-litho printing, which is the traditional option, so the latter is commonly used for big printruns and open edition work. Digital printing is ideal for speculative projects and testing the market.

'Open edition prints' can be produced in unlimited quantities and the same image may be seen on other products (greeting cards, jig-saws, etc.); their relatively low price reflects the fact that they are not exclusive. The

term 'poster' has become interchangeable with open edition print, though technically a poster is an advertising vehicle bearing a slogan or exhibition details. However, though newly published open editions are not valuable, they can be aesthetically sophisticated and look great when properly framed. A problem for independents is that the chain stores tend to stock open editions, so you need to source images carefully and present them imaginatively so that they are not directly comparable.

'Limited edition prints' are produced in small editions, typically 50 up to 850, and buyers do not expect the image to appear in any other form. Buyers perceive a value in the limited availability of these prints, so are prepared to pay higher prices for such images. Buyers may have unrealistic expectations about how the value of limited editions will increase; you need to explain that this may happen, but that the customer should not rely on it.

The Fine Art Trade Guild has standards for printing limited editions, which include specifications for paper and ink quality. Retailers should make themselves familiar with these standards, as knowledge of them can help impress upon customers that the work they are buying is of a particular quality. See the Guild website, *www.fineart.co.uk/printstandards.asp*.

Limited editions tend to be signed by the artist and numbered in pencil; some collectors want certain edition numbers and some collect artists' proofs, where the initials 'AP' appear instead of a number. Artists' proofs have no inherent value and should be identical with the rest of the printrun in the case of reproduction prints (this is not the case for artists' prints; see below). Some limited editions have hand-drawn cartouches in the margins; these are called remarques, and make a print particularly desirable.

Reproduction prints are generally supplied by fine art publishers and self-publishing artists. These can be found at trade shows such as the Spring and Autumn Fairs Birmingham, through trade magazines such as *Art Business Today* and via the Fine Art Trade Guild which holds lists of publishers and the images they print. Guild members have access to a 55,000-strong international prints sourcing guide. Publishers also buy mailing lists and send out sales reps targeting galleries, so very often the publisher will find you.

There are many publishers, including artist-publishers, out there, and a significant proportion of these are very small concerns. Digital printing has made it very easy for people to set up as fine art publishers, but many who do so don't have the operating capital or business and marketing expertise to last more than a few months. You need to choose your suppliers carefully.

Your reputation will suffer if you are let down by a supplier and cannot fulfil an order. If a customer complains because a print quickly fades to pale blue (the yellows often go first) then you will only be fully protected if you have insisted the prints are produced to Guild standards. The retailer is liable for selling images that infringe copyright or illegally reproduce a trademark, even if you bought them in good faith from a publisher you thought to be reputable. Selecting Guild member publishers and those with long-standing ethical reputations will minimise this risk and give you the best chance of redress should a difficulty arise.

Some of the larger publishers offer quite extensive marketing support to galleries who stock their images. While this is of course a good thing, bear in mind that the larger publishers' work is inevitably rather widely available. Some galleries prefer working with well-established publishers because they trust that publisher's judgement, they know 'the brand', and are confident the stock will sell. Others prefer dealing direct with artists and are prepared to forgo the marketing support and publisher's expertise, knowing that they are offering an exclusive range of artwork.

Reproductions tend to be sold on the same basis as framing materials, with publishers following up references and galleries opening accounts with them. Very few publishers offer work on a sale or return basis; most find that galleries are more effective at selling prints they have actually invested in.

Publishers will often supply shops with glossy catalogues from which customers can choose images, enabling the shop to offer a wider range of work than they actually stock. This tends to work best with open editions, as sought-after limited editions can sell out pretty quickly, and may even be on strict allocation to galleries that support a full range. Bear in mind that many publishers have minimum order charges, so if you are ordering one-off prints for customers they may appear quite expensive.

Artists' prints

Artists' prints are handmade and the term encompasses techniques such as etching, woodblock printing and engraving. Artists' prints are sometimes referred to as 'original prints', but the British Standard for fine art prints states that this term is misleading, so artists' prints has become established as the correct term. The BSI classification for fine art prints, BS7876:1996, categorises prints from 'A' to 'G' according to the level of involvement by the artist. A Category A print is made entirely by the artist while a Category D print, for example, is made by a printmaker with the artist looking on.

Artists' prints are not reproductions after paintings, but are original works themselves, so galleries that position themselves as upmarket sometimes sell artists' prints but not reproductions. In some sectors of the art world people look down on reproductions, and some art fairs do not allow exhibitors to show them, whereas artists' prints are recognised as bona fide works of art. (The value of reproductions is that they broaden accessibility to the wider public, with limited edition reproductions offering an element of exclusivity.)

Artists' prints are generally produced in quite small printruns, often of around 50, which increases the idea that they are exclusive products. Artists' proofs (prints signed 'AP' at the bottom, instead of a number) are not identical with the rest of the run with artists' prints, but are impressions taken by the artist to ensure that the colours and textures are right before beginning to produce the run.

Artists' prints are likely to be bought directly from artists and artists' collectives, whereas reproduction prints are often sourced from large print publishing companies. Once you have developed a reputation for selling artists' prints, artists will probably start approaching you. Other places to look are printmaking exhibitions, shows where artists take stands and sell direct, open studio and open house weekends and the specialist magazine *Printmaking Today*. There are some artists' prints at big trade fairs such as Spring and Autumn Fairs Birmingham, but the majority are reproductions.

Some galleries sell 'later impressions' taken from original metal printing plates (these are sometimes called 're-strikes', but publishers see this term as derogatory). Some publishers hold collections of printing plates, mainly from the 18th and 19th centuries, and employ

traditional labour-intensive printing techniques to produce modern impressions from these old plates. These prints are often hand-coloured.

Later impressions can work well for galleries that have clientele with traditional tastes, who might see modern reproductions as too down-market but could not afford antiquarian prints. They can also work for galleries with a reputation for niche subjects, such as rare sports (croquet, coursing, ice skating) or humorous images and caricatures. Later impressions can be a good way of adding to your stock of these images.

Antique prints and maps

There are specialist antiquarian print and map dealers who have acquired a wealth of knowledge over an entire career, and their galleries are dedicated to selling this type of print. The field of antiquarian prints is wide ranging and complex; to set up as a print dealer requires expertise that has to be learnt over time and is acquired by looking at thousands of prints. It could be dangerous to assume that buying and selling antique prints is easy; you could damage your reputation by unknowingly selling, for example, a late-19th-century impression made from the original copper plates, and hand-coloured in the 20th century, as an 18th-century print. And this would be an easy mistake to make.

However, some galleries sell a limited range of antique prints and maps that complement their other stock, and that are bought from a reliable source. This last point is important; you can then leave problems of attribution to your supplier. The key is to give your customers accurate and comprehensive information.

Dealers tend to buy their stock at auction and from private individuals who approach them direct. They also buy from online auctions, trade extensively among themselves and some buy old books and rip out the illustrations (this practice is frowned upon by many). Dealers dedicate a lot of time and resources to finding stock.

If antique prints and maps are a sideline for you, it might be best to rely on a dealer who specialises in supplying the trade. *The Antiques Trade Gazette* would be a good place to find such a supplier.

Quite a number of dealers have eBay shops, which could be a good way of finding a supplier and getting to know the market, but you

must vet suppliers found in this way extremely carefully and follow up trade references. Dealers who have an eBay shop but no bricks and mortar outlet can theoretically disappear very quickly, so such outfits should be researched with particular care.

Paintings and sculpture

Typical arrangements between galleries and artists are discussed in detail in *The Artist's Guide to Selling Work*, also published by the Fine Art Trade Guild and A&C Black (ISBN 0-7136-7159-9). The main points are outlined here.

If you asked a selection of established galleries where they find their artists the reply would overwhelmingly be 'through word of mouth' and 'artists recommend other artists'. However, galleries do take on artists that approach them direct and gallery owners also visit open house weekends, degree shows, art society exhibitions, trade shows, etc.

Original work tends to be bought direct from the artist. There are not many agents handling original work, as there are not many artists whose work commands sufficient prices to fund a 'middle man' (where an agent does exist, this often turns out to be a member of the artist's family, who is prepared to work for a lower wage in the short-term).

Some publishers of reproductions supply galleries with originals by their artists, particularly where a special exhibition of an artist's work is planned.

Some galleries sell work that they acquire via the secondary market, either direct from private clients, at auction or from other dealers. Just as selling antique prints and maps (see above) is a career in itself, so is dealing in secondary market art. There are a lot of out-and-out fakes on the market, as well as over-restored and wrongly attributed works, so dealing on the secondary market should not be seen as an easy option. The internet and the global market is also making it increasingly hard for dealers to source artwork at prices that allow for a reasonable margin.

Many galleries sell the occasional piece that they acquire on the secondary market, normally by artists in whose work they specialise. Galleries need to be aware of the Artist's Resale Right, or Droite de Suite, which became law in Britain in 2006. This royalty allows artists and their descendents three to four per cent of the sale price when work in copyright, valued at

over about £700, is sold by art professionals on the secondary market. Bear in mind that original artwork bought outright from publishers also attracts this royalty. See Chapter 2: The formalities (p.24).

Most galleries take original work on consignment, or on a 'sale or return' basis, from artists. Few galleries can afford the capital outlay of buying work outright, and it is less risky to take it on SOR as well as allowing the gallery greater flexibility. A few pieces might be bought outright as a gesture of support, but galleries are extremely unlikely to buy whole exhibitions from artists. It is also rare for galleries to pay artists a retainer, or annual salary, though this does happen at the top end of the market where there is fierce competition for artists.

Galleries commonly keep between 40 and 60 per cent of the sales proceeds when selling an artist's work. However, before agreeing your commission rate with an artist you need to be clear what is included. In addition to a gallery's day-to-day overheads there are direct costs involved in arranging an exhibition of an artist's work; some galleries pay all of these except framing, while others expect the artist to help cover some promotional and printing costs.

Some galleries hold lavish private views (at which a high volume of sales are achieved), print full-colour catalogues, mail to thousands of customers and take out full-page advertisements. A gallery that is footing more of the bill, and demanding higher prices, can reasonably expect to retain a higher percentage of the sales price.

It is common practice for artists to pay for framing. This of course must be up to the gallery's standard, which should be specified in advance. If the gallery is also a framing workshop then it would be standard to sell framing to the artist at a good discount. Many artists cannot afford to pay to frame a whole exhibition, so the gallery might help underwrite the cost, then deduct it from sales proceeds. The gallery normally takes its commission on the whole sales price, including framing.

Sometimes artists also help cover the cost of printing a catalogue. The gallery may underwrite the cost and then deduct it from commissions, but it is good for artists to have catalogues of their work so they may be prepared to shoulder some of the cost.

It is important to give artists consignment notes when taking their work on SOR. Complex contracts may not be necessary, but some

proof of ownership that also outlines key trading terms is important.

Galleries should make it clear to artists when they will be paid, which should be within 28 days after payment has cleared to the gallery.

Galleries cannot reasonably, or legally, be too restrictive with artists about which other galleries they can work with. However, galleries can expect their artists to be up-front about which other galleries they supply and they can reasonably ask them not to supply similar work to others in the same geographical catchment area. The internet makes it easy for buyers to contact artists direct, so galleries need to be sure that artists are not offering work at much lower prices on their own websites and that they are not trying to sell direct to the gallery's own customers.

Most galleries would begin by taking on a few of an artist's works, then if they sell the gallery might consider including the artist in a mixed show with a view to a solo show the following year, if all goes well. Few arrangements are much more long-term than that, other than at the very top end of the market.

Ceramics, gifts and craft items

There are almost infinite possibilities when selecting ceramics, gifts, jewellery and craft items to sell in your gallery. It is important that these reflect your overall style and will appeal to your target customer. Most independents are constantly in search of items that cannot be seen elsewhere, particularly in the chain stores.

However, though you probably want to stock products that are a little bit different, beware of offering things that are too unique. It is easier to sell items that you know people want, than to risk trying to educate your customers into buying something completely new. Persuading people to change their buying habits and plump for products they have not thought about before can go horribly wrong; far better to focus on products that you know sell, but to ensure that yours are that little bit more wacky, or classy, or beautifully packaged, etc.

It is perfectly reasonable to ask suppliers if they sell to specific big retailers when you are considering taking on their products. Suppliers are aware that selling to these companies can lose them business from independents. Many suppliers prefer dealing with independents as they do not make such stringent demands as the chain stores, both in terms of trade discounts and operational requirements. (Some chain stores

expect their suppliers to tailor their payment terms, new product launches and computer systems to comply with their own internal systems. Once their hefty discounts are taken into consideration, it may not be worth supplying them.)

Some art publishers supply glass and ceramics featuring their artists' designs. Collectors may complain of having no wall-space left, or may tire of buying a particular artist's prints, but may be enthusiastic when shown that artist's work in a new form. Artists themselves may offer work in other media, including jewellery, which may appeal to both committed collectors and new buyers.

When sourcing products, good places to start are the trade organisations, magazines and trade shows that represent that sector. The British Jewellery & Giftware Federation and the Crafts Council are useful. Think about which interior design, furnishing and gift trade shows might be suitable for you.

The Spring and Autumn Fairs in Birmingham are a good place to start, as well as the Top Drawer family of trade shows. It is essential to plan visits to shows and allow sufficient time; your judgement may be skewed if you are too hassled and run out of time. Trade shows can include hundreds of exhibitors, so you need to know what type of goods you are looking for and within what price range. There is no point in just wandering round picking up leaflets about goods that vaguely appeal to you; you need to have specific aims.

As well as trade magazines, think about subscribing to interiors, women's interest and fashion magazines; these can be rich sources for finding small manufacturers, distributors and importers.

Gift importers and wholesalers often have trade showrooms that you can visit, many of which are in the London suburbs. They also have websites and catalogues, which can be a useful sourcing tool, though nothing beats actually seeing the products you are thinking of buying, either at trade shows, in trade showrooms or out of a sales rep's suitcase.

Visiting trade showrooms, while time-consuming, can be well worth it if gifts make up a high percentage of your stock. You can see the full range in your own time, take stock away with you there and then and maybe get a cash discount. Staff should be less frantically busy than at trade shows, so should be able to give you valuable advice on what is selling.

Some gift shop owners spend a large percentage of their time travelling the world in search of new and interesting products. An advantage of this buying technique is that you can be fairly confident that your competitors will not have access to goods from, for example, the same papier mache co-operative in Laos. This gives you a lot of flexibility when pricing. However, this option is not usually viable when ceramics, gifts and craft items are supplementary to the core business of selling art and framing.

Remember that once you are established gift companies and their sales reps will start to target you.

Greeting cards

Many independents sell greeting cards that emphasise their style and complement their range, but in most cases this product group accounts for less than ten per cent of turnover. However, cards can be a profitable sideline that occupies minimal display space. They may bring customers into the shop who then buy higher priced items, or framing customers may buy a few cards while waiting at your counter.

According to the research company Mintel the UK card industry is worth over £1.2billion annually. There are more than 800 card publishers in this country producing over 2.6 billion cards each year. In fact, everyone in the UK sends an average of 55 cards per year.

Around 35 per cent of cards sold annually in the UK are Christmas cards, but blank 'art cards' sell best for gift and art retailers. Most want products which are different from the chain stationery shops, so they tend to buy from small suppliers and self-publishing artists and sell specialist upmarket cards. The type of products that sell are stylish and contemporary and include features such as foil embossing, or handmade and textured papers.

Cards published by museums featuring their collections sell well for some independents. There are a few large mainstream publishers that sell to both independents and chain stores because their ranges focus on quality art images from contemporary and antiquarian artists.

Cards can be a valuable sales aid. Some galleries sell cards featuring the work of artists whose prints and originals they sell, and find that loyal card customers trade-up to buying pictures. And people who own originals by an artist might find it had to resist buying a selection

of cards by the same painter. Once you have developed a reputation for your cards, you can try techniques such as positioning them at the back of the shop so that customers have to pass the higher cost items in order to reach them. Cards tend to work best for retailers with passing trade. Those that are very much destination shops may find that turnover is not sufficient and cards do not work as a sales aid.

Retailers should not frame greeting cards and sell them as framed products without first seeking the card publisher's permission. This would arguably constitute breach of copyright, as you would be changing the use of the product from that for which it was originally intended. Some publishers are happy for you to frame their cards, and even produce large-format cards with this use in mind, while others do not allow framing (maybe because the artist's original work and prints are small in size, so would be easily confused with framed cards).

Card publishers will often provide retailers with 'spinners' for displaying cards free of charge. Some retailers would argue that there is no point in just having one spinner of cards as you can't build a reputation on that little stock, and that buyers need more choice.

There are two types of card publisher, those who sell through wholesalers and those who sell direct to retailers, sometimes via agents or sales reps. Wholesalers tend to operate in the mass market, so most independents buy direct. Many independents have built up their range from artists and publishers who have approached them. Conveniently for retailers, the main trade fairs for cards are the same as the gift fairs, namely the Spring and Autumn Fairs in Birmingham and Top Drawer. See Appendix: Useful contacts (p.222) and Chapter 20: Useful further reading (p.231) for details of trade magazines and the Greeting Card Association.

If cards are a small secondary product group you need to buy carefully to avoid minimum order charges and to ensure that your stock is carriage-paid. It is important to change your stock frequently as many people buy cards on a regular basis. Cards are susceptible to changes in fashion and quickly reflect new trends, so you have to be prepared to invest in new stock throughout the year.

Art and craft materials

More than ten per cent of art and framing retailers sell art materials. On the plus side, they carry a high probability of repeat business as artists typically replenish their supplies every three months. According

to *Leisure Painter* magazine, which has 100,000 readers, their typical reader has 'a good disposable income and a willingness to buy new painting products'.

Some retailers find that framing, art materials and craft supplies and construction kits complement each other well, as each sector brings customers in for the others. Many are not sure that art materials would be sufficiently profitable on their own, but work well as part of the product mix.

The problem with art materials is that there are highly professional catalogues, internet sites and out-of-town discount stores that sell the big brands at competitive prices. A quick glance through publications like the *Artists and Illustrators Magazine* and *The Artist* shows that such companies often sell well below the recommended retail price and are marketing themselves aggressively. Artists are often price conscious so art materials are not an area in which retailers can be too bullish with pricing. If someone easily accessible or local is selling the big brands cheaper, then customers will go to them. Most artists repeatedly buy the same products, a buying pattern that makes it easy for them to surf the internet for bargains.

The art materials market is dominated by a few very big brands. There are less expensive products from the Far East, but retailers repeatedly report that artists want the quality of the big brands and that their tutors encourage this. Artists tend to be loyal to certain paints and don't want to change. There are specialist niche products and sundries that also make up the art material retailer's range, but the big names are a dominant force. Some retailers successfully focus on their exclusive range of products, and don't bother with the big names, but most find that they need to stock them. Art materials retailers therefore find it harder to source stock that makes them stand out from their competitors than retailers in other areas of art and framing.

However, while many independents would acknowledge that internet businesses have affected them detrimentally to some extent, many say that artists are loyal to them because of their wealth of experience and superior product knowledge. Independents can win customers from big, impersonal retailers by being willing to spend time talking to them and listening to their requirements. Retailers find that artists particularly value this type of personal service and friendly atmosphere. This product knowledge can also mean that

independents stock a more well-planned range than the discount stores, partly because they understand the stock and the customers better, but also because they are aiming at long-term customer loyalty and not just short-term profit.

Independents can also develop a reputation for niche products, which will bring in customers who may also buy framing. Items such as calligraphy, illumination and gilding supplies, for example, would never really appeal to the discount retailers as volumes of sales would be small and considerable staff expertise would be required. However, customers may be prepared to travel some distance for these products and would be loyal to a retailer who could supply them.

Some retailers choose not to stock art materials because they take up a lot of display space relative to the profits they generate. Retailers also need to tie up a lot of money in stock as artists won't come to you unless you have a good choice, and suppliers provide their full marketing support to those who stock their complete range.

Many retailers report that the demand for craft supplies has mushroomed recently, with hobbies such as scrapbooking, card making and rubber stamping becoming big business. These are mostly products whose popularity began in America and they tend to be backed up by magazines, books, interactive websites, cable TV shows and highly professional 'front people'.

The great thing about craft supplies is that most craftspeople use a lot of materials in a short space of time, whereas artists can make a pad of paper and some paints last for much longer. Craftspeople tend to constantly want to widen their range of materials, and a vast range of products is appearing to help them fill their time and satisfy their creative impulses. The diversity of crafts means that there is a much wider potential customerbase than there is for art materials. However, craftspeople are less likely to buy framing or printing services than artists.

Craft supplies are available from a wide range of suppliers and it is hard to predict which ones will sell. Fads come and go, and craft hobbies are very fashion-led, so managing stock can be problematic. Stocking a full range of craft supplies also occupies a lot more floorspace than a similarly comprehensive range of art materials would take up.

Chapter 11

Pricing

Your pricing strategy helps you position your shop and find the right competitive niche for your business; in order to be effective it should mirror your market position and be focussed on your target customers' priorities. It is important to be consistent with your pricing.

There are three basic types of pricing strategy:

1. **High end** – prices are set above market levels because of exclusive products, staff expertise, excellent customer service, an established reputation for style and upmarket appeal. Profits rely on good margins rather than high turnover.
2. **Medium** – the retailer sticks to average recommended retail prices and wins customers on the basis of location, product range, friendly atmosphere etc. Turnover and margins are balanced.
3. **Low end** – prices are below market levels to compete for higher volumes of sales. This requires tight stock control, clever buying policies, low overheads, etc.

Whatever your pricing niche, you (and your staff) need to feel confident that your prices are 'fair'. If high, you need to know that your customer really is getting the added value, if low you need to make a profit and know that your customer is getting a good deal. If your prices are higher than those of competitors you must make it absolutely clear why, and what type of value your customers are getting for the added price they are paying.

An advantage of stocking unusual specialist goods is that they are not as easily compared as, say, a pint of milk, so customers won't have such clear expectations as to what they should cost. Therefore it is largely up to you to convince customers that your price is the right price. You can set premium prices and if your customers have disposable income they will still be attracted to your range of goods and style.

You need to become thoroughly familiar with typical mark-ups in your field, and your suppliers will help you with this. While customers for luxury goods may not be essentially price-driven, you need to be aware of how others, including chain and discount stores, price similar goods.

Your selling price needs to reflect the cost of the goods + operating costs + desired profit. (Framing, however, is a little more complicated as the time taken to make the frame needs to be included; this is discussed in this chapter under 'Frames and framing' on p.125.) In order to work out your operating costs you need to take all overheads, including tax and owners' salaries, and divide them by your annual sales total. You need to consider adding a few per cent to your operating costs to cover shoplifting, breakages and items that are spoilt when used as display models.

When assessing how much profit to make on each item you need to allow for various types of discount. You don't want to start off offering goods at the lowest price you will accept, as that might mean you will end up selling them at a lower price than is viable for you. For example, you might allow a margin for bargaining, you might need to mark down goods at the end of the selling season (quite likely with fashion-led items) and your sales strategy might include January sales, discount vouchers in the local newspaper, student discounts for art materials, loyalty cards, etc. Deciding which types of discount might work for you is discussed in Chapter 14: Sales and discounting (p.154). The important thing is to establish two levels of pricing: your 'bottom line' selling price – which is the lowest price you can sell goods for and still make a workable profit – and your initial selling price, which allows some room for manoeuvre.

As a general rule, buyers will not expect to be able to bargain for most product groups, though expensive original artwork might be an exception. This is discussed in more detail under 'Paintings and sculpture' later in this chapter.

It is crucial that all independent businesses accept credit and debit cards; this is discussed in Chapter 5: The financial side of setting up (p.60). Don't forget that the card companies take a percentage of the sale price, which also needs to be built into your prices.

Prices that end in 99p or 95p could annoy buyers of luxury goods and might be more appropriate to groceries. However, slightly 'uneven' looking prices convey the idea that prices have been carefully worked out, so represent good value and are not negotiable.

How prominently to display your prices, or whether to display them at all, is an important issue. This is discussed in Chapter 16: Effective layout and display (p.172).

Though you need an overall pricing strategy, each product group may have slightly different pricing conventions, the most typical of which are discussed below.

Frames and framing

How you price framing work is largely down to your market position and what your market will bear. If you took the same print into ten framers in and around a given town you would be amazed by the range of prices you were quoted: a recent frame pricing survey by leading trade magazine *Art Business Today* showed that you might pay between £25 and £69 to have a 500x700mm poster framed in a 30mm black frame with non-reflective glass, and between £15 and £65 to have a 125x180mm cross-stitch put into a simple gold frame with a double mount.

You need to constantly keep yourself up to date with what other framers charge, but not be frightened to charge a professional price for a quality job. There is a widespread tendency among framers to undercharge and not ask a proper hourly rate for their work, which is not a good basis on which to grow a business. You need to have sufficient confidence in your service to ask a reasonable price for it. If you are doing lots of work and making no money, then there is something wrong with your prices.

If people shy away from paying realistic prices, then consider repositioning the business and its product mix before you begin offering framing at unsustainably low prices and working seven days a week to fulfil orders which aren't making any money.

It is better to lose work that doesn't make a profit and focus resources on winning profitable jobs than to spend your time fulfilling unprofitable orders on the off-chance that the customer will suddenly give you the most fantastic order (they won't).

Framers often complain that the little jobs, such as cutting mounts to fit into customers' ready-made frames, or fitting new D-rings and wire to old pictures, take up too much time and are not profitable. You should not allow this to happen: charge a fair price for even the smallest jobs. If customers complain you must be prepared to politely explain your charges, but, ultimately, be prepared to lose the work if the customer won't pay a realistic rate. (You can often add value to these little jobs by making polite, informed suggestions: for example, you can point out that the old frame onto which you are fitting new D-rings and wire is rather scratched and suggest that you carry out some basic repairs.)

Educating customers is a key function of developing a good framing business. The Fine Art Trade Guild's Five Levels of Framing help you to trade customers up to more profitable, better framing and justify your charges. For more information, see *www.fineart.co.uk/FramingStandards.asp*.

There are pricing programs that help you work out prices on your computer, and customers tend to respect prices that have been worked out in this way and are less likely to question them. These programs will prompt you to supply information such as the percentage of moulding that is wasted, your mark-up on materials, your labour charge, etc. The key thing when pricing is to ensure that you make a realistic profit.

Framers use many methods for pricing their work, but these essentially boil down to two main techniques:
1. Cost of materials x a multiplier
2. Cost of materials + time taken x hourly rate.

The first method is crude and works best for very average uncomplicated framing jobs; it makes large frames expensive, small frames too cheap and is unviable for time-consuming specialist work.

The second method is better, and involves working out the hourly rate you need to cover your overheads and make a profit. Hourly rates are often worked out by taking into account all business overheads, including tax liabilities and owners' salaries, adding around 15 per

cent profit, and dividing this figure by the number of hours spent framing each year (for example, six hours framing each day, five days a week for 45 weeks). Hourly rates inevitably vary but might typically work out at between £25 and £45 per hour.

Framers who adopt the first method use very different multipliers, hence the wide range of prices charged. It is quite common for framers to multiply the cost of raw materials by four, while others use a multiplier of ten, and some stick at three. Some use a sliding scale to make the method less crude, for example mouldings priced at 50p a metre might be multiplied by eight, while those costing £2 a metre might be multiplied twice.

Frame pricing software is rapidly becoming the norm, and is discussed in Chapter 12: The role of computers (p.131). While this software is very useful, it does not mean that you do not need to address the issue of pricing at all. The software comes with pre-set hourly rates and multipliers, which you need to adapt to suit your business.

In order to work out how long the average task takes you need to time yourself a few times. However, it may take two minutes to cut a piece of mountboard if the board is already roughly cut to size and easily to hand, or it might take nearly ten minutes if you have to locate and unpack a new parcel of board. You therefore need to come up with an average time. Frame pricing software does this job for you, though you may need to adjust the time, which the programs allow you to do, particularly in the case of jobs such as lacing needleart, where it is hard to predict how long it will take as each job is different. Some framers adopt a system for typical frames where each function (such as cutting the glass) is allocated an equal amount of time, such as five or seven minutes, which makes it easier when working out the time taken.

Whatever pricing method you use, you must keep regularly abreast of what others are charging. Not necessarily with a view to under-cutting them, but to help you remain aware of your market position.

Some framers offer discounts to artists, particularly members of certain art circles and societies, as well as to art students. Artists might expect a quantity discount if they are having a whole exhibition framed. You might also run special offers, for example ten per cent off the price of lacing needlework or during the quiet summer period. Some framers work closely with other local businesses, for example offering discounted framing to customers sent to them by a local photographer.

Your prices need to allow for these discounts and still make a profit.

Reproduction prints

Retailers buy reproduction prints at a trade price, which is generally half of the recommended retail price. If the print will retail for a high three-figure sum retailers might consider a smaller mark-up, particularly if a lucrative framing job is involved. Some retailers are prepared to make very little profit on reproductions if they are good at adding value to framing work.

Artists' prints

Artists, printmakers and distributors will probably suggest a retail price to you, which may be double the trade price. However, as artists' prints tend to cost more than reproductions it may not always be possible to double the price. Artists may not be able to afford to sell prints to you at half-price, so you may have to accept a smaller mark-up. Many artists have one selling price, which is retail, and may be unfamiliar with the concept of a trade price, so will not have made allowances for this discount when establishing their prices. You should talk to the artist if you want to alter prices up or down, as it is in both party's interests that prices are consistent.

Later impressions, or re-strikes, are priced in the same way as reproduction prints. Publishers are likely to have clear ideas about trade and retail prices and retailers should be able to set up accounts with the publishers.

Antique prints and maps

If you are buying from a specialist trade supplier they should suggest retail prices. However, prints are not unique so in most cases you can check current market prices on the internet. Some prints are of course in better condition than others, some have original colour and some were coloured later, but so long as you know what you have got you should be able to check the price.

Paintings and sculpture

The prices you can ask for paintings and sculpture depends largely on the artist's reputation; you must be able to justify prices to customers, and feel confident that customers are getting good value, so high prices need to be backed up with impressive artist biographies. The work of

an unknown artist may be very similar in style to that of a very famous artist, but the prices the market will accept will be very different. The market for all commodities is affected by consumer confidence, and art buyers are influenced by an artist's past successes and prices. In other words, there is more to pricing original work than just aesthetic judgement.

When buying original work for four-figure sums some customers expect discounts of up to ten per cent. You may not give discounts at the beginning of exhibitions, but you may decide to do so at the end. Many galleries will give discounts if buyers take several paintings. Discounts must be discussed with artists in advance; both gallery and artist must be clear about the lowest price both will accept and the preferred asking price. It must also be clear from whose profit the discount will be deducted, or whether this will be split between artist and gallery.

VAT is an important consideration when selling work on behalf of artists, and this is discussed in Chapter 5: The financial side of setting up (p.60).

When selling work bought from or on behalf of an artist, Artist's Resale Rights do not apply. However, if selling an original bought from someone else, even a distributor, your sale is the second transfer of ownership and therefore ARR should be paid to the collecting society. This sum needs to be taken into account when pricing. See the discussion of ARR in Chapter 2: The formalities (p.24).

Ceramics, gifts and craft items

The mark-ups on gifts vary hugely, and are largely dependent on where you sourced the product. For example, if you or an associate bought some goods in the Far East at a very low price, you should price them in accordance with your overall pricing strategy regardless of the cost. Retailers often enjoy significant margins on unbranded imported goods, and are frustrated that margins on established brands are not so profitable.

Greeting cards

Most independents do not try to compete with the chain stores on price. They tend not to sell, for example, multi-packs of standard Christmas cards. Suppliers will indicate whether most people double the trade price and pricing of course needs to reflect your overall

position on pricing. Customers tend to perceive handmade items as specialist and are prepared to pay a premium price.

Art and craft materials

Art materials have a recommended retail price; most retailers stick to this guideline because, since the market is dominated by so few suppliers, artists would quickly find out if their local shop was charging over the odds. Margins are generally around 40 per cent, with some longstanding customers negotiating up to 45 per cent. Some smaller suppliers offer better mark-ups, but they tend to only represent a small percentage of retailers' turnovers.

Art materials do not therefore have the profit potential and flexibility of bespoke framing (a pricing survey in leading trade magazine *Art Business Today* showed that some framers charge up to five times more than others for the same job). However, some retailers assert that you can increase margins by buying wisely; suppliers have a range of offers at different times of year so retailers need to plan carefully when to buy stock, and keep on top of what offers their suppliers will be launching. Retailers can choose to pass these discounts on to customers, which helps to secure their loyalty.

It is standard practice for art materials retailers to offer art students a ten per cent discount, and many extend this to local art groups. Some retailers would only give the ten per cent off when the artist spends over £10.

Loyalty cards work well for some retailers. These typically give a ten per cent discount and are sent to art tutors and clubs to give out to students and members. The card might be stamped each time the customer spends £5 and once £200 worth of stamps are collected the customer is given £20 of free stock (the equivalent of a ten per cent discount).

Craft supplies operate in much the same way as art materials. Retailers tend to hold regular demonstrations of new techniques and materials and then sell these at a ten per cent discount on the day.

Chapter 12

The role of computers

In terms of accounts, customer mailshots and general business administration, your office computer means that tasks that used to take up a whole day can now often be done in an hour. It goes without saying that you will need to invest in a computer; the question is what functions you want your computer to carry out, and which software would be best suited to fulfilling these requirements.

Hardware and operating systems

It has never been cheaper to buy IT equipment; if you want a basic office computer for word-processing, spreadsheets, email and so on, then you will have plenty of change out of £500. Dell, PC World or your local computer shop (often a good choice because of accessible support) will have plenty of choice.

For most, the first decision is whether to buy a desktop or a laptop computer. A desktop (the computer itself usually goes under the desk) is cheaper and easier to upgrade, but there are a lot of wires at the back and the whole thing takes up more space than a laptop. Laptops are more expensive (though prices have dropped considerably in the last year or so) and more difficult to upgrade, but they are neater and take up very little space. With a laptop you have the advantage of being able to sit at your PC anywhere in your business premises or home. This advantage is becoming ever clearer as we move towards 'wireless' internet access.

Wireless technology means you can connect to the internet via radio signals, rather than having to be connected to a telephone socket with a cable - you can be in your workshop and also connected online.

Like the rest of the equipment, printers have never been cheaper, or better. A simple printer costing around £30 today will produce a print that would have been considered photographic quality just a few years ago. Look out for the cost of replacement ink tanks or cartridges; if you mainly print text then the cheaper compatible ones (if available) are quite suitable, though you should be aware that these may affect your warranty, an important consideration if you buy an expensive large-format printer to produce *giclée* prints. At the time of writing, you would need to spend around £1000 to buy a printer capable of producing A2 fine art prints or larger, though prices are dropping all the time.

It is really handy to keep a spare keyboard and mouse in stock. Neither is at all expensive, but my experience is that when they fail that you will be glad you did.

The next decision is which operating system to go for. The operating system is the software which runs in the background and takes care of everything from the way the computer starts up and shuts down, to allocating enough memory for the document you are working on. The two main ones are Apple Mac and Microsoft Windows. The Apple Mac route needs a dedicated machine that is more expensive than a PC; Macs are ubiquitous in the graphics industry because they are so graphically capable. The software is more expensive and Macs can be 'thief magnets', but you are unlikely to get a virus because Macs make up less than ten per cent of computers.

The vast majority of software is written for PCs running Windows, and this includes frame-pricing software. Whatever you think of Microsoft (in some sectors of the IT industry they are reviled) Windows is the most user-friendly operating system around. If you do develop a problem then somebody will have had that problem before and it will be relatively easy to fix.

At the time of writing Windows Vista has just been released. This is the latest incarnation of Windows and if you buy a new PC chances are that it will have Vista already installed. Make sure that the machine is sufficiently powerful (particularly having enough RAM, at least 1GB) to run it, as Vista needs significantly more resources than Windows XP.

Another operating system used by some is Linux. There are many versions and most are free, but Linux is not for beginners (many Linux enthusiasts will disagree though). One point in its favour is that it is far more secure (as is Mac OS) than Windows. Unfortunately Windows is a victim of its own success; if you are a virus writer why bother with the small-fry? Your virus will go much further on Windows systems. So, this means that if you have a computer running Windows then anti-virus and anti-spyware programs are a must and they must be kept up to date (at least weekly in the case of the anti-virus program). On the other hand, if the computer is never used for the internet or email then you can ignore this paragraph.

Software

This brings us onto the programs you'll be running on your computer.

1. Office suite

You will need an office suite (word processing, spreadsheet and database programs linked together). To most this means Microsoft Office in one of its many forms; this is certainly a very capable application, though most people will use only ten per cent of its features. Don't dismiss Ability Office (*www.ability.com*) or Open Office (a free download from *www.openoffice.org*); both can work with Microsoft Office files and using one of these programs saves you the best part of a hundred pounds.

You should make an effort to regularly build up your customer database and keep it up to date. A strong customer list containing as much useful information as possible about customers and their buying habits will help maximise sales and becomes a valuable asset when it comes to selling the business. Nowadays it is easy to email people using your database, as well as to print out address labels, so targeted mailings are easy to process.

2. Photo editing and graphic design

Getting a little more specialist, there is photo editing. Retailers with skills in this direction sometimes offer to re-touch and tint old photographs, which in turn generates framing business. Adobe Photoshop, or its cheaper cousin Photoshop Elements, are often used for this purpose, or try The Gimp, another free download from *www.gimp.org*. Adobe Photoshop is the software most commonly used to manage and manipulate images if you have invested in a wide-format digital printer.

If you have got to grips with Photoshop you may also want to design advertisements and marketing material in-house, which would involve buying a graphic design program such as Quark Xpress or Adobe InDesign. These programs are relatively complex to use and this is probably only a sensible move for retailers who are particularly interested, and skilled, in graphic design.

3. Accounts

There is also accountancy software; check with your accountant to see what they recommend. Some retailers only take their bookkeeping as far as filling in the Excel spreadsheets that are included in their Microsoft Office package, while others find it cost-effective to use proper accountancy software.

Sage is the market leader in accountancy software and there are various packages aimed at businesses of different types and sizes. The advantage of accountancy software is that it does proper double-entry book-keeping, which means that each time you make an entry your accounts are updated in several areas, which saves both time and accountancy fees. For example, you can print out management reports, profit and loss records, balance sheets and lists of debtors and creditors at the push of a button (as long as you input the correct data in the first place).

4. Framing software

Specific to the framing industry are: frame pricing software; frame visualisation software; and software to drive your computerised mountcutter.

Frame pricing software is rapidly becoming the norm and taking over from the pricing chart that used to be taped to every framer's countertop. This software is generally designed by framers with an interest in computers; it is available from framing suppliers and a list of designers can be seen on the Fine Art Trade Guild website. A big advantage of pricing software is that it looks professional and customers tend not to question prices that have been generated by a computer. Pricing software means that all members of staff should quote the same price for the same job.

Frame visualisation software is a new innovation that has been made possible as digital cameras have become widely affordable. This software allows customers to see what their artwork will look like in different frame designs. The retailer photographs the customer's art-

work, which then appears on-screen and can be surrounded with different frames. This type of software may revolutionise the way framing is sold, but it is as yet in its infancy.

Framers who use a computerised mountcutter (CMC) very often have a dedicated computer with which to drive it. CMCs tend to come with their own computer; once it is set up and running smoothly framers may want to keep it off-line to prevent the risk of attack from viruses. However, there is no technical reason why you should not load your CMC software onto your office computer and, if the CMC is in a different room from the computer, the two could be networked.

5. Tills and barcodes

Most art and framing retailers do not have sophisticated computerised tills or use barcodes. Barcodes work best when you are selling prepackaged goods direct from the manufacturer, but are less useful when you are carrying out bespoke work and each frame is slightly different. Art materials are generally pre-packaged and manufacturers have been allocating them with 13-digit ENA numbers or barcodes and labelling them accordingly for many years, so retailers selling these may choose to have a barcode reader on their till.

Computerised tills that warn you when stocks of a particular product are running low, and generate re-orders, are not common among art and framing retailers. For example, such tills may know how many metres of moulding you have in stock, but they won't know how many pieces the moulding is in.

6. The internet

The internet means you can contact customers and suppliers quickly and easily, you can raise your profile through a website and you can access business information quickly. You connect to the internet using a program called a web browser. Nine times out of ten this means Internet Explorer supplied with Windows, which is now on version 7 (much more secure than version 6), but you don't have to use it. Some people prefer browsers such as Firefox (free from *www.mozilla.com*). It is the same with email: you don't have to use Outlook Express, there are alternatives such as Thunderbird, also from Mozilla.

Working practice

If you have a computer at work and one at home, then the ability to transfer files from one to the other is useful. The 3.5" floppy disk is now a thing of the past; most people use a USB memory stick. Commonly used are ones with capacities of up to 2GB, which are reasonably priced (have a look on Amazon or Ebuyer). For more permanent storage there are CDs (with a capacity of around 600MB) and DVDs (4.7GB), as long as you have the appropriate writer.

Ask yourself what would happen if the hard disk on your computer broke down; the hard disk is the bit which stores all the operating system, program and document files. This would be catastrophic if you have not backed up your data properly. However, as long as you have copies of all your data and program disks catastrophe should be avoided. So, put into place a routine to regularly back up or copy those important files and to keep program disks somewhere safe. Don't think it won't happen to you.

Computers and programs tend to take time and patience to set up, but once configured to your way of working they are invaluable, and you wouldn't be able to imagine life without them.

Your website

Three quarters of respondents to a 2007 *Art Business Today* survey said that they have a website, and many of the remaining quarter were in the process of launching one. These sites vary enormously in scope and quality, but the main thing is that even sole traders tend to see some presence on the web as essential.

Some retailers design their own website, while most employ a specialist to do this. You also need to pay someone to host your site; your designer may throw this into the package, or the company from which you bought your domain name might also host the site. Hosting is an on-going cost, but will probably be less than £50 a year for most retailers (large sites with lots of email addresses and a huge number of hits pay more).

Once they have had their site designed, many retailers update the site and upload new images themselves. This is a good idea as it minimises ongoing costs and encourages regular updating. It is essential that your website is updated regularly; there is no point in using cutting edge technolo-

gy to display out-of-date information. This frustrates customers and is very bad PR for your business. The more up to date your news and stock information, the harder your website can work for you.

Some retailers have a secure shopping facility on their site. There is an annual fee for this service, which means that people can buy goods directly from your website and their credit card details are encrypted to prevent fraud. The cost is currently around £250 per year, but different internet payment providers offer a range of packages which include various features, so you should shop around to find the package best suited to your needs. As a rule of thumb, the more automated the package, the higher the cost.

Retailers who don't have a secure shopping option argue that art and framing are not the types of products that people buy online, preferring to come in and actually see the goods. Those that do sell framed art in this way report that people tend to buy artwork from artists they know and already collect, but would be reluctant to buy work from a new artist without having actually seen it.

If you do not have a secure shopping option your website becomes a way of advertising your products and services, which invites people to call you or come in to your shop. Customers may find your website a handy and quick way to find out, for example, what time you close on a certain day. Some retailers invite visitors to register and join their mailing list online, which hopefully maximises the usefulness of the website. Others make it easy for visitors to email them, or get in touch in other ways, which is important.

It is a good idea to use a service that monitors and analyses the visitors to your website, such as *www.statcounter.com*. Such services are generally free, though for about £5 a month you can get more detailed information about a wider range of visitors. You just type a hidden code into your website in order to receive invaluable information on, for example: which links people followed to find your site; what keywords they typed into various search engines; how long they stayed on your site; their geographical location; and whether they have visited you before.

You can devote a lot of time to ensuring that your website stays at the top of the search engines, in other words, that it comes up first when people type in certain keywords. Search engines have various complicated formulae for working this out, which evaluate factors such as

how often certain keywords appear on your website, how many hits you receive and how many other sites link to yours. Websites such as *www.searchenginewatch.com* explain how search engines rank websites; information gathered here can help you, for example, to use the right combination of keywords at the right points in your website.

Staying at the top of internet searches is a time-consuming black art. The most important thing is to ensure that you publicise your web address to your customers, and anyone who passes your shop or reads your marketing material. Make sure that these people remember your web address by writing it prominently on all your stationery, your shopfront, your carrier bags, the side of your van, etc. If you do this, people should not, for example, go somewhere else because they didn't know you were open on Sunday and sold hand-gilded frames; they could ascertain these two facts at the click of a button or two.

When thinking about the design of your site you need to remember that people browsing the internet want information quickly. They may not stay to look at images that take too long to download, so make sure that the images you upload are of a suitable size. Nor will they stay to read long essays; they want easily-accessed, easily-digested information. It is therefore essential that your site is easy to navigate and using it requires simple common sense. There is nothing more infuriating than visiting a website in order to obtain some straightforward information, and being unable to find it. Your site should also reflect your house-style, colours, typefaces, design and incorporate your logo.

Test your planned design on as many people as possible; ask them to find their way round it and acquire certain bits of information and see how easy they find it. You should look at as many art and framing websites as possible before finalising your design, and see which features impress you; the Fine Art Trade Guild site lists just under 1000 retailers, most of whom have web addresses.

The section entitled 'E-marketing and the web' in Chapter 13: Effective marketing (p.139) explains how retailers use emails with links to their websites to stay in touch with customers. See also the section entitled 'Registering your web address' in Chapter 2: The formalities (p.24), which discusses acquiring a website name and email addresses.

Chapter 13

Effective marketing

Marketing and advertising are likely to be your largest outgoing after salaries, the cost of your premises and buying in stock and materials. An accountant might suggest allocating three per cent of your turnover to your marketing budget, though some retailers might spend four per cent or more. Even for a small business this amounts to several thousand pounds, so it is important that this resource is used as wisely as possible.

This chapter looks at how galleries and framers attract new business, and try to ensure that when customers think of art and framing they think of you first. There are numerous ways of allocating your marketing budget in today's multi-media marketplace, and what follows is a discussion of the methods that are most commonly used in the art and framing world.

You may be a master craftsman achieving standards of technical perfection that few could aspire to, but you will only be profitable if people know you are there and understand the benefits of shopping with you. It can be hard to know the best way of getting your message across to potential customers: should you invest in a website and try e-marketing, or would the money be best spent on tried-and-tested methods such as ads in the Yellow Pages? And is it worth hiring a PR person, or is that only viable for big businesses?

The 2007 *Art Business Today* carried out an in-depth marketing survey, filled in by around 200 art and framing professionals; their views form the basis of this chapter. The magazine sent out a similar survey in 1999, which means that it is possible to see how marketing trends have developed over eight years.

Advertising

99 per cent of retailers advertise, and the remainder are mainly winding down their businesses and settling into retirement. Eight years ago 93 per cent said they advertise; the increase reinforces the idea that only professional businesses are surviving in today's competitive marketplace.

The most popular way to advertise your business is still a display ad in the Yellow Pages: three quarters use this method, which is pretty much the same as in 1999. It would not have been surprising if the popularity of Yellow Pages had dwindled, with more and more of us using Google rather than referring to phone books, but this has not happened. Yellow Pages' place in pole position has been reinforced by the success of *www.Yell.com*, its online equivalent. 20 per cent advertise in Thomson Directories and their online version, *www.ThomWeb.co.uk*, while the same percentage opt for the BT phone book.

Local print-based media are an important advertising avenue, and the internet does not seem to have affected this. Local newspapers were the second most popular advertising option eight years ago, which is still the case today. Paid-for newspapers are the most popular option, followed by regional magazines and then free newspapers.

Nearly half of all art and framing retailers advertise in parish magazines. These ads tend to cost very little, often around £25, and they are generally photocopied low-budget publications. The reason for their popularity must lie in the fact that most galleries and framers have a largely local clientbase, and parish magazines are distributed to precisely the right geographical area. And, of course, most businesses can afford the occasional £25.

The fact that so many advertise in the parish magazine also suggests that art and framing is a personal business, where local people visit their local independent trader because they value the personal service they receive. Local networking is important for independent retailers, and supporting the parish magazine is part of this.

Grass-roots local advertising is very important for galleries and framers. Many advertise in directories and listings of local services, regional show and event guides and local theatre programmes. Also popular are school fete programmes, Rotary Club publications, golf club literature (such as diaries) and district council 'new household' guides.

Galleries and framers seem to feel that if they support local publications and events, local people will support them. They want people to view them as a trustworthy and valuable part of the local community, so utilise many opportunities to reinforce their role in that community.

16 per cent advertise in special interest magazines, for example publications focusing on motor racing, equestrian matters or dogs. Local radio is a consistently popular minority option, with around ten per cent using it for promotional purposes.

Being too creative when designing advertisements can be dangerous: your sales message must not be confused with over-clever ideas. The copy must be specific and easy to understand, but remember to 'sell the sizzle' and convey genuine enthusiasm. Good ads include facts, not fiction: descriptions like 'amazing' and 'new improved' have lost their lustre. Always look at your ad once you have written it and delete any words that on second thoughts are superfluous or are stating the obvious.

Internet advertising and eBay

Predictably, the advertising option that has enjoyed the most rapid growth is the internet, with 37 per cent utilising it in 2007, as opposed to 20 per cent eight years before.

www.Yell.com and *www.ThomWeb.co.uk* are the most popular options. Some retailers publicise themselves via *www.thebestof.co.uk* and *www.ufindus.com*, while others advertise with local search orientated websites and internet business directories.

Google Adwords are popular. Your advert appears on Google when particular searches are requested and you pay according to the number of hits you receive. Google allows local and regional targeting, which makes it a viable option for businesses whose clientele are locally based.

A growing number of art retailers have an eBay shop. Many see this as another facet of the marketing mix, which works well alongside a

bricks-and-mortar shop and a retailer's own website. Some say people feel more confident buying from an eBay shop that is part of an actual bricks-and-mortar retailer.

An eBay shop can be a good way of discounting old stock, but beware of selling currently published prints too cheaply as this annoys publishers who may refuse to continue supplying you. It may also work against the way you have positioned your bricks and mortar shop and have a negative effect on sales. Some see their eBay shop as a good way of directing traffic to their own site; eBay do not permit you to put your own web address on your shop page, but it is easy for people to find you. Many traders report that they pick up good quality customers and repeat business from around the world through their eBay shop.

Many warn that selling on eBay is not as inexpensive as it might at first appear. The charges mount up and you may pay when you list an item as well as when you sell it (or fail to sell it), and Paypal takes a percentage for processing payments. eBay's fees are apparently rising all the time.

Spending and frequency

Most businesses take out ads that cost under £100, though some also take out ads in higher price brackets. Typical spend for a retailer would be £25 for a parish magazine, just under £100 for an ad in a local free full-colour magazine and up to £300 for a full-page ad in a county newspaper.

Many retailers spend £300 or more on display ads in Yellow Pages, which emphasises what an important resource this is. Fine Art Trade Guild members can also benefit from inclusion in a Guild box advert in Yellow Pages, where they are grouped with other local members and the box is highlighted with the Guild logo. This option often costs under £100, depending upon geographical area. *www.Yell.com* and Yellow Pages seem to work separately and do not promote savings if you book adverts with both of them.

An advantage of online advertising is flexibility. For example, *www.Yell.com* allows you to 'turn your advert on and off' so you can choose to only advertise on certain days. Google Adwords boasts no minimum spending requirement; you can, for instance, set a daily budget of £5, so your ad is 'turned off' once you have received sufficient 'hits' to total this amount. Both options can therefore be

inexpensive, and, if required, can be kept below £100 per month.

Many people book ads every couple of months, in addition to year-long bookings such as Yellow Pages. Those that advertise less often tend to take ads during the pre-Christmas period, or when there are local events to support, or when they have a specific product or exhibition they want to promote. Local radio advertising tends to be a brand-building exercise, with ad bookings running for several months or a year at a time.

Direct mail

Well over half of art and framing retailers use direct mail (excluding e-marketing, which is discussed later). This figure is increasing, probably because businesses are having to adopt professional sales and marketing strategies in order to survive. Also, the cost of printing is becoming much more competitive and data handling has become easier and more efficient.

Some publishers supply their retailers with direct mail material, which is part of their support-package for customers. This will work along with point-of-sale artwork, catalogues, visits by artists and pre-written press releases. Publishers offer a high level of support to retailers who are loyal to them and prioritise selling their products. The Fine Art Trade Guild produces consumer information leaflets that can be over-printed with member retailers' own details.

Direct mail is mainly sent to customers on the database and given to people who visit the shop. These are both 'hot' sales leads; they are on your database or in your shop because they have expressed an interest in your products, so are the two most likely categories of customer, and potential customer, to actually make a purchase. So it is not surprising that retailers target their direct mail at these types of customer.

About a quarter of retailers do mail drops in certain postcode areas, and the same amount distribute sales literature through local hotels, art centres and Tourist Information Centres. Both of these techniques bring sufficient results that businesses tend to repeat them.

Businesses mainly use direct mail to promote their products and services generally, so these leaflets will have a long shelf-life. The second most popular use for direct mail is to publicise exhibitions, then to advertise the arrival of new stock and lastly to promote special

offers. However, while general leaflets may develop awareness of your business, they are less likely to result in immediate sales than those offering discounted services during a given time. Think carefully about what you want your direct mail to achieve before you decide upon your message.

Half of retailers print between 500 and 3000 leaflets each time, while just under half go for printruns of less than 500. Very few opt for printruns of more than 3000.

Most businesses distribute between two and four direct mail leaflets each year. Those that do more tend to be galleries holding regular exhibitions.

The 60-30-10 rule is a trade maxim among direct mail professionals. This means that 60 per cent of the success of a direct mailing is down to the quality of your mailing list, 30 per cent is concerned with the quality of your offer and ten per cent is down to the creativity of your design.

There are lots of factors that can affect how successful your direct mailings are. You need to consider your offer, the price, your wording and the timing of your mailing. A special offer with a cut-off date can galvanise people into action (such as 20 per cent off framing in January and February).

E-marketing and the web

More than a third of art and framing businesses market themselves to their customers using email. Some feel that e-marketing messages irritate people whose email inboxes are already full of unwanted messages, others say that e-marketing is an invasion of privacy in a way that posting leaflets is not. People change their email addresses much more regularly than they move house, so keeping an up-to-date email list can be difficult. There is also the problem that people's spam filters can block group messages with attachments. However, one reason that two thirds of art retailers don't use e-marketing is possibly that they just haven't got round to it yet and prefer to use tried-and-tested direct mail techniques.

Those who do use this method manage to maintain extremely regular contact with their customers, and generally use email for several different purposes. The most popular use for email is to notify collectors about new stock; for example, all those whose database notes refer to

an interest in wildlife art will receive an email when new wildlife images come into stock. This type of email is quick and easy to send, it is easy to target just the right people and there are no printing and mailing costs.

Most people who do e-marketing also send an e-newsletter, notifying customers when there is a special offer and telling them about forthcoming exhibitions. So they are in regular contact with their customers which, so long as people aren't irritated by the emails, must help to ensure that customers think of them first when they want to buy art and framing. Most people send an e-newsletter once a month, or every two months.

It is best to keep e-newsletters short; people tend to read their emails in a hurry. Ideally your newsletter should be viewable in one take on the screen. One or two images are normally sufficient and don't increase the size too much. If newsletters are in the body of the email, rather than as an attachment, they are more likely to get through people's security software.

When you add someone to your email list it is good practice to send them an email telling them that you have done this, and giving them the option to 'unsubscribe'. You should also reassure them that their email details will not be passed on to any third party. People can be very annoyed by unwanted emails so it is important not to contact them too often and always to make the option to 'unsubscribe' very clear. The last thing you want your emails to do is create negative feelings towards you and your company.

For e-marketing to work effectively you need to ensure that each email appears as personal as possible. People are much more likely to respond positively to an email that addresses them by name.

Email can be used to tell artists about special offers on art materials, which apparently brings very good results, probably because artists are loyal to their brand, need to replenish supplies regularly and are price-conscious. Email gets the message out quickly and cheaply.

Some email software programs allow you to track how many emails were opened and which links were clicked on.

Remember that different email browsers 'read' email in different ways, and may rearrange your carefully designed newsletter. It is therefore a good idea to try opening your email on as many browsers as possible.

Private views

The majority of those who sell artwork hold regular private views. Anyone who wonders whether this formula might be getting a bit tired, and questions whether people are excited by a free glass of wine these days, would be surprised. It seems that private views can still help to sell art. Most people hold two or three a year, with some galleries throwing as many as six private view parties.

However, some galleries do report falling attendance and put this down to private view invitations being so commonplace. Many would agree that you have to work hard these days to entice people to attend your private view, and, though the formula can still work very well, people need a strong reason to attend such a function in an increasingly busy world.

Like any marketing tool, private views only work if they are carefully planned and targeted to appeal to the right people. Gallery owners often claim that up to 50 per cent of an exhibition might sell at the private view, and this percentage may be higher if the work is under £2000, as quick buying decisions are more likely.

People buy at private views partly because they worry that someone else will snap up the work if they don't, partly because they may be slightly flattered to be invited to an exclusive event and partly because the party atmosphere and flowing alcohol encourage them to throw caution to the wind and reach for their wallets. Gallery owners need to capitalise on these favourable factors.

The downside is that the formula may not work in a culture where people work long hours and spend a lot of time travelling. The demands on people's time are too heavy. Galleries in commuter towns, for example, may find that people get home too late to attend early-evening private view parties, and see their weekends at home as too precious. You need to decide whether private views are right for you and your marketplace.

If you are going to hold private views you need to find the best time to do so. Galleries in towns where people have second homes may find that the only viable time for private views are Saturday afternoons,

while London galleries avoid weekends as good clients may be out of town. Champagne breakfasts, Sunday lunch and late night openings are all options; you need to find out what will work best for you and your target customers.

Funky contemporary galleries have tried every attention-grabbing device, from invitations printed on packets of condoms to messages in bottles. A memorable invitation could be the deciding factor in ensuring that your customers make the effort to attend, or put the invitation somewhere prominent that will remind them to do so. The main thing is to ensure that your invitation reflects the type of art that will be on show, and that it will appeal to your target customer. Most galleries send invitations about two weeks before the event.

The amount of money spent on hospitality is generally related to the value of the art on show (people buying expensive originals might expect champagne). Some galleries provide cocktail snacks while others haven't the space or complain that this attracts time-wasters. Food and drink can be used to reinforce a theme, such as tapas at a show of Spanish works or seafood to complement marine works.

Many galleries are annoyed by the freeloaders who turn up to private views. A bouncer at the door might deter the less determined; an off-duty policeman or club doorman might do the job for a small fee. Making sure that everyone signs a visitors' book can help identify free-loaders so they can be deleted from the database.

Other ways of attracting people to your private views can be special events, themes and guest appearances. The promise of a celebrity making an opening speech or an opportunity to meet the artist (see below) can appeal. Gimmicky ideas such as fortune tellers and magicians can work at the right event.

A charity donation can be a way to attract a celebrity to participate. Find out which charity a local celebrity supports and pledge a percentage of your proceeds to that charity, or auction a painting in its favour during the private view. Customers may be more happy to buy a picture if they feel they are also giving to charity. It may be more effective to state on each picture, for example, '£179 including a £35 donation', as this could seem more plausible to customers than '25% of proceeds to charity'.

Editorial

PR in the local media can be very beneficial for a business selling to a locally-based clientele. Sending out press releases is essentially free and need require only minimal effort, yet businesses tend to neglect to do this as there are so many pressures on their time. However, good PR can give your business added credibility and greatly enhance your reputation. Editorial is, in effect, someone else saying you are good, whereas advertising is you saying you are good; people are more likely to pay attention to the former.

Appearing at regular intervals in the local media keeps businesses in the public eye and attracts new customers. It also boosts the confidence of existing customers and it can raise staff morale to see their company in print. Good PR is a dripping tap of awareness.

You are a local business person, the editor and other journalists are local business people. Get to know them and their papers and other media. Find out how they position themselves to local people and what they need to keep readers and listeners interested. The closer you get to meeting their readers' interests with your press releases, the better success you will have. Be sure to target local media that targets the kind of people you want as customers. You will increase your chances of free publicity and goodwill if you advertise, even occasionally.

Retailers who don't send press releases may well be missing a trick, since of those that do a high proportion succeed in getting valuable free coverage. Emailing a short news story and a JPEG is quick and cheap these days, so is definitely worth the trouble.

Very few retailers incur the cost of hiring a PR person, preferring to handle PR themselves, making it even more of a potentially useful low-cost exercise. Some retailers send out press releases prepared by the publishers whose prints they sell, which means that minimal effort is required.

You need to create newsworthy stories, which tend to be human interest stories combined with a local reference. Get permission to share the story when customers bring in unusual objects for framing. Make sure you tell the local media about window displays, competitions, tie-ins with local events and exhibitions of local artists' work. Think about the PR opportunities presented by national events and celebrations.

But, above all, 'make a noise' and create opportunities that will reflect positively on your business.

Your press release should be short and to the point; if the news editor is interested he or she will pick up the telephone and get in touch with you. You don't need to spend hours choosing the right words - that's the editor's job - just make sure you've got down the essential facts and made them easy to understand, and that your contact details are easy to find.

These days most press releases are emailed, but a quick call to the local paper will ascertain how they prefer to receive copy. Send it along with a JPEG and make sure that it is obviously a press release and not spam that will be ignored. It is best to include your story in the body of the email, rather than as an attachment, as this increases the chances of the right person reading it. Local media often send out their own photographer, but your photograph may attract their attention in the first place, so it is worth sending one.

The media are more likely to include news stories from businesses that support them with advertising, even occasionally. Many retailers will not advertise unless they are promised editorial coverage as well. It can look tacky for your ad to appear on the same page as a news story about you, but two hits in the same publication can be highly effective at raising awareness.

Sponsorship

Many retailers sponsor local events, which can generate good PR in the local media and strengthen bonds with key groups of customers. Some retailers sponsor two or three events each year, on the grounds that they get their picture in the local paper, get their name on all sorts of publicity material and sponsorship can be cheaper than a local paper advertisement. Sponsorship is a way of supporting the local community, which can also have direct benefits for your business.

Sponsorship can take many forms and returns come in different packages. Money may not change hands; for example, you may sell tickets on behalf of local operatic societies or amateur dramatic societies, which can be effective as it brings people into your shop, and people who are interested in the performing arts are likely to be interested in visual arts too. The words 'tickets available from X Gallery' would appear on all publicity material, adverts and posters too.

You may offer discounted framing for a local arts festival, in return for which your name and logo appears on all publicity material. Or you may donate the framing for a painting which is auctioned in aid of a local charity, which would ensure that your name would be included in all local press coverage and publicity.

Sponsorship of events at local museums can be a good idea, as that links your business name with museum-quality framing in people's minds. It may cost much less than £2000 to support an exhibition in your county museum, yet the publicity could be high-profile. If you can't afford it you could try asking one of your suppliers to come in with you.

Meet-the-artist events and art courses

Demonstrations and visits by artists can help sell art as well as art materials and this, in turn, sells framing. People see artists as talented and glamorous; meeting artists and talking to them is part of our cult of the celebrity. Asking the artist to hand-draw a cartouche in the margin of a print, or write a personalised message on a mount, can turn artwork into a very special gift or memento.

Artists can be their own best publicity machines and the best sales-people for their work. Gallery owners confirm that once an artist has charmed a customer and told them an anecdote about the location or subject for a painting, the work can be as good as sold. Galleries with sufficient space may decide to have artists demonstrating their technique on-site, and then back-up the event with a discounted price on that artist's prints. Some galleries employ a photographer to attend meet-the-artist events and if someone buys an image they are sent a photograph of themselves with the artist.

Some publishers will arrange for their artists to visit their gallery customers.

Quite a number of retailers are able to teach art courses themselves, as for many owning a gallery grew out of a need to sell their own art. However, most would choose to work with an art teacher. Art courses are generally taught in a local space such as a village hall and lunch is supplied. The initial outlay can be small and the returns good in terms of sales of art materials, framing and other products.

Affinity marketing

'Affinity marketing' means working with other businesses to your mutual advantage. This works best if you are both selling to the same target customer, but are selling products that are very different.

You might try swapping mailing lists with a local home accessories or upmarket kitchen equipment shop, or including each other's marketing material in mail shots. Or a local bridal shop may allow you to hang some framed wedding memorabilia in their shop, along with your contact details, on the basis that you give them a percentage of any business this generates. Framed sports shirts and memorabilia in local sports clubs may also work well. You could organise a wine tasting for a local wine merchant in your gallery, and share the promotional costs. Linking with a photographer to offer professional framing to their customers is particularly recommended for qualified framers, and carrying out fine art printing for photographers can work well for both parties.

Open days and street parties

Some retailers who claim that people are no longer excited by the prospect of a free glass of wine at a private view, find that a street party or open day works better. All the retailers in a given area need to club together and organise competitions, children's entertainments, special offers, complimentary snacks and special events.

Retailers all benefit from each other's mailing lists, marketing clout and local media contacts. Each participant only need be responsible for one facet of the event, minimising the effort involved.

Jaded customers who are used to being bombarded with special offers are more likely to respond positively to an invitation that, for example, allows them to tackle a high percentage of their Christmas shopping in one go.

Marketing art materials

Retailers seem to agree that the best way to sell art materials is to couple expert product knowledge and levels of customer service with regular promotions, classes and demonstrations.

It is standard practice for art materials retailers to offer art students a ten per cent discount, and many extend this to local art groups. Some offer students ten per cent off only if they spend more than £10.

Loyalty cards work well for some. These can be distributed to art tutors and clubs to give to their students and members. The card might be stamped each time someone spends £5; once £200 worth of stamps are collected the customer is given £20 of free stock (the equivalent of a ten per cent discount).

Many special offers on art materials are driven by suppliers. The advantage of this type of promotion is that the supplier will advertise and market the promotion on behalf of its retailers, and provide printed leaflets free of charge. Some retailers think up their own promotional ideas and then seek support from their suppliers. Suppliers tend to incentivise retailers to take on their full ranges by offering them 'premier store' status, which brings many marketing and promotional benefits.

Classes, demonstrations and special events stir up business for many retailers, and sometimes suppliers will provide and pay for a demonstrator. Some retailers even hold mini art festivals and two-day workshops. Regular demonstrations can be a good idea, so customers can build these into their calendars, for example two demonstrations each month on alternate Saturdays. 'Road shows' with celebrity artist demonstrators go down well; local art clubs and customers should be invited, and the event would be accompanied by a range of special events and offers, maybe with a small charge for lunch.

Labels and personalised packaging

Some retailers would argue that the best form of marketing is the labels you put on the backs of frames and pictures that you sell. These labels can apparently generate business over many years. People know that if they take their picture off the wall your contact details will be on the back. It is therefore very important that every picture that leaves your premises is properly labelled.

The same goes for gifts, ceramics and sculpture: affix a small sticky address label to the bottom of such items, so that people can quickly find out where the item came from.

Carrier bags printed with your details can be worth the added cost. Large frames don't tend to fit into bags, so consider investing in personalised parcel tape, so that frames wrapped in bubble wrap look that bit smarter and are working for you in marketing terms.

Personal recommendation, networking and local business groups

By far the most effective way of attracting new business is personal recommendation. This reinforces the concept that one of the main reasons people shop with independents is due to their expertise, high level of product knowledge and excellent personal service: people recommend businesses to others because they have enjoyed a very positive shopping experience themselves.

Given the importance of personal recommendation, locally-based businesses must consider all the networking opportunities they can. Join local business groups and your Chamber of Commerce and attend their meetings. All businesses need wall décor, Christmas cards and leaving presents; make sure that they know about your services. In some areas local trade associations can access funding from district, county, national and European bodies, and you may be able to benefit from grants that are not available to individual businesses. You can get together to organise Christmas shopping evenings, street parties, arts festivals and other business-generating get-togethers.

Be sure to attend your regional Fine Art Trade Guild branch events. The chance to meet others in the trade can be invaluable in many ways, one of which is that you may meet fellow business people who need your services. For example, you may make a contact who will send fabric framing work to you, while you might send people who want reproductions to them (depending what you both stock and which services you offer).

Repeat business

Many galleries and framers rely to a large extent on repeat business. This demonstrates once again that independent businesses are valued for their personal service and expertise; people keep coming back because they enjoy shopping with a particular retailer, and trust their judgement. Frames may be cheaper in the chainstores, but the shopping experience is less pleasant and customers value working with framers to get exactly what they want. Art and framing retail is both a personal and a professional service.

Chapter 14

Sales and discounting

Most retailers on the high street hold sales. A recent survey by Ernst & Young noted that UK shoppers no longer regard discounts as high as 50 per cent as unusual, and that people expect hefty reductions all year round. Many multiples have been pushed into offering year-round discounts, but, according to Ernst & Young, independents can avoid eroding their margins in this way if they have an 'authoritative offer'. This is what galleries and frameshops have: they can emphasise the enduring quality of their artwork and the prestige it brings to the home.

The art and framing industry is divided as to whether discounting is a good idea. Leading trade magazine *Art Business Today* carried out a survey in 2007, which revealed that 54 per cent of art and framing retailers do discount and hold sales.

The argument against discounting

Some art and frame shop owners feel that discounting is inappropriate for artwork, and that buying art is about social aspirations, not saving money. They say it devalues the product, meaning that people are less likely to buy it than if it was sold at full price. Art is not like electrical goods or fashion, the argument goes; it is much more subjective and you won't necessarily sell an image because you drop the price. 'Everything must go' is not a sentiment that sits well with original artwork; people do not expect art to go down in value. Art that is pitched as one-off,

unique or one of a very limited number is sold on the basis that there is more demand than supply, and discounting it contradicts this.

Buyers may feel there is something wrong with discounted artwork and so do not feel confident to buy it. They say that art is a luxury that no one 'needs', so people are not looking to get it as cheaply as possible. Rather, the key factors affecting whether you make a sale are that the buying experience is enjoyable, that the artwork matches your target customer's taste, that the gallery staff are knowledgeable and trustworthy, and that the buyer feels that their home will be enhanced by the artwork.

Retailers against discounting will remind you that people can always buy goods cheaper on the internet and in the multiples, so it is pointless for independents to try to compete on price. Rather, they need to emphasise their 'authoritative offer' (see above). Retailers may lose some price-sensitive business, but they should focus on educating people to understand that they are paying a little bit more for a quality service and product.

There is the potential problem that if you hold regular seasonal sales customers will learn to sit tight until the sale to make purchases they would otherwise have made at full price. People can begin to perceive the sale price as the 'real price', and full margins as a rip-off.

Discounting can attract the wrong type of customer for your business, whereas a properly targeted promotion can bring in the right people. Bargain-hunters may never become regulars, while collectors who are made to feel privileged should do so.

Retailers who don't discount have to consider how to shift slow moving stock. They have to be prepared to re-frame images, re-hang the gallery and have sufficient storage to hold onto old stock to offer afresh as seasons and fashions change. They also need to be sure that their cashflow is sufficiently buoyant to allow them to retain stock. Some publishers let loyal customers swap unsold images, but not many.

The argument in favour of discounting

All retailers have to tackle the problem of what to do with stock that has not sold and discounting is the standard way of releasing capital that is tied-up in slow moving and out-of-date stock. Sales can ensure the sell-through of stock that is costing money in storage and

which may become terminally damaged or out-dated if left too long. Carrying the wrong stock can cause serious cashflow problems; sales can help reduce stock at key times such as the end of your financial year.

Some retailers affirm that artwork in discreetly marked discount browsers helps stimulate spending and that discounting need not discredit a shop if handled appropriately. They ridicule the idea that art buyers are not looking for a bargain.

Sales can bring new and different people through the door, who may end up spending more than they had planned. The trick is to convert new price-conscious customers into regulars who are prepared to pay higher prices because of your range and product knowledge. Someone might spend a few pounds on a slightly dog-eared print, but then spend £60 on framing.

Some retailers argue that it is a myth that independents can't compete with the chains in pricing; while they can't compete across the board due to the economics of scale and buying power, they can run special offers and target these more effectively. They can, for example, highlight a few special discounts that can attract customers and convey the idea that you do offer value for money. It may be a good idea to run discounts that are different from the chainstores, so your prices cannot be compared so easily, such as 20 per cent off lacing fabric art, or 20 per cent off specialist glazing products. Independents have more flexible management structures and can respond more quickly to demand than the multiples.

Some retailers who do not like discounting sell their old stock on eBay, which is discussed under the heading 'Internet advertising and eBay' on p.141.

How to handle discounting

Below are some of the options and points to consider when discounting or holding sales.

1. Targeting your offer

You must begin by deciding what kind of offer will appeal to your target customer. Think about why people shop with you in the first place. There is no point in presenting people with a special offer that will not appeal to them. There are three main types of discount to consider:

- Money off, or a percentage discount. This might be on the total sale, or just part of it, for example, 20 per cent off framing on artwork bought here
- Free product, such as buy-two-get-one-free
- Added value, such as free conservation glazing on frames costing over £100, or free delivery and hanging.

2. Added value

If the reason people shop with you is your superior product knowledge and expertise, then a special promotion adding value to each sale would appeal to your customers and emphasise your USP. There is a widely held view in marketing that the ideal promotion involves giving customers something free of charge, which entails them spending more money with you. For example, offer to stretch and mount their fabric art for nothing if they get it framed with you.

3. Protecting margins

It is important to protect your margins, even at sale times. When you first price an item there must be sufficient margin to ensure that even if you end up having to discount it, the item does not fall below your break-even price. Retailers talk about 'initial' mark-ups, which is how items are priced at the beginning of the season, and 'maintained' mark-ups which are the price you will not go below, even during the sale.

Do your sums: for example a 20 per cent markdown on an item that has a 55 per cent markup leaves you with a 43.75 per cent gross margin. This is an important part of running a profitable business. A long-standing problem in retail framing has been that prices have been set too low to allow any profit to be made from discounting (see Chapter 11: Pricing on p.123).

4. Promoting sales

A lot of art retailers prefer not to plaster their windows with 'sale' posters, opting instead for discreet stickers on sale items. They tend not to promote discounted stock very hard, but direct customers to it if they sense that the person would respond well to the idea of a bargain.

Some do not advertise discounts in the gallery, but contact their customer database directly offering specific 'loyalty discounts' (see below). Others shout as loudly as possible about their sale, advertising it in the local paper etc., on the grounds that an important function of a sale is to bring new people into the gallery.

5. Stirring up business during quiet times

Sales can be used effectively to stir up business at quiet times, such as January and February. Some retailers hold regular post-Christmas sales with the aim of shifting excess Christmas stock. Others run special offers at these times, such as '20 per cent off framing on prints bought here'.

Some hold two sales a year, one after Christmas and one in the summer, before the new Christmas stock comes in.

6. Dedicated 'sale' areas

A lot of galleries have dedicated sale areas, browsers of discounted prints or even a 'bargain bin'. A browser of unframed prints that are a bit tatty round the edges is a favoured discounting technique.

7. Linking in with local events and special promotions

Many retailers gear their discounts to local events and tourist attractions, when there will be a significant increase in footfall. If there is a bank holiday fair or festivity, retailers sometimes buy in extra stock and plan special promotions, and these can also be good opportunities to push slow-moving products.

Some retailers create themed windows, then offer discounts on the services displayed. For example, you might create a window display of framed 3D objects, such as coins and sports shirts, then offer ten to 15 per cent off 3D framing. Or you might offer artists' work at a preferential rate when artists are demonstrating their technique in the shop or 'meeting customers'.

8. Limited editions and original artwork

Because discounting limited editions and originals conflicts with their status as rare and collectable items, galleries sometimes stimulate sales of slow-moving images by discounting the framing of this artwork, or adding value to the sale in other ways such as free delivery or some free greeting cards featuring the same artist's work.

9. Volume discounts

Some retailers will give discounts to customers who buy several items, but many don't offer this unless the customer actually asks for it. Some reduce the price of the second picture if the customer buys two, or a

second print might even be free. Others offer to frame a second art purchase free during limited periods when business is slow.

10. Loyalty discounts

At quiet times some retailers get in touch with regular customers offering 'loyalty discounts' on certain services, which can stimulate business. Others are against this idea, saying that there is no point in offering discounts to people who already buy from you at full price. However, a loyalty discount such as ten or 15 per cent off framing in February can encourage regulars to have items framed that would otherwise languish unframed in the loft for many months. This 'thank you' for their business can also be good PR.

11. Percentage discounts

Ten per cent discounts may not stimulate sales in a retail environment where people are getting used to massive 50-70 per cent discounts along the high street. Many art and framing retailers opt for 20 per cent discounts, though some feel that ten per cent is still effective.

Another option is a sliding scale, offering ten per cent off stock that is unsold after six months, increasing to 15 per cent then 20 per cent.

12. Bargaining

Your strategy on bargaining needs to be clear. People buying expensive artwork may automatically expect a discount, and may ask for your 'best price'. You may only be prepared to negotiate on items over, say, £1,500, in which case your initial mark-up needs to allow for this. You and your sales staff must be clear about your 'best price' and must never go below your maintained mark-up.

Interior designers and corporate art suppliers often expect a 'trade discount'. This might be a standard ten per cent, or it might be higher on some items than others, increasing when a large quantity is bought.

If you are selling artwork on sale or return from artists you need to agree minimum sales prices with them in advance.

Some galleries make sure that their 'trade price' and 'best price' for each item is clearly marked on a stock sheet, which is accessible to all staff. These prices are often written in code, just in case the customer should see them.

13. Art materials

Art materials retailers tend to offer discounts which are driven by suppliers who help promote the offer. These might be percentage discounts or buy-two-get-one-free offers. Some retailers argue that artists respond well to free product, where the discount is a physical reality; artists know they will need to re-stock with the same products soon anyway, so they will most likely value the free item.

14. Discounts for art students and art groups

Art materials and framing are often offered to artists at a ten per cent discount, which is advertised through art groups and art colleges. Some shops use a loyalty card which is stamped whenever the customer makes a purchase, then their tenth purchase is free, which tends to work out at a ten pent discount overall.

Chapter 15

Customer relations

This chapter explores how you can maximise the value of each sale and promote customer loyalty by winning people's trust. It is an old marketing adage that it is far easier to sell more to your existing customers than to find new ones, so developing strong relationships with customers is critical.

One of the most important ways in which independent retailers can attract and keep customers is to take great care with the details. You can offer levels of customer service and 'a personal touch' that large faceless shops with ever-changing staff find it hard to compete with. The way in which you communicate with customers needs to reflect your position as the friendly local expert in your field. You need to make people relax and feel good when they are in your shop.

In other words, you need to cement your customers' trust, as this is what will keep them coming back to you. Trust is one of the most basic human values, and nothing is harder to regain than lost trust, so you and your staff need to be properly geared up towards developing this. Most of us do business with people because we trust them and the claims they make about their products and services. You win people's trust by being knowledgeable, efficient, polite and delivering what you promise.

Effective sales people should have two clear aims: they must set out to solve customers' problems and make them feel good. In other words, they must sell them goods that fulfil their requirements and they must ensure that shopping with you was a positive and enjoyable experience.

Your 'business culture'

In order to win customers' trust and loyalty you need to start by instilling the right values into your staff, and ensuring that you fully understand them yourself. Everyone deserves to be treated according to the golden rule: do unto others as you would have them do unto you.

Your 'business culture' should be founded on the following basic principles:

1. Truth

Trust and solid relationships are built on telling the truth, both to staff and customers. It is important that this value is represented in everything your business does. A lack of solid ethics erodes morale and can crumble even the most powerful of companies.

2. Responsibility

You and your staff must be fully aware of each of your responsibilities and be prepared to be held accountable for them. You must take ownership of mistakes, and be honest about them, and focus on being diligent about finding ways to correct them.

3. Attitude

Customers appreciate retailers who go out of their way to satisfy customers. Little helpful gestures, such as offering to carry heavy shopping bags to a customer's car, may only take a few seconds but can make a big difference to how you are perceived by customers. People don't appreciate sensing how badly you want to go home or to answer your mobile.

4. Teamwork

Owners and staff must work well together and be prepared to help each other out during busy times. Staff must be made to feel it's worth their while to go that extra mile, and that their efforts will be rewarded and acknowledged.

Greeting

You must of course begin by politely greeting each customer and meeting their eye. This might sound obvious, but it makes an enormous difference to how relaxed and welcome people feel. If all your sales staff are busy and a new customer walks in, it is important that you do not ignore the new customer, but say something simple like, 'Good morning. I won't be a moment. Please have a look round, or have a seat if you'd rather. And feel free to put your shopping bags down over here'. No one likes to be ignored, and a few friendly words do not amount to an off-putting hard sell.

When exchanging a few words with browsers it is generally considered best to avoid yes/no questions. For example, 'Are you looking for anything in particular?' or 'Can I help you?' can both result in a 'No', which puts a stop to any potentially useful discussion. Upbeat remarks such as, 'We've done brilliantly with those abstracts. Do you prefer the greens or the reds?' are more likely to be fruitful.

While it is important to acknowledge people who come into your shop, you do not want to be overbearing. If you sense that someone wants to be left alone to browse, all you should do is create an atmosphere whereby they feel happy to approach you when they feel ready.

Expertise

One of the main reasons why people shop with independent retailers is their perceived expertise and readiness to give advice. It is therefore important that you, or your staff, are prepared to take time with customers, and do not see this part of the selling process as an annoying interruption to the process of making frames or re-hanging the gallery. Time spent with customers needs to be built into your pricing system.

Expertise is where you really get the edge over the chain stores. The fact that you are probably involved in sourcing and buying your stock can be a great help here (chain store sales staff may know very little about the origins of the goods they sell).

A little anecdote and some personal detail may help clinch a sale. For example, share the exhilaration you felt upon first seeing colour-mixing being done by the potter who made the bowl your customer is deliberating over. This could be followed up by some brief details about the age-old techniques she uses and how these mean the colours

won't fade over time. It can be easier to sell work by artists and crafts-people whom you have met and got to know, as this makes these details and anecdotes easier to find.

You must be knowledgeable about the goods and services you are offering, and be confident that you can deliver what you say you will do. Beware of offering services that you or your staff do not fully understand, as promising things you cannot deliver may cost you dearly.

Be wary of sub-contracting work to people who you don't yet fully trust or know: your reputation will suffer if they do a bad job.

Price

You must not impose your own ideas about price onto the customer; this unimaginative approach can be counter-productive. People come from all sorts of cultural backgrounds and have wide-ranging tastes, values and priorities, which you can only understand and supply by listening carefully to your customers' responses to questions. Never make assumptions based on people's dress and conduct; experienced retailers have endless tales to tell about down-at-heel-looking people who have astonished them by choosing the most expensive picture in the gallery.

Always remember that one person's luxury might be another person's minimum requirement. You cannot pre-judge people's expectations of price. Try not to assume, even at a slightly sub-conscious level, 'Oh, she'll only be wanting a simple black frame', this assumption being based on age, dress or social skills. Start by offering, for example, the frame that will honestly best suit the artwork, regardless of price. You may be surprised and the customer may go for it, otherwise, when you notice the person hesitate, be sure to quickly put them at their ease and offer alternative, less expensive options. So long as you are polite and friendly you shouldn't lose the sale by offering a more costly option first. And if you start by offering something you sincerely believe will look great your enthusiasm may well be infectious and you are more likely to make a sale than if you are offering a boring old thin black frame, for which it may be hard for you to stir up much enthusiasm.

The hard sell and adding value

Retailers need to maximise the value of each sale, which should definitely not be the same thing as trying to hoodwink people into spending more than they want to, or selling them things they don't want. Suggesting that a customer upgrades to museum-quality glass, or a print with a hand-drawn cartouche in the margin, should be done in a friendly enthusiastic way, which allows the customer to say 'no' without feeling embarrassed. A customer who feels intimidated, embarrassed or pressurised may not shop with you again, whereas someone who has been shown a wide range of products and services should feel they have had a positive experience.

You must be sure that you and your staff fully understand the element of added value in more expensive products. Remember that you are not trying to get more money out of people for nothing if you are offering them a better level of service or a superior product. They are paying more for a tangible benefit.

Few of us are good enough salespeople to be able to effectively sell products that we don't believe in, or to ask prices that we know to be absurd. If you are asking high prices, your sales message needs to be absolutely clear about the added value that the customer is getting for the added cost. You should not be afraid to ask a high price for a high level of expertise, a rare product or a specialist service.

Rather than doing a 'hard sell' you need to be enthusiastically explaining a tangible benefit.

Ask three questions

You may have expert product knowledge, but you need to match this with knowledge of your customers' requirements. A good rule can be to ask three questions, which will help you match the product with the customer. For example, you might ask where the image is to be hung, the dominant colours in the room and what other artwork already hangs there. This will help you find something complementary and to provide a frame that offers the correct levels of protection.

Do not be afraid to ask questions; customers may think they know what they want, but may change their ideas if you make friendly informed suggestions. They may not be fully aware of the range of products that are available, and they may be grateful for the advice.

Dress

You must dress in a way that will make your customers feel at ease. Your style of dress also needs to reflect your USP and convey professionalism. If most of your customers wear suits and smart clothes, and you are trying to sell them mid- to top-end pictures, you should probably do the same. They are likely to take you more seriously than if you were wearing casual clothing.

However, if your customers mainly wear jeans and casual clothes they may find be-suited sales staff patronising or even archaic looking. A business suit may not be the right attire in which to sell contemporary art (unless the cut is particularly hip), any more than a shapeless tracksuit would be appropriate.

If you are a framer whose primary message is quality craftsmanship and a bespoke service, a smart apron with an organised array of tools in the front pocket might inspire confidence.

You need to find the balance between looking authoritative, and enabling your customers to relate to you and trust you.

Framing

When a customer unrolls artwork on your counter you should immediately say something polite about it. You don't need to sound over-effusive or insincere, but a friendly gently flattering comment can only be a good start. A compliment is particularly important when a customer unrolls needlework or other artwork that you suspect they have made themselves. You only need to casually remark, 'What a wonderful blue in that sky', or 'Matisse posters always bring a room to life'.

Anyone offering a professional framing service needs to have a good understanding of the different types of artwork, including needle crafts. Even if you are not selling, for example, etchings and woodcuts, you need to be able to identify these so that you can talk knowledgeably to customers and win their confidence, and also to enable you to offer the best advice on framing them.

Framers repeatedly allege that offering customers too much choice confuses them and can put them off making a choice at all. Many say that you should not offer more than three mouldings and three designs of mountboard. Begin by listening carefully to the customer's

requirements, then produce the three designs that seem most likely to match these.

When customers say 'I have no idea what would look right', you need to ask a few questions, and these must be related to design rather than price. Even if a customer says 'I've no idea what would look right, but I don't want to spend much,' don't automatically show your cheapest designs; people have very different ideas about what constitutes cheap and expensive. Once you've asked a few design questions, bring out chevrons in different price ranges and listen to the customer's response; if there's a sharp intake of breath at the most expensive, then move down the price scale. You must not, of course, make people embarrassed about choosing cheaper designs, just mentally eliminate certain choices.

The three questions you ask your customer (see above) will help you assess how conservative, or extrovert, the customer's tastes are. And remember that everyone likes talking about themselves, and answering questions about their home is an extension of this. At this point you do need to make some judgements about the customer's tastes: if they seem to be worried about making a mistake, steer them towards reassuringly safe designs; if their colour scheme is unusual offer hand-finishing; or if they seem to have original ideas, choose designs that are a little bit different.

As well as aesthetic choices, you need to guide the customer through technical ones. The Fine Art Trade Guild has devised Five Levels of Framing in order to help with this process; the levels range from Museum to Minimum and can be seen in full on the Guild website. The levels enable framers to justify their decisions to customers, which lends an authority to the decisions they make.

Before deciding which level of framing is appropriate you need to know if the artwork has sentimental or commercial value, and if it is to be preserved for future generations. If the answer to any of these questions is yes, then you should offer a minimum of conservation framing materials and techniques. See the section on framing in Chapter 9: Which services to offer (p.96) for a discussion of this concept.

Remember that specialist materials can add value to a sale; for example, it takes the same amount of time to cut and fit museum glass as ordinary float glass, but you can make more profit from museum glass. Once customers see the difference, and accept the superiority of the product, they are unlikely to quibble about the price difference.

Lending artwork overnight

Sometimes customers will not make a final decision about whether to buy artwork until they have seen it in position in their home, or maybe taking artwork to their house is the only way their partner will get to see it, and they won't buy it without their partner's agreement.

Many gallery owners are happy to lend artwork overnight and find that this is very likely to result in a sale. Once they have seen it in position, people may be reluctant to part with a picture or object. They begin to feel ownership the moment the item is in their home. They may also be flattered that the gallery is prepared to go to so much trouble for them, and appreciate your trust.

Home visits are a good opportunity for the gallery owner to see a customer's home and further understand their taste and requirements. Customers often use the opportunity to point out places that need a picture or sculpture, or artwork that needs re-framing. This service can differentiate you from your competitors, but make sure that you advertise the service properly to gain the advantage.

If you are lending artwork you need to insure it while it is in a customer's home and in transit. Specialist art and framing insurance polices should cover this. It may be necessary to ask a few basic questions about your customer's security, so check your policy and be aware of your responsibilities.

Compiling and using your customer database

Galleries have long devoted considerable energy to keeping records of customers' requirements and contacting them when the appropriate stock arrives. This task has of course been made much easier with the advent of sortable databases and the ability to email images of artwork as JPEGS.

It is essential to invite, for example, people who have bought wildlife art to wildlife exhibitions. The same obviously goes for people who collect a particular artist's work. You may want to target all the people who brought in needlework for framing and offer them a special discount, to stir up business during quiet periods. Or for your pre-Christmas exhibition, you may want to send a fat catalogue to key customers and an inexpensive flier to people with whom you haven't had contact for over two years.

It is equally important to collect details of potential customers and their interests. You can then target them with marketing initiatives and focus on converting them into customers.

Many galleries find that customers react well to more personal approaches, such as an email or letter containing an image of new artwork. People like being treated as individuals, rather than receiving generic group mailings. They may be flattered to know that they are being offered the artwork first, and a polite reminder that it will be necessary to show it to a wider selection of customers after a certain date can help the buyer make up their mind. This approach makes buying artwork very easy for a busy customer, and even eliminates the need to choose between several items.

In order to use this method of selling effectively you need to be meticulous about capturing the relevant information about your customers, and potential customers. A visitors' book in the gallery works well for many, with a section where people can note what they collect or are looking for.

You should regularly update each person's record, with notes of dates they visited the gallery, exhibitions they came to and interests they expressed, how they first heard of you, as well as what they actually bought and on what date. You also need to note their gender, approximate age and any information about their habits, the shops they frequent and their jobs.

This information will help you to build up a profile of your best customers and what they are looking for. You can then target your marketing accordingly.

You must ensure that your database, and the uses you put it to, comply with the Data Protection Act 1998. One of its rules is that you must delete people from your mailing list if they ask you to do so. They also have the right to know what information you hold about them. The Information Commissioner's Office is the government agency responsible for making sure that personal information is not misused; you can see the rules in full at *www.ico.gov.uk*.

There are database packages available for small businesses, many of which should fulfil all your requirements. What you are looking for is called CRM software in the computer industry, which stands for

Customer Relations Management. Your database should integrate and be compatible with your invoicing and accounting software (though not all small retailers use this).

There is software specifically for the art and framing industry, which is nearly always designed by a framer and retailer with an interest in IT. This type of software normally includes a frame pricing program. Look on the Fine Art Trade Guild website for contacts.

If you employ a company or IT person to manage your IT, it may be part of the package for them to analyse your database and highlight emerging trends and a profile of your key customer types. However, most owners of art and framing retail businesses end up doing this themselves.

Once you have developed a clear idea about who your key customers are you might consider buying a mailing list. A quick Google search should reveal brokers who hold lists that include your target customer. It is cheapest to buy a list for one-off use, which means that you can only re-contact people who have responded to you.

You must 'clean' your database regularly. There is no quick way of doing this, you just have to update your records every time post is 'returned to sender' or emails bounce back, and be meticulous in asking customers to confirm their details.

Your database should allow you to group together people who have not responded to any marketing or visited you for a set period of time, such as three years, and remove them from most mailings. Some businesses send such people a pre-paid postcard asking them if they still want to remain on your mailing list, but the problem is that it may well be the 'timewasters' who say they do want to stay.

Mistakes

Everyone makes mistakes occasionally, whether it is accidentally damaging customers' artwork or not being able to fulfil an order. The essential thing is to handle such situations professionally. If you make a mistake and then apologise sincerely and immediately set about rectifying the situation, or compensating for it, you can even strengthen the bond between you and your customer. You should only lose the customer if you are evasive, lie or handle the problem badly.

People do not always expect others to admit responsibility for problems, and doing so can considerably increase their respect for you. Having admitted culpability, you should move straight on to how to resolve the situation, rather than dwelling on the hows and whys of what has already happened. Try saying 'What can we do to make up for this problem?'; very often the customer will suggest something far smaller than you were prepared to offer.

Framers who fail to train properly do their customers and their industry a disservice. Framers who are trained to Guild Commended Framer standards will not damage customers' artwork through ignorance.

Chapter 16

Effective layout and display

Refurbishment, shop furniture and display equipment are often by far the largest overhead for a new retailer. And you can of course spend any amount of money on these items; for example, you can buy an artist's easel for under £20 or a Victorian oak one for several hundred pounds. The same variation applies to flooring, chairs, counter tops and lighting.

Bear in mind that there are guidelines for shop design, but that in retail design (as in any other discipline) the most interesting results can be achieved when the rules are treated creatively, and maybe bent slightly.

You need to begin by deciding what impression you want to convey, which is in turn decided by the look that your target customer would most relate to. Once you have got this idea firmly lodged in your mind, you can allocate resources and prioritise certain aspects of your fixtures and fittings.

If you are planning to sell 'edgy' contemporary art to youngish buyers in an urban area, your shop would of course need to look very different to one selling equestrian and sporting art to conservative couples in the country. You may want to create the feel of a Florentine gilding atelier, or emphasise the highly contemporary things you can do with moulded Perspex and chrome.

Galleries are often accused of being intimidating environments, with

retailers selling inexpensive art sometimes preferring the term 'art shop' to gallery. Such retailers strive to make their shops feel accessible to all, and often use inexpensive items such as greeting cards and gift stationery to draw people into the shop. The idea is to turn them into art buyers once they have overcome their initial concern about stepping into a 'gallery'.

If you are selling top-end art your shop needs to convey exclusivity and quality, which may create an intimidating environment, yet it is partly the idea of sharing in this exclusivity and luxury that appeals to buyers.

The important thing is to be absolutely clear which type of outlet you want to create. It may only take a few seconds to walk or drive past your shop, so the first impression of your business that is created by your shop design needs to speak volumes.

Shop design: some guidelines

There are no hard-and-fast rules about the most effective way to lay-out a retail space, but below are some pointers that might help independent retailers.

1. Shop fittings

Choosing shop fittings is a minefield. Art and framing retailers need to look at equipment such as sculpture plinths, gift cabinets, racks for ready-made frames and greeting card spinners. The main thing is to keep the look consistent; too many styles and materials end up looking like a jumble sale. You should avoid too many units; customers need to be able to flow through the shop. If you like a display stand that comes free from a supplier, then use it, but you must reject it if it jars visually, and come up with something more suitable yourself.

2. Maximising wall space

Some galleries maximise all-important wall space by installing 'concertina walls' or short display walls or screens jutting out into the gallery. This idea also breaks up the space and adds interest: a rectangular gallery can look dull and samey. Breaking up the space with additional walls also allows you to theme areas of the gallery, making it easier for customers to skip areas of no interest and move straight to products they like.

There are excellent picture hanging systems for galleries, that enable an ever-changing variety of pictures to be exhibited with minimal fuss.

3. Eye level

Remember that pictures hung at eye level, and other merchandise displayed at this height, is the most likely to catch customers' attention. Try not to fall into the common trap of hanging pictures too high, particularly if you yourself are six foot tall or more. Similarly, cards at eye level on a spinner will attract attention, so display your most attention-grabbing designs at this height; if customers stop to look at these, and like them, they will then browse downwards. The same applies to gifts in cabinets, art materials on racks and other merchandise. A few feet up and down from your imaginary 'eye level line' are the most important display areas.

4. Quantity

It is tempting to pack as much into your retail space as possible, but this can overwhelm customers and make it hard for them to come to a decision. It can be more effective to display less, but well-chosen items, to their best advantage. If there is less on display, it is more likely that staff will need to interact with customers, which gives them a chance to find out about the customer's requirements.

5. Grouping and props

How you group items together is very important. Bear in mind that certain paintings work because the artist has grouped together an aesthetically pleasing array of shapes (abstract designs) or household items (still lifes), which shows that composition and shape have powerful potential to attract people. This is as true in shop design as in the artwork itself.

Items on display should be grouped together and organised into a shape or outline that is easy to look at. Within this shape there should be gradual variations in height; boxes covered in decorative paper or material (velvet, wrapping paper, felt or wallpaper) can be useful here. Clear plastic display cubes can look good in a modern gallery; these are very versatile and can be stacked and grouped into different arrangements.

Products can be stacked, suspended from the ceiling or lent against each other: the limit is your imagination. It is a question of your personal vision for your shop whether you want neatly organised displays, or a more spontaneous look.

Some gift shops use hampers and baskets in their displays, from which an abundance of goods can flow out enticingly. If you sell items such as bowls or even decorative waste paper baskets, these can usefully be filled with smaller items such as Christmas decorations.

Remember to tidy your displays regularly. They can start to look messy very quickly, particularly when customers are handling the goods and removing them to buy them. Gaps never look good and must be quickly filled with new stock.

6. Colours and themes

Think about the impact of colour and let it form part of your theme. Colours can be grouped into bright, subtle, neutral and so on.

Themes may be seasonal, such as the seaside in summer and Valentine's day in February. You can go for a look or feel, rather than trying to create a precise scene. You can gather sand for summer displays, leaves for autumn ones and berries and pinecones in winter. Spray-on snow works well in winter, perhaps to complement displays of bright white, silver and shiny goods. Christmas decorations can be suspended on nylon thread, along with white candles and sparkly white papers.

7. Changing your displays

All displays must be changed regularly, to give the impression of a lively, vibrant shop that is successfully selling a lot of stock. Window displays need to be changed most frequently, so they can work to entice the widest possible range of passers by.

It may be good discipline to change all displays every three to four weeks, with key pictures changed round every few days. This is a good way of bringing the things that you want to sell most to customers' attention; this may be high-margin stock or slow-movers that need help in selling. Remember that fragile textiles and works on paper may suffer if left in bright light for too long, so should be moved round for conservation reasons.

8. Music

Music can play an important role in creating a particular atmosphere, so think carefully about your choice of music, or whether to have music playing at all. Music must not be so loud as to prevent you talking to customers, and the sound quality must be good: a crackly radio might irritate people and drive them out. Needless to say, music must be chosen to reflect the tastes of your target customer. If you will be playing music you need to hold a Public Performance License; tariffs vary according to usage and information is available on the Performing Rights Society website (*www.mcps-prs-alliance.co.uk*).

9. The sales desk

Too many retailers have messy sales desks, which of course creates a bad impression. Mountboard samples, leaflets, details of special offers and such like must be neatly displayed, and there should not be too many of these. Organisation is essential: it is all too easy to clutter up the working area, so this needs constant vigilance. Every tool and item of stationery must have its proper place.

Low-cost items such as cards, photo frames and stationery can be displayed by the sales desk to encourage impulse purchasing. Grouping is vital when displaying these: keep them together, they lose impact when they are dotted about.

10. Discounted stock

Some retailers have a dedicated area for discounted stock, so that regulars know where to find reduced items. Galleries tend to use discreet signage to indicate the discount browser, as bright 'sale!' signs do not match their stylish ambience. Some opt for a 'reduced' sticker across the corner of framed images.

11. Consider the needs of your clientele

If you are near a school, or young families come in, then distractions for the young may be a good idea. Don't let toys drift into too large an area, designate a space such as a table for them. Plan and monitor such efforts and don't carry on with the idea unless you can see that it really is helping promote sales.

Similarly, chairs for people to rest on might be a good idea and can even contribute to a homely look and help show people what the artwork might look like in their homes. Chilled water dispensers are

becoming increasingly fashionable and can convey the right message.

All of these things are designed to make customers feel positive about the experience of shopping with you, which should encourage sales and customer loyalty. The downside can be that such comforts encourage time-wasters, so they need monitoring.

The outside of your shop

Needless to say, this should be clean and smart. Windows must be cleaned regularly, rubbish cleared from in front of the shop and your canopy must not be covered in bird droppings. Your lettering and shop logo must be clean and fresh looking and you must not let the paint start to peel off, which can happen at the end of summer, giving a very down-at-heel impression.

A canopy is generally a good idea for galleries, depending upon location and local planning restrictions. You must check the latter. A canopy can help prevent artwork on paper fading in the sunlight, and can be pushed back to maximise daylight on less sunny days.

An A-board outside the gallery can help attract customers, but this too may be subject to local planning regulations. The effectiveness of this would depend upon your exact location. If the pavement is narrow, it might annoy more people than it alerted to your presence.

Lighting

The right lighting can be the factor which attracts customers into your gallery in the first place, albeit subconsciously. Lighting plays a significant role in creating atmosphere, so must be used to its full advantage. There is no question that well lit artwork looks more appealing than poorly lit products, and that lighting can make or break a gallery space.

Bear in mind that the light level on a miserable day in winter is often 25 times less than on a summer's day. The right lighting should ensure that your merchandise looks as enticing on a dreary day with deadening daylight, as it does on a bright summer's day.

Many galleries favour directional lighting spots on tracks that can be moved to give flexibility. The most important element of any good lighting system is flexibility.

Many spaces are lit only from the ceiling. You should consider combining ceiling lights with low-level floor-mounted lighting, which increases flexibility and dramatic potential. Wall-mounted lights can be used to good effect, but are not really an option for most galleries, who need all the valuable wall-space available and maximum flexibility of use.

Filters that can change the focus of the beam of light, soften its colour and make displays look more interesting can be used to good effect. Filters can elongate the beam, change its shape and intensity, alter the colour temperature of white light and bring cohesion to a display. Good commercial lights should come with a wide variety of attachments for re-focusing and re-arranging displays. For example, a 'framing attachment' creates a perfect square or rectangle of light, which can provide extremely dramatic impact. You should be able to switch from a large soft beam to a sharper narrow beam when appropriate.

Coloured lights are not recommended in galleries as they alter colours, and people want to see the exact colours in the artwork. Even though coloured filters can enhance colours and designs, they would be counter-productive in a gallery.

Dark and uninteresting corners, such as walls by staircases, can feature a fixed spotlight to bring up the level of lighting and prevent them from becoming 'dead' display areas.

It might sound obvious, but busy retailers can overlook important details: it is essential that bulbs are changed the instant they stop working. Lighting should not be wasted by shining onto empty walls, or be left shining onto the pavement. Make sure that your spots are properly directed each time you move stock around. Each display, hanging picture or print browser should be emphasised with good direct lighting.

Consider keeping your lights on after you've closed, particularly if you are in an area with a lot of restaurants and night life. You can always use a timer so they go off when the local restaurants close.

Bear in mind that lighting companies offer free advice on lighting. You need to consider such factors as 'colour temperature', which a good lighting company should discuss with you. A light source with a high proportion of blue will appear cold, whereas a high proportion of yellow will appear warm. Find out which type of light would best suit the dimensions of your gallery space, the levels of natural light and the type of artwork on display.

It is best to work backwards – light each display first and then add supplementary light if necessary. The choice of lighting will often be determined by the style and size of work on display. For example, large canvases may be best displayed with wide beam units at a reasonable distance, while groups of smaller images can be lit softly with an overall wash and then highlighted separately with a narrow beam unit. Try moving the narrow beam of light around and see how it helps to sell artwork. To provide dramatic effects, such as for a night-time window display or a private view, narrow beams of light on selected pictures can be very effective.

Some form of control of daylight is recommended, such as blinds, so that in the summer the gallery maintains an inviting atmosphere that is not too bright, and shafts of sunlight can be allowed to create their own special ambience. In winter, the blinds can be opened to allow in whatever feeble light is available, or drawn, allowing the artificial light to work more effectively, adding drama and interest.

Window displays

It is often said that you have three seconds to grab people's attention and make them decide to come into your shop, which means that the quality of your window display is critical. And imagination is much more important than money when it comes to creating a powerful window.

Windows and fascias are the face of your business and, as we all know, first impressions count. Inadequate planning and layout will create a dull area in what should be a key focal point for your business. A miscellaneous assortment of pictures, frame chevrons and oddments will not help your business at all.

If people stop and look at your window because they are attracted or intrigued, they may well come in and buy something. But even if they don't on that occasion, they should remember your shop and may even mention it to their friends.

There are certain problems that confront gallery owners when planning their windows. Pictures tend to vary in theme and colour, making it hard to form coherent groups. Many window areas have no walls, making it hard to display pictures, and it can be difficult to think how to utilise the floor area. On top of which, pictures are nearly all flat, rigid and rectangular so you don't have much variation in shape.

It would be misleading to lay down a set of foolproof rules to assist in the dressing of the perfect window display. Rules, especially in artistic endeavours like display and presentation, are made to be broken. And in our cultural climate of 'anything goes', this is more the case than ever. There are, however, some classic layouts and techniques for grouping objects and working to a theme that can pretty much guarantee success. Your window display must mirror the effect created by the gallery interior; customers who are drawn into a shop by the window display want to see more of the same inside.

Start by keeping it simple. Forget about being too arty-crafty and cut out elaborate ideas about props. Let your ideas develop over time as you see what seems to make people stop and look, but focus on the essentials at the beginning.

1. Quality control

Remember that your window is designed to sell specific products, but also your services and expertise generally. It is therefore very important that any frames on display are flawless, and all products in the window are examples of your finest stock. Never use your window to try to shift old or damaged goods. While this may work in the short-term, in the long-term it is a self-defeating tactic. Your display should inspire the customer's imagination.

Your window must be clean, inside and out, and must be free of dead insects and dust. This might sound obvious, but is easily overlooked at busy times.

Too many stickers and posters look tacky and detract from your main message, so only display the most important ones. Your opening times must be clearly displayed, along with your web address and telephone number. It is a good idea for this information to be clearly visible from the road, so that people driving by can quickly see when you are open and how to contact you.

You will regularly be asked to display posters for local events and charities; display these sparingly, and only if you really feel that doing so would be good for your reputation. Lots of badly-produced posters and fliers in your window will not convey a good message to customers. A trade association logo can inspire confidence, as will the Guild Commended Framer logo, the sign of a professionally qualified framer.

2. Light

Good lighting is essential; light and colour are the two most important ingredients in any window. Ensure that items and groups of items are properly spotlit, and don't forget to move the lights when you change the window.

Track lighting generally does the job, either attached to the ceiling, floor or sides of your window. Lights should be bright, but not dazzling, and avoid fluorescent strip lights as all but the most sophisticated cast a rather dead light.

Lightbulbs must be changed immediately and your windows should be lit 24 hours a day.

3. Grouping and structure

You can choose a symmetrical or asymmetrical layout. It is harder to achieve a visual balance with the latter, but the results can be more interesting. Avoid placing anything dead centre as this breaks your space into two equal halves and subsequent placements are made more difficult. Remember to place your most important images at eye level from the pavement (it is easy to forget this if your window has a high or low floor).

Don't fill every corner or be afraid of overlapping if pictures are suspended at different heights and depths. Remember that when people walk by they see things from several different angles, so be sure to use the side walls of your window.

Give height to small frames and objects by placing them on tables or display blocks; small table-top easels can be useful here.

Think creatively about ways in which you can arrange and position the items you want to display. For example, an open trunk with pictures emerging out of it could be effective; aluminium step ladders might make good display stands for a contemporary display; whole branches of trees could be used to display a range of decorated and coloured mounts. The limit is your imagination.

Be aware of the power of space around your products. This can emphasise their importance and draw the eye to them.

4. The floor and background

Don't let the floor be a messy afterthought. Items should be displayed in one or two clear groups that tie in with the main display.

Publishers' catalogues can be left open on the floor, slightly propped up at the back. This helps give passers-by an idea of the scope of the range of work they can obtain through your gallery.

Panels and screens can take pictures on both sides and are versatile and portable. Most framers could make their own screens from MDF, which can then be painted or covered to blend it with the décor.

Blinds can be used behind your window display; this technique is particularly effective if your window is open to the rest of the gallery. They can be pulled down to varying heights to delineate where the window display ends.

Screens or simple gauze-like sheer fabrics can be dropped as large banners to make a soft light-admitting foil for your display. Soft furnishing shops carry huge stocks of organzas and voiles in every shade imaginable, including striking metallics.

5. Themes and schemes

Simple ideas can work really well, such as just picking out a colour. Remember that colour and light are the two most important aspects of any window display. Regularly re-painting your window and display equipment can create a whole new look. Try working to a given colour scheme such as blue, turquoise and green, or red with black and white.

Natural objects such as sand, pebbles, driftwood, wheat, twigs, branches, leaves, cow parsley and such like can add texture, mood and interest if properly controlled.

If you are having an exhibition of an artist's work, try re-creating certain hallmark aspects of the artist's work in 3D. It needn't take long to cut out an MDF shape and paint it, particularly if you've got framing equipment on the premises. Transforming your window into a '3D painting' is eye-catching and not as hard as it may sound.

Moving displays always catch the eye, such as revolving display stands and flashing lights. A flatscreen in the window with a slideshow of

some of the frames you have made can be highly effective. But always remember that if your window is a stage, your frames and pictures are your leading players. The setting and scenery must play a supporting role, and shouldn't be allowed to dominate.

6. Choosing the right artwork

Bold striking abstracts and stylised works make their point quickly, so can be effective at grabbing the attention of people passing by quickly, such as in cars. Delicate detailed pictures need to be studied at close range, so are not ideal subject matter for window displays that will be seen by people from the distance of their cars.

7. Changing your display

It is essential that your window display is changed regularly; you need to ensure that this space is made to work for you to its fullest extent. Passers-by need to see the widest possible range of stock and a changing display gives the impression of a vibrant, interesting business. Also, delicate works on paper may be damaged if left in bright sunlight for too long. Window displays should be changed at least once a week, as many people walk past several times a day; changing the main pictures or focus in a window every day can be a good idea, and this creates an impression of a vibrant business with goods constantly moving in and out.

8. Paying a window dresser

Some independent retailers choose to pay window dressers, while others enjoy handling this job themselves. Many people who work as picture framers are also artists, so have the flair and sense of design to create windows for their employers. Some retailers might find it worth paying a window dresser up to a maximum of around £1500 to create their Christmas windows, but do others themselves. Recognising your skills and which ones you need to buy in is crucial to optimising the effectiveness of your business.

Point of sale

The term 'point of sale material' refers to graphics, signage, leaflets and other literature that encourages people to buy. Point of sale is designed to make customers stop and look, to help them locate what they are looking for and to reinforce a business's image. You may offer the best

framing service in town, but you will only be successful if you ensure that people know about it, which is where point of sale comes in.

Think carefully about your point of sale message; you don't want to crowd the shop with signs and leaflets that will confuse the customer and look messy. Too much signage may mean that none of it will be read or taken in.

Don't just pile leaflets haphazardly on the counter; if they are worth displaying at all, they need to be in proper dispensers. Leaflets should only be used for a well-defined purpose, and too many of them just clutter the workspace. They can provide good back-up when a customer is making a considered purchase, and requires more information and time to think.

Below are some of the most popular point of sale ideas used by framers and galleries:

1. Trade association membership

Reassure customers that you are a professional by advertising your status as a current Fine Art Trade Guild member who abides by a strict code of ethics. The Guild supplies a range of point of sale material including window stickers, a certificate written by a calligrapher and a range of consumer leaflets including one about its code of ethics.

2. Company information

Many retailers print short leaflets about their business for customers to take away, and for staff to put in shopping bags. Others favour bookmarks or postcards branded with the shop details. The labels that are stuck to the backs of frames and the bottom of some gifts complement this activity.

3. Awards and qualifications

These help convince customers they have come to the right place, and might include copies of press coverage, certificates, window stickers or trophies. Be sure to make the most of any opportunities. For example, if your framer has just qualified as a Guild Commended Framer (see the section on framing in Chapter 9: Which services to offer on p.96) make sure that you obtain all available point of sale material from the Fine Art Trade Guild; customers need to be made

immediately aware that they are in a professional establishment and that their artwork will be safe there. If you have won an award, or an artist whose work you stock has done so, makes sure that you have point of sale material letting people know of this achievement.

4. Information leaflets

These range from advice about caring for your framed artwork, an explanation of the advantages of conservation framing, or descriptions of the different printmaking processes. The Fine Art Trade Guild produces a range of leaflets that are designed to be personalised with retailers' own details.

5. Samples of framed items

Nothing sells your superior framing skills and full range of framing options as well as a good display of high quality framed artwork and objects. See the section on 'Framing' below.

6. Suppliers' publicity material

Some print publishers and other suppliers produce point of sale material for their retail customers to give out. Art materials suppliers sometimes provide a range of graphics to accompany their ranges.

7. Print catalogues

Publishers' catalogues can be left for customers to browse through, to show that you can provide a much wider range than is currently on display. Catalogues should be displayed neatly, and remember that too many of them equals too much choice, which may put people off. Keep extra catalogues hidden and produce them when necessary. Print catalogues are often also available on DVD.

8. Books

Books featuring an artist's work help convey the idea that the artist is collectable and successful.

9. Sale and discount notices

See Chapter 14: Sales and discounting (p.154) for a discussion on the different ways retailers tell customers that certain items are discounted, and make them aware of special offers.

10. Exhibition posters and lettering

A3 posters advertising exhibitions are often put in windows, either before or during a show. Galleries sometimes put lettering on the inside of their windows advertising current exhibitions.

Displaying pictures

1. Pile 'em high

There are galleries that seek to create an accessible environment by stacking pictures on the floor, on windowsills and on chairs. They deliberately pack as many pictures on the walls as possible. They want customers to feel happy to browse, and this casual method of display implies that the work is affordable to their target customer. People are likely to stay longer in a shop with a lot of merchandise on display, which may increase the chances of them buying something. And they may feel that they have unearthed a bargain if they find a picture at the back of an awkwardly positioned stack. But remember that too much choice can put off some buyers altogether.

2. Making each item seem special

Galleries seeking to convey the idea that each piece of artwork has been carefully selected and presented will inevitably have less work on show, and each piece will be hung and lit to its best advantage.

Ideally, pictures 'need room to breathe' which means there must be sufficient space between them to allow customers to focus on one image at a time. Pictures that are crowded together do not look their best, particularly if they are very different in style. It may be best to discipline yourself to hang a small selection of pictures properly, then put the rest in browsers, rather than to hang too many in a way which does not do them justice.

3. Grouping pictures

Tightly hung groups of pictures can make a bold statement, though this technique only works if the images complement each other. You need to be sure that the images do not conflict, or that some do not totally dominate the others, making them appear washed out and nondescript. Ideally each tightly-hung group should be surrounded by space for the images to breathe.

Pictures can be grouped according to price, colour, style or subject matter. It doesn't matter which way you group the images so long as there is some element of unity to help the customer make a choice. Your aim is to make it as easy as possible for customers to find what they are looking for.

If you are primarily selling inexpensive wall décor, then grouping pictures according to colour and price might work best: customers are probably looking for something to decorate a specific spot, and the general feel of the image may be more important than the subject matter. However, a gallery selling sporting art would need to group according to subject matter (customer requirements tend to be specific; someone looking for rugby images wouldn't want to have to look through a whole lot of cricketing art).

It can be easiest to begin by clearing your display wall, then visualise an area within the space, maybe a large square, rectangle or vague circle. Then place the largest picture at the heart of the imagined area, with the rest arranged around it in order or size.

You should follow the feel of the picture when hanging. For example, if you are hanging a group of ordered abstracts you might follow the lines of the images in your display. Images of a more ebullient, wild nature would lend themselves to a more spontaneous-looking display.

If your pictures are of very different sizes it may not look good to attempt to align them either top or bottom. Your imagined shape should provide sufficient structure to your display. It can work better to align pictures according to your imaginary eye level line, making sure that this line runs through the centre of each picture (where possible). Some people like symmetry, while others prefer a more random look.

4. Browsers and unframed artwork

Many galleries use poster browsers to display art on paper and unframed work. Sometimes work that is less expensive than that on the walls is displayed in browsers; for example, originals may be framed on the walls, while prints are unframed in browsers. The most popular type of print browser is the floor-standing cradle type, which is filled with prints in sleeves. These are available in a range of styles, from tubular aluminium to hand-crafted wood. Sleeves can be leather-bound or plain plastic.

Wall-mounted print display modules work best for shops selling inexpensive artwork, as galleries selling expensive work tend to want to keep their walls free for hanging exhibitions, and do not want the gallery to be dominated by unframed prints and posters.

Some print publishers supply artwork mounted and shrink-wrapped, which can be displayed in a browser without the use of additional sleeves. Even retailers who do their own framing may choose to buy some ready-mounted artwork; publishers mount work in volume so can offer attractive prices. Less expensive prints are sometimes provided shrink-wrapped with a cardboard backing ready for immediate display.

5. Hanging systems

Most galleries are fitted with some kind of picture hanging system, as it would be impractical to keep banging holes in the walls. However, some top-end gallery owners feel that pictures look best when hung from a hook as they would be in someone's home, so they use this method and fill and re-decorate as necessary.

A picture hanging system involves a metal rail around the top of the gallery, then rods or cords with picture hooks are suspended from this rail. Square-section metal rods used to be the norm, though a range of white and clear plastic rods and cords is now available as well.

Security hooks are a deterrent against shoplifting and accidents; these lock the picture onto the rod by clipping onto the wire at the back of the picture.

Some galleries favour all-in-one lighting and picture hanging systems which look neat and fit discreetly along the top of the walls.

6. Easels

Easels are of course a good option for displaying pictures. Easels can be used to maximise the amount of pictures you can display, and they can visually break up a gallery space that is looking a bit stark with just pictures on the walls. Easels are available in a wide range of sizes, including small counter-top ones. They are also made in traditional woods and modern metals, with a range of designs to complement different styles of gallery.

Framing

1. Chevrons

All framers need to display their moulding chevrons. Too large a display can be bewildering, and few framers have the space for this. Your core lines need to be clearly visible, while others can be stored in drawers if necessary. Most framers use Velcro to attach their chevrons to panels which they cover in Velcro fabric; they can be easily removed and placed around customers' artwork. Ensure that you use a strong complementary colour behind your chevrons. Some framing suppliers provide customers with chevrons.

2. Mountboard

Mountboard corners can be displayed on the countertop in a box. Manufacturers often provide swatch charts, which are a useful guide, but corners are invaluable as they can be placed around the artwork along with the moulding chevron. Some manufacturers also provide mountboard corners. If you provide mount decoration, you should of course decorate some corners in typical styles.

3. Glazing

Specialist glazing can be a good profit centre. While its benefits can be complicated to explain, visual displays can speak a thousand words. A piece of artwork framed with strips of three different types of glazing works well; it is easy to see how much better the part framed with 'invisible glass' looks. Glazing suppliers may provide point-of-sale displays. It is a good idea to display this sample rather than keep it in a drawer, so it can attract people's attention while they are browsing or waiting.

4. Samples

Wall space is an issue for many framers, particularly those who also sell artwork. However, many find that hanging examples of framed work on the shop wall can generate business. For example, if people see a frame containing a wedding invitation, posy, champagne cork and swatch of dress fabric they might be inspired to bring in their own memorabilia, whereas the idea wouldn't have occurred to them if they hadn't seen the display.

The list of objects that people get framed would fill a book, but among the most popular are sports shirts and accessories, and babies' bootees and christening gowns. It may well be worth your while to display some samples of such 3D frames. The samples on display should be varied according to the season, for example, cricket memorabilia in summer and football in winter. Local cultural trends may also influence your choice of display; if you are on the 'Jurassic coast' in Dorset framed fossils might stir up business, while a display of framed fishing flies might do the trick if you are based near a popular river. Any display of unusual objects that have been attractively framed can inspire people to bring in their own collection or souvenirs.

Framed children's pictures can suggest to people that framing is not just for visually sophisticated or valuable items, but that any item which means something to you is suitable for framing.

Some framers display the same image framed in various different ways, which shows customers what a difference a frame can make. This type of display shows that frames can be used to 'link' artwork to a room and to bring out different colours and aspects of the artwork.

Some framers find that a breakdown of a frame is a talking point and helps customers understand what is involved in making a frame. This cross-section generally features explanations about each component, with each 'layer' cut back to reveal the next. Glass cut with a wavy edge is visually effective

Help from suppliers

Suppliers often provide display equipment, though this might come with strings attached, such as an undertaking to stock the full range and not to use the equipment to display anyone else's products. Greeting card publishers often provide spinners, some print publishers provide browsers and other display units, and art materials manufacturers may provide display shelving.

Equipment provided by suppliers may be branded with the supplier's name and logo. This can be useful if customers are seeking a particular brand, which is often the case with art materials, but it can detract from your own branding in other circumstances.

Displaying prices

Discount stores tend to display their prices in their window and prominently inside the shop, as their low prices are the main reason people shop with them. Conversely, top-end art galleries often do not display prices at all, because they want to engage people in conversation about price and are worried that if they see a price tag without guidance from gallery staff they might be frightened away. Some people dislike this technique and feel that if the prices were reasonable the gallery need not be afraid to display them, so this practice might alienate some customers. If prices are not clearly displayed people are more likely to presume that they are negotiable, which is, in fact, often the case with expensive works of art.

When running special offers or discounts, prices should be displayed prominently. This will hopefully encourage people to buy and reinforce the idea that they are getting a bargain. People who are attracted by bargains are motivated by price, so this message should be loud and clear.

Computers for display

1. Slideshows

Most retailers have a problem with choosing which items to display most prominently, when they firmly believe in the quality of their whole range of products and services. Computer-generated slideshows can help to solve this problem. A monitor in the corner of the workshop can be used for a slideshow of interesting framing projects or artwork that is available but not currently on show. Images tend to look good on screen as they are lit from the back, which gives them life and accentuates colours.

Moving and changing displays attract browsers and make people stop and look. Framers wanting to adopt this idea need to be disciplined about taking digital photographs of interesting work (such images can be a useful sales aid as they can show customers what their artwork might look like in a particular frame).
A flat screen featuring a moving slide show and placed in the window can be effective in stopping passers by, so may help increase footfall.

2. Visual display software

Visual display software allows framers to quickly scan customers' artwork and then show what it would look like in a range of frame and mount designs. This technique can be authoritative and help customers reach quick decisions.

Cards, art materials and impulse buys

Many retailers adhere to the well-established idea that inexpensive items will sell as impulse buys if they are positioned by the counter. This is therefore where you would usually put spinners of cards, gift stationery and small ready-framed prints.

If you have a reputation for a particular product, maybe art materials or a good range of upmarket cards, it can be a good idea to position these lines at the back of the shop. Customers will then need to walk past the rest of your range to find the products they seek, and may be attracted to buy something else on the way

Chapter 17

Employing staff

Small business owners often find it hard to delegate as their business-
es are such personal projects. However, there are only so many hours
in a day and if you want to maintain a balance between life and work
there comes a time when it is sensible to delegate to an employee.

You need to consider which tasks you do best and which could better
be delegated, in order that you can focus on your strengths. If you
don't start to delegate you may be drawing a manager's salary for
doing routine tasks, which doesn't make business sense.

Many owners of small retailers find that they are the most effective at
selling, as it is very much in their interests to 'add value' to each sale.
They are also the most confident at talking with customers and
explaining the advantages of, for example, conservation framing.
Many therefore delegate framing and administration before they take
on sales staff. They do not have too much trouble finding arty people
who can be trained to make creative frames, and are happy to do so
at a relatively low salary; such employees are often artists who benefit
from the opportunity to frame their own work after hours, and derive
job satisfaction from working in an arty environment.

A survey by *Art Business Today* shows that a third of art and framing
businesses do not employ anyone other than the owners, which leaves two

thirds who have taken on staff. Only 11 per cent of the industry's retailers employ more than six people, with most employing just one or two.

Employee profiles

The largest group of art and framing employees are female part-timers, who account for 37 per cent of all employees. A total of 46 per cent of employees of both sexes are part-time.

People of all ages are employed in art and framing retail, including nearly a quarter of employees who are over 50. The sector seems happy to employ semi-retired people and 'empty nesters' on a part-time basis. 11 per cent of employees are under 20, who are generally part-timers working at weekends and during peak times such as the run up to Christmas.

Many art and framing retailers delegate framing: 38 per cent of those who employ people take on general framers, with a further eight per cent employing skilled specialist framers (gilders, frame restorers etc).

Only 12 per cent of businesses employ gallery managers, as in most cases the owners fulfil this role.

Hiring staff

1. Where to advertise

Most art and framing employees find their jobs through word of mouth recommendation. Employers prefer to take on framers with no previous framing experience, as they want to train staff to frame using their own favoured techniques. It is because employers are generally looking for relatively unskilled staff that new people can often be found among the network of friends of existing staff and the owners. It should be noted, however, that this practice does not comply with Equal Opportunities legislation, and may not secure the best calibre of candidate.

The next most popular way of finding staff is to put a notice in the shop window; a quarter of art and framing employees find their jobs this way. This method too is most likely to work where relatively unskilled staff are required.

Trade press advertising is used by a small minority as the best way of finding skilled employees. (Classified advertisements in *Art Business Today* and its online classified pages are an excellent way of finding qualified Guild Commended Framers).

20 per cent of businesses find their staff via local newspaper advertisements and 14 per cent use employment agencies.

2. Interviewing

Let the candidate do the talking; a common mistake is to spend too much time talking yourself. Prepare some questions first; a few should be about the candidate's past experience and a few about their suitability to the job on offer. Treat all candidates in the same way. It is a good idea to end by asking the candidate to explain what they understand the job to entail, to ensure that you are both in agreement. You need to assess whether the candidate's expectations of the job would be fulfilled if you took them on and, of course, whether they would be capable of doing the job competently.

Bear in mind that it is against the law to ask questions that may be interpreted as sexist, racist, ageist or discriminatory against disabled people. It is worth familiarising yourself with employment legislation before you even advertise for your first employee.

Most employers offer second interviews to two or three people.

3. Job offers and contracts

Once someone has verbally accepted your job offer you need to send them a letter confirming salary, hours, the start date and basic terms and conditions. You both need to sign and date copies of this letter. A contract need not be overly complex; even a simple one helps ensure that you both understand what the employee's responsibilities will be.

The contract should include:

- The job title and a job description
- Name and address of employer and place of work
- Start date (and finish date, if applicable)
- The length of the probationary period, which is commonly three or six months. Make it clear that employment can be terminated immediately during the probationary period

- The salary and when it is paid, e.g., paid monthly in arrears
- Benefits such as bonus schemes, pensions, holiday leave, discounted goods
- The hours to be worked
- The notice period for both parties (generally one month)
- Confidentiality clause, e.g., forbidding the employee from taking key clients to a future employer
- Your system of warnings for misconduct and disciplinary procedures (see below).

Some employers include a training manual with their job offer (see the section on training, below).

Paying staff

1. Setting up a payroll

Staff will be paid through HM Revenue & Customs' 'pay as you earn' (PAYE) scheme. Once you register as an employer with the Revenue they will send you tables so that you can work out how much tax and national insurance both you and your staff should pay. If you find the tables hard to understand, there is a number you can call and staff will help you. The HM Revenue & Customs website is very helpful and there are guides on important matters, such as how to pay statutory sick pay, that can be downloaded.

Employees who are foreign nationals should be paid through the PAYE scheme, whether they are from within the EU or not. Even people who will only be working for you on a short-term basis must be paid through the PAYE scheme.

People who are self-employed, and are therefore working for you as contractors on a part-time basis, need to invoice you before they are paid, and their invoice must include their Self-employed Tax Office Reference Number. They must have other contracts or are likely to be considered to be employed by you by the Inland Revenue. It is important that you follow the correct paper trail here, otherwise you may find yourself liable for their back-dated tax. Self-employed people do not generally receive benefits such as holiday pay, sick pay and paid lunch hours and they handle their own tax and national insurance payments.

There are computerised payroll systems, though retailers employing one or two people may not bother with these. Payroll is an aspect of

running a business that can easily be outsourced to a book-keeper; retailers are generally very busy so this may be a sensible task to delegate, though you should not delegate it solely because you fear it will be too complicated. Managing a payroll is not difficult once you have a system up and running, though it may take time to ensure that you have understood everything at the beginning.

Both income tax and national insurance will be deducted from their gross salaries, and you have to make contributions as well. As a small employer you will probably have to pay this each quarter, so long as you meet the right criteria, otherwise you will pay monthly. Some employers also deduct pension contributions. Your deductions from salaries will be adjusted if your staff are eligible for tax credits, statutory sick pay, maternity pay, paternity pay or the student loan deduction scheme.

You need to give staff a payslip each time they are paid, detailing how much tax and NI have been deducted. Once a year you must provide both your staff and the Inland Revenue with a summary of all deductions and pay.

You do need to keep up to date with changes, for example the amount people can earn tax free changes annually, though the Inland Revenue will send you amended tables which reflect any important changes. In the 2006/7 tax year people can earn £5,035 before they pay any tax. In 2008 the basic rate of tax will be a flat rate of 20 per cent, while it is presently 22 per cent with only ten per cent tax paid on the first £2,151 of taxable income.

2. How much to pay

The results of *Art Business Today's* wages survey begins, 'The good news is that art and framing employees must love their jobs - they are unlikely to be motivated by financial gain alone.' In other words, rates of pay are very low. The industry's predominantly female part-time workforce is likely to earn a little under £7 per hour. Very few employees are paid more than £10 an hour. Exact rates of pay are determined by the going rate locally, rather than by what other framers across the country are paid.

Though rates of pay are low it is important not to fall foul of the minimum wage. The national minimum wage will be £5.52 per hour for

people over 22 from October 2007, and this figure is likely to change annually. The rate for 18 to 21 year olds will be £4.60 and the rate for 16 and 17 year olds will be £3.40 per hour.

Framers are generally paid more than sales staff; sales jobs in art and framing retail are mainly on a lowly scale as the owners handle most sales.

3. Part-timers

Since it is likely that most employers in this sector will take on part-time staff it is important to remember that it is a legal requirement for part-timers (less than 30 hours a week) to earn the same pro-rata as full-time workers who are doing the same job. The 2000 Part-time Workers Regulations mean that part-timers must receive the same hourly rates, overtime, sickness pay, holiday entitlements and access to training as full-timers (on a pro rata basis). Part-time workers have the same statutory rights as full-time staff.

Employment law

Bear in mind that employment law changes all the time and you must keep up to date with the major changes to avoid the risk of negative publicity and time-consuming, expensive employment tribunals. Best practice will also help you provide a happy workplace and develop a stable workforce. The Department for Business, Enterprise and Regulatory Reform website (see Appendix: Useful contacts on p.224) is a good place to start; it provides up-to-date practical advice, handbooks and useful weblinks. Fine Art Trade Guild members benefit from free access to online employment and health and safety advice.

1. Personal safety

Under Occupational Health & Safety legislation, particularly the UK's Health & Safety at Work Act 1974, employers have a legal duty to ensure that employees feel safe at work. It is not legally acceptable for employers to think that abusive customers are 'an inevitable part of the job'. This important issue is discussed in Chapter 2: The formalities, under the sub-heading 'Security and personal safety' (p.222).

2. Rights for families

Employees have maternity and paternity rights, as well as the right to ask for flexible working time if they are caring for children under a certain age.

People whose children are younger than six, or with disabled children under 18, are entitled to ask for flexible working hours. You do not have to accept their request, but you have to be seen to consider it carefully and can only reject it if it would adversely affect the business to accommodate the suggested working hours. Family-friendly and flexible working practices can help to keep employees happy, productive and loyal.

Women are presently entitled to maternity pay for 39 weeks and 52 weeks maternity leave. Employers pay statutory maternity pay through their PAYE system, but can then claim it back from HM Revenue and Customs. (To qualify for statutory maternity pay women must have 26 weeks continuous service by the end of the fifteenth week before their baby is due, and they must have earned at least an average of £84 a week.) There is a common misconception that the employer has to foot the bill for maternity pay, rather than the government, which is not the case. Maternity pay is currently 90 per cent of average earnings for the first six weeks, and then a flat rate of £111 per week (or 90 per cent of average earnings if that is less) for 33 weeks.

Statutory paternity pay is currently £108.85 per week or 90 per cent of average weekly earnings if this is less. Men only qualify if their average weekly earnings are more than £84 a week and they are allowed a maximum of two weeks off.

3. Young workers

A 2003 amendment to the Working Time Regulations state that people aged between 16 and 18 cannot work more than eight hours a day and 40 hours a week. There are exceptions to this rule, but employers should err on the side of caution.

4. Disciplining and getting rid of staff

Disciplining staff is no fun and the best way of avoiding this unpleasant task is to take care when recruiting, to train staff properly (see below), to motivate staff (see below) and to play to their strengths.

Employees can generally only claim unfair dismissal if they have worked for you for at least a year. To dismiss someone fairly you need to be seen to have acted reasonably, which involves listening to the employee's side of things and not, for example, over-reacting in a fit of rage.

You must outline your dismissal and disciplinary procedures and include these in employees' contracts. If you stick to these you are far less likely to be found guilty of unfair dismissal. Below are the steps you should take:

- Informal action - talk to the employee and offer training, etc.
- Hold a disciplinary meeting and give an allotted time for the employee's performance to improve. Explain that next time there will be a written warning. Keep 'minutes' of the meeting and give a copy to the employee
- Once the allotted time is up, and assuming the agreed improvements have not materialised, hold a second meeting. If the employee cannot offer a satisfactory explanation issue your first written warning
- After the given time has elapsed issue a final written warning if warranted
- If there is still no improvement you need to follow a three-step dismissal process. Employees should be notified of their right to appeal and to be accompanied to all disciplinary meetings.

Summary dismissal without notice or pay may be justified in cases of gross misconduct. However, always take legal advice before commencing disciplinary proceedings, to be certain of your grounds and the latest legislation.

Training

More than a third of small and medium-sized businesses in the UK don't train their staff, according to the government. This lack of training can stifle the chances of such companies surviving and growing. Improving the skills of your workforce, whatever its size, helps your business run more efficiently, keeps customers satisfied, helps to win orders and motivates staff. A skilled workforce is more likely to take pride in the quality of its work and to strive for perfection. Skilled employees are more likely to enjoy their jobs, and happy employees can only benefit a business.

In today's marketplace art and framing retailers need to offer the best possible advice and guidance; they also need the skills to make high quality frames and deal with customers professionally. These goals would be unattainable without proper training for both owners and staff.

The options for training are endless; you need to decide which would be useful and appropriate for you. There are organisations lining up to sell training programmes and there are grants available to encourage you to put training initiatives into place, whether they be professional or skills based. There are three common barriers to staff training: financial cost; worries about demands for higher wages; worries about the disruption of work.

Professional framers should recognise the value in qualifying as Guild Commended Framers, and employers should support their framing staff towards taking the qualification. Framers, however experienced and talented, learn a lot from the process of qualifying and workforce skills give a competitive advantage. See the section on framing in Chapter 9: Which services to offer (p.96) for information on the GCF qualification.

Many retailers opt for 'on the job training', as opposed to using specialist training providers, though there are some excellent framing courses listed at the end of this book in Appendix: Useful contacts (p.222). In other words, it may be more cost-effective to train your staff in your own premises than to send them off to a training course, at a cost of a few hundred pounds per person. Don't feel that training is not valid because it is carried out in-house; judge by end results. If your staff emerge, for example, with a thorough understanding of the Guild Commended Framer Study Guide and the ability to pass the exam, then your in-house training must be up to the standard of this important industry benchmark.

Your business plan should outline your future plans, your unique selling point and your aims. These points will all affect your strategy for training. For example, if your niche is that you offer great technical expertise and product knowledge, then your staff need to be trained to do this.

Once you are certain of the areas in which it would be productive to train staff, and how training them would help you achieve your clear

goals, you should compile a list of the skills they need to acquire. There is no point in training staff to a higher level than is necessary for them to do their job as well as possible; you would not see a good return on that level of training. Training has to be focused if it is to be worthwhile. And you must continually analyse your business needs; if the business is changing, so must your training programme.

Many retailers have a 'training induction programme', which need only be a few pages long, and it need not take more than a couple of hours to compile such a document. This simple checklist should outline the skills which employees need to master in order to provide the correct level of service to customers. It should include simple, but important, standards such as that the telephone should not be allowed to ring more than four times before it is answered. It should explain, for example, the correct method of using the cash register, how credit card payments should be processed, the knowledge required to sell conservation mounts to customers, how to use your frame pricing software and various housekeeping matters.

The Guild Commended Framer Study Guide should be the basis of all framing training programmes, as the standards set out in this manual are accepted across the framing industry as being the benchmark of good practice. The good news is that this means you don't need to start from scratch when compiling a framing training programme.

Employers should send their training induction programme out with their offer letters when they appoint new staff. They should explain that this is the level of knowledge required and that it will (typically) take three to four weeks to work through it.

Once you have an induction programme, in order to ensure that the business and staff benefit from it, basic instructional techniques need to be employed. These can be covered in four simple steps:

1. Explanation
2. Demonstration
3. Imitation
4. Consolidation.

Keep checking that employees have mastered each point on the list until you are certain that they can carry out each task competently. Training should not end until you have ticked every box; listen to

them, watch how they progress and maybe offer further explanation and demonstration until they have mastered each task.

Training does not need to be expensive or complex, but it does need to be thoughtful. It should be properly integrated with your business plan, to ensure that it is clearly directed towards helping you achieve your pre-set goals. Remember that training and planning are inseparable.

Motivating staff

Since most art and framing businesses are managed by the owners it should be obvious to most employees that the opportunities for promotion are minimal. Staff are therefore probably not ambitious and the section on how much to pay (above) shows that most are not financially motivated. The chances are that staff like the job because it is convenient, the working environment is flexible and there are fewer pressures and issues with office politics than in big organisations. Many art and framing employees are artists themselves, and one of their motivations for working is access to discounted art materials and framing. Such employees tend to value a friendly happy atmosphere without much stress.

You need to play to these motivations. There is no point, for example, in 'rewarding' staff by involving them in business decisions when they know they will never be running the business and are not motivated by an interest in this. Instead, you need to ensure that the atmosphere in the workplace is upbeat and try as hard as is reasonably possible to be flexible and accommodate the other commitments of part-time staff. If your staff are artists, you could consider letting them get creative with window displays, shop design and even advertisements and marketing material.

Chapter 18

Case studies

Case Study 1

This is an analysis of a real award-winning art and framing business, which has been trading for 19 years in a prosperous city with a population of 80,000.

The legal status of the business is a partnership and there are two partners. The partners paid £11,000 for the 'goodwill' of an existing framing business in 1989. At that time, the business was based in rented premises.

Bricks and mortar

The business has two outlets in the city: a good secondary high street location, which was bought in 2000 for £180,000, and a unit in a small city centre shopping mall, which was opened in 1998. The first outlet is a framing business, while the second is a retail gallery. The framing business is freehold but the purchase was funded via a self-invested personal pension with a rent set at £18,000 per annum to be paid over ten years (you do not pay tax on the capital appreciation of a property if it is owned by a pension fund). The annual rent and service charges on the gallery are now £45,000, the size of the gallery having doubled in 2005.

The frame shop has now been purchased outright, is valued at £400,000 and occupies four floors with a 300-square-foot shop area. The framing area occupies 1300 square feet, and there is also a kitchen and bathroom. 20 square feet are given over to displaying framed mirrors, but otherwise the space is for bespoke framing.

The total sales area of the gallery in the shopping mall is 800 square feet. This is devoted to selling limited editions, *giclées* and screen-prints, both framed and unframed, as well as a small range of ready-made frames. The gallery sells an extensive collection of images of the city, introduced in 2006. The shop takes bespoke framing orders which are carried out in the main workshop.

Customers

80 per cent of the frame shop's customers are prosperous middle class individuals aged between 30 and 50, and 90 per cent of customers are from the city or within a 15 mile radius. The ten per cent of customers from other areas include tourists from the USA, New Zealand and the Middle East and people who have moved away but are loyal to the business because they cannot find the quality they require elsewhere. Some customers are professional artists and the business also serves local city museums and galleries.

The customer base at the gallery is more prosperous, but it is still focused on the 30-50 age range. 80 per cent of customers are couples; regular visitors to the city who come to enjoy themselves and spend money.

Finances

The annual turnover of the business for the tax year ending September 2006 was £650,000.

The company's turnover is split roughly 50/50 between the two outlets. 70 per cent of the business's total turnover is from bespoke framing; ready-made frames account for three per cent; five per cent is unframed prints and posters; and 22 per cent is framed prints and posters.

In the year ending September 2006:

• The net assets of the business were audited at £790,000
• Sales totalled £650,000

- Expenses totalled £284, 000
- Profit for the year before tax and drawings by the partners was £167, 910.

Staffing

The frame shop employs:

- One full-time partner
- Four full-time framers
- One full-time sales assistant/administrator.

The gallery employs:

- One full-time partner
- Two full-time sales persons.

Opening Hours

Frame shop:
8am-6pm Monday to Friday
9am-5.30pm Saturday

Gallery:
9.30am-6pm Monday to Saturday
11am-4.30pm Sunday

Suppliers

This company buys from:

- 12 framing suppliers
- 13 print publishers
- 6 artist-publishers
- 10 local artists and photographers producing images of the city.

The partners visit the Spring and Autumn Fairs and use the trade press to source new suppliers, publishers and artists, but also receive calls and mailshots from a whole host of trade suppliers. The company specifically targets moulding manufacturers and print publishers who can provide products that are not mainstream – they remain fiercely independent.

Marketing and advertising

This company has a very high profile. The partners firmly believe that their active ongoing promotional and marketing campaigns have played a key part in their success.

1. Sponsorship

Sponsorship is the most effective and positive marketing tool for this business. Customers perceive that the business is giving back to their community, whilst targeting the right events and audiences brings measurable business. Examples range from frames and prints for charity functions, supporting musical and theatre events, donating time and products to schools, hospitals and other needy causes. The business is highly selective about what to sponsor; the partners need to feel confident that sponsorship will produce results.

2. Advertising

The business is in the usual telephone directories, but beyond that the partners are very ruthless as to what and when. They try to tie adverts to events or awards, rather than just booking them because a sales rep calls. The partners believe that editorial desks will support you if you support them with advertising, so they place some ads with the local press. Their preferred media are glossy magazines, shopping guides, local newspapers (not free ones) and local homes and gardens magazines. They are careful to search out those that will reach their target market.

3. PR and press releases

The partners strive to be creative with newsworthy stories and are strongly aware of the benefits of media coverage that exposes their business to the public at large. They believe that local newspapers are desperate for copy and the secret is to make it easy for the editors by providing clear, well written copy and attaching photographs. The business is hugely successful at achieving media coverage with both art and business stories. The partners take the trouble to nurture relationships with local media personalities. With a few exceptions, all PR is done inhouse.

4. Window dressing

The partners take presentation a step further than many retailers; huge effort goes into their award-winning windows, which often attract media coverage. They are keen to enter any window dressing competitions, as

success leads to effective publicity. Their designs are occasionally over-the-top and they value thinking big and being creative. All windows are done in house, and great care is taken to ensure they appear professional.

5. Leaflets

The company has recently produced a twenty-page magazine about their workshop and gallery. This is unusual for a high street retailer, but has been overwhelmingly successful in raising their profile and bringing in business. 14,000 were printed, 10,000 of which were distributed within a city glossy magazine. They also print A3 folded, double-sided leaflets for mailshots.

6. The internet

There are separate websites for the frame shop and gallery, which comprehensively detail the activities of the business, but customers cannot buy online. The websites have been recently re-vamped resulting in increased hits, enquiries and indirect sales. The partners paid a web designer to re-vamp the sites and they pay a host to deal with day-to-day problems, but are able to update the news pages themselves. The business does not do any online advertising. They regularly communicate with customers by email but newsletters, invitations, etc., are posted.

7. Branding and logo

The partners see it as important to develop long-lasting recognition with a strong brand and logo. This is used on: all correspondence; advertising; sponsorship; stationery; vehicles; clothing; plastic bags; the shop front; and wrapping tapes.

8. Private views

These are held in the gallery on a quarterly basis. Shows are based around: significant changes of stock; new collections; seasonal events (Christmas, Valentine's Day); an individual artist's work; and exhibitions by genre.

9. Other activities

The business plays an active part in the community by being involved with local events and projects, such as: chairing the local street committee; sitting on festival and arts group committees; being a Prince's Trust mentor; organising local promotional events; entering competitions organised locally, as well as by trade suppliers and trade magazines.

10. Awards

The partners enter many competitions, such as: the Fine Art Trade Guild business and framing awards; the local 'city in bloom' contest; local window dressing competitions; street cleanliness awards; local business competitions.

Sales and offers

The partners held their first sale in the gallery this year, after ten years' trading, in order to shift a small amount of stock that had stuck. Selected items were reduced by 20 per cent for a four-week period. There has never been a need to hold a sale in the framing business.

Computers

The business has a strong database and keeps in touch with customers via mailouts, particularly newsletters and invitations. The business has not embraced all aspects of computerisation; it does not have a computerised mountcutter, frame pricing software, barcodes or computerised accounts.

Accounts

The business employs a book-keeper to handle (manually) day-to-day and VAT accounting matters. An accountant handles the payroll.

Future expansion

Many owners of a business as successful as this one would expand further. However, in common with many art and framing retailers, the owners recognise their business is highly personal and expansion would mean taking on shop managers. They would therefore lose essential direct contact with the customerbase and managers are unlikely to be as motivated as the owners, so further outlets would be less profitable.

A further 400 sq ft of workshop space has been purchased recently which helps cope with an increasing workload, and accommodates a new double-mitre saw.

Case Study 2

The art and framing business studied here is typical of many smaller art and framing businesses. It was established 15 years ago and is now based on the high street of a small town with a population of 4000.

The business has one owner whose legal status is that of a sole trader. The business originally focused on framing and was run from the owner's home, but following requests from customers to provide them with artwork the owner made the decision to acquire commercial premises, which were taken on in 2004.

Bricks and mortar

The business has a shop window on a high street with good passing trade. The framing workshop is behind the main gallery and all framing is carried out on site. The shop is leased from a private landlord.

Products and services

The USP of the business is 'we can frame anything', so object and needlework framing are specialities. The owner has qualified as a Guild Commended Framer. The business retails limited edition prints, dog prints, original artwork and takes portrait commissions. A dry mounting and laminating service is also offered.

Customers

95 per cent of customers are private individuals, mainly couples in the 30 to 55 age range. The buyers tend to be women, who come in with their partners on Saturday, make decisions over the weekend, and very often come back to buy on Monday. In other words, Saturday is not the busiest day for this business, it is the day when men come in to browse. Most customers live within 15 miles of the shop.

Finances

The annual turnover of the business for the tax year ending March 2006 was £59,000.

87 per cent of the business's turnover is accounted for by framing; 12 per cent by prints; and one per cent by original artwork.

In the year ending March 2006:
• The net assets of the business were audited at £21,500
• Sales totalled £59,000
• Expenses totalled £21,000
• Gross profit was £33,500

- Profit for the year before tax and drawings by the owner was £13,000.

Staffing

The owner works full-time and employs three part-time staff. One member of staff is an all-round framer; the second cuts mouldings and assembles frames, but does not operate the mountcutter; the third helps with general administration. The owner handles most of the sales.

Opening hours

The shop is open 9-5pm in the week and 9-4pm on Saturday. None of the local shops open on Sunday. The shop opens longer hours before Christmas; local retailers get together and agree when it would benefit them all to open late.

Suppliers

The business buys from three framing suppliers. One fulfils most requirements and delivers on a weekly basis, which means the owner can keep stock levels low. Two other suppliers provide more specialist picture frame mouldings.

Two of the UK's best-known print publishers supply most of the gallery's prints. The owner also takes artwork on sale or return from artists, most of whom initially approached the gallery.

Marketing and advertising

The business markets itself in the following ways:

- An annual Yellow Pages advertisement, which is part of a Fine Art Trade Guild members' display ad
- An ad with Yell.com
- Ads in local and regional magazines
- Ads in town guides
- Sponsorship of the town's summer show, as well as supporting local playgroups, church initiatives and other local events and causes
- One private view is held each summer, which stirs up business during a quiet time
- The business has a website, though this is more of an information point than a major marketing tool. The owner is responsible for

uploading new images. The business does not carry out e-marketing
- Press releases are sent out very rarely
- The business has had leaflets printed in the past but did not see a good return on this activity
- Window dressing and display are done by the owner
- The owner designs advertisements, which are generally laid-out by the publication concerned. The business's logo was designed with help from a graphic designer.

Sales and offers

The owner used to believe that people bought art regardless of price, but has since found that discounts do sell art. Therefore artwork that has been around for several months is marked with fluorescent discount stickers and put in the window.

Computers

The business uses a frame pricing program, but does not have a computerised mountcutter or use barcodes. The customer database is used to mail people about private views and is also invaluable for checking which frame designs people have bought in the past, so these can be matched.

Accounts

The owner does the accounts on an Excel spreadsheet and is submitting the end of year accounts online for the first time this year. An accountant does the owner's personal tax return and advises on tax and business matters. The owner handles the payroll using forms supplied by HM Revenue & Customs, and finds that the Revenue's website, leaflets and telephone support ensure that this job is not complicated.

Case Study 3

This business is based in a county town with a rapidly growing population of 220,000.

The owner registered as a sole trader and started keeping proper accounts in 1999; before that he had been framing part-time at home and also had another job. For the first five years he did not draw a salary and all profits were re-invested in the business; he re-mortgaged his house and lived off savings.

The gallery grew from the framing business; the owner framed for many artists and saw that there were no galleries selling quality originals in his town, so he decided to open one. While the owner has never bought an existing business, he has on occasion paid a few hundred pounds for mailing lists and equipment from people who have been winding up art and framing businesses.

The gallery operates as a sole trader and is not registered for VAT, as the owner finds this simpler when dealing with artists who are invariably not VAT registered. The art materials and framing sides of the business have been formed into a limited company, which is VAT registered.

A unit in a new local authority-owned arts centre was additionally opened in 2007. This sells art books, magazines, hand-made jewellery and craft items. The venue was failing in its previous incarnation so the owner and a group of other art professionals sought funding to turn it into an arts centre. Local authority and Arts Council funding have been awarded for the project.

As the business has little passing trade, the owner has positioned it as a one-stop destination for anyone in the area who is interested in the visual arts. This is why he has diversified into several product groups, as people may come to buy one thing and end up buying others as well.

The business offers the following:

- An on-site framing department, which is the mainstay of the business
- A gallery selling original art, limited editions, artists' prints and photography
- A comprehensive restoration and conservation service for paintings, art on paper, photographs and frames
- Art books and magazines
- Painting and life drawing courses
- Sculpture, ceramics and art glass.

The business has a clear USP, which is that it sells quality products and services in a no-nonsense manner. The owner eschews the idea of art as a commodity that is cynically churned out in line with interior design trends. The business's niche is that its superior products are not available all along the high street. It plays an important role in supporting the local arts scene and ridicules art world pretensions.

Its marketing material stresses that all its framers are qualified Guild Commended Framers who can carry out specialist work and are used to working with valuable artwork.

The business boasts the county's only specialist art materials shop and offers a ten per cent discount to artists and art students. It does not sell the two market leaders, but focuses on offering carefully chosen quality products that are a little bit different, and which allow for slightly better margins (these are generally minimal on art materials).

A range of art courses are held in the gallery space. These cost around £75 for a five-week course which runs for two hours, one night a week. These are not a huge income stream, once life models and tutors have been paid, but the owner sees them as an interesting sideline and likes to see the venue being used properly. Also, they bring people into the shop, who buy artwork, framing and art materials. The tutors are artists for whom the owner does framing work.

Some conservation and restoration is carried out in-house, but if the item is of value or the work required is complex this is out-sourced to a leading conservator, with whom the owner has worked for many years and fully trusts.

Art books are supplied by leading specialist publishers such as Taschen and Phaidon Press. The gallery also sells quality art magazines such as *Tate Etc.* and *Ceramic Review*.

Bricks and mortar

The owner took on his first commercial premises in 2001, which were a unit in an industrial estate. After a couple of years he moved to a retail shop on a secondary site; in 2006 the landlord put the rent up by 70 per cent so the owner moved to his current premises.

The new 2500 square foot premises are in a converted factory, which has little passing trade and no shop window. These are rented on a three-year lease, which will probably be extended for a further seven years, and the rent is currently £10,000 a year. The landlord is an individual who owns a number of properties locally, and a managing agent is employed to handle his tenants.

About a third of the space, or 800 square feet, are occupied by the framing workshop. A further 400 square feet are taken up by the art materials. The rest is an open-plan gallery space.

Customers

The gallery and art materials shop serves a local clientele, while the framing website attracts private and corporate business from all over the UK, and sometimes abroad.

Due to the wide range of products and services on offer, the customer base is similarly wide-ranging. Artists, university students and sixth formers come in for art materials. People in the 30 to 60 age range are the biggest buyers of paintings, while the age range for buying framing is slightly younger.

Finances

The annual turnover of the business for the 2007 tax year was £128,000.

Percentage of turnover accounted for by each product group:
• Framing 65%
• Art materials 10%
• Art books and classes 10%
• Sales of art 15%.

In the year ending 2007:

• The net assets of the business were audited at £48,500 including stock, equipment, fittings and vehicle
• Sales totalled £128,000
• Expenses totalled £121,000
• Profit for the year was £7000 (*this was expected to be low for the first year following the move to new premises*)

The business is part of the Arts Council's Own Art loan purchase scheme, which allows people to buy art via an interest-free loan.

Staffing

The business employs the owner full-time, plus two other full-timers. Two of the three are qualified Guild Commended Framers and all share

in the rest of the jobs that need doing. At busy times another part-time framer helps out and members of the owner's family help with sales.

The new art centre outlet does not require full-time staffing; the unit-holders help each other on a rotating basis

Opening hours

10am - 5.30pm Monday to Friday
10am - 2pm Saturday

The owner recognises that he could probably do business on Sundays, but wants a day off.

Suppliers

A local wholesaler fulfils many of the framing requirements, and the business also buys regularly from three major national framing suppliers.

The owner tried selling artwork from the major publishers when he had a shop in a secondary position, but found that this did not sell (in his opinion you need high street footfall to sell mainstream art). The shop holds catalogues from a couple of major publishers of open editions, but these do not sell in a big way to his customers, who are more interested in art than wall décor. Occasionally interior designers and corporate clients look through the catalogues.

Original artwork sells best, and this is generally bought from artists on a sale or return basis. Artwork is made by UK resident artists and is carefully chosen (the business stresses that it does not sell imported art with an indecent mark-up). The business supports local artists and art and craft groups. Original art and artists' prints from big-name artists are available, often for several thousand pounds apiece. The owner scours the UK in search of exciting artwork.

Marketing and advertising

Most business is acquired via word-of-mouth recommendation. The second most important source is the website, which brings in a lot of framing work.

The owner finds grass-roots involvement with the local art community to be the next best way of generating new trade. The business works

with its artists to attract new framing business; for example, they receive discounted art materials in return for which they publicise the framing service at their exhibitions and on their publicity material. The owner also supports local events, village magazines and sponsors aspects of local art shows.

The business has tried Yellow Pages and local paper advertising, but has not found either to be successful.

The owner is currently working hard to re-establish the art side of the business, which has diminished since the move from a secondary retail site, so is beginning to hold quarterly private views and exhibitions.

Sales and offers

The business has never held a sale or discounted products (other than when the secondary high street shop was closing down and a sale cleared old stock, not always at a profit). The owner feels that this may be appropriate if you are selling mainstream reproductions from a high street site with good footfall, but would not work for him. Galleries selling artwork on commission from artists do not have the problem of being left with unsold stock, it is not necessary to discount framing and art materials are not sold with sufficiently high margins.

Computers

The owner enjoys technology and designed and manages both websites (for the gallery and framing business). The business has had a website since 1997, now receives 80,000 hits a month, and wins a lot of framing business from contacts made via the website. The owner works hard to ensure that his sites stay at the top of the search engines.

The owner uses a frame-pricing program, which he sees as essential. This enables consistent pricing, which would not be possible with a manual system, particularly when a wide range of materials and techniques are on offer.

The owner has a till with a barcode reader (which he bought second-hand). This is used for art materials, books and magazines, all of which are supplied with barcodes. Original artwork and frames are not barcoded.

The business does not have a computerised mountcutter.

Accounts

The accounts used to be done on an Excel spreadsheet, but in 2007 the owner switched to a Sage accounting package, which became necessary as the business grew. The owner does not enjoy paperwork so employs a book-keeper, who has a good understanding of Sage, one day a week. He also employs an accountant.

Case Study 4

This business operates from two high street locations; the framing workshop is in the heart of a town with a population of 17,000, while the art showroom is in a town with a population of 70,000. The area is an old industrial belt and is not particularly prosperous.

The owner opened his first shop in 1989, having gained some framing experience in the past. He opened with no capital and only the most basic hand-tools. The premises he wanted had been empty for some time so the landlord was prepared to let him pay his first week's rent in arrears. The shop was in a side street and was very small; the owner spent £50 on some basic shop fittings and got his first set of frame chevrons free from a supplier. To begin with, the owner could not afford to buy framing materials unless he took a 50 per cent deposit from customers, then went and bought the materials required for each job.

In 1990 he moved to larger premises and bought some secondhand equipment. In 1993 he heard that the owner of a gallery in a town four miles away was retiring, so he bought his lease from him. Once he had two outlets he had to employ someone, which he initially did via the Youth Training Scheme.

The owner began to draw a proper wage from the business in 1997. Prior to that he survived from his wife's wages and also had two part-time jobs.

In 2004 the business became a limited company following advice from the owner's accountant, who said this would be more tax efficient. Before that its legal status was that of a sole trader.

The business sells fine art prints, original artwork and a range of bronze statuettes. Some of its artists have international reputations, while other artwork is sourced from the local area. Some artwork is highly traditional in style and some is abstract and contemporary.

Limited editions start at around £40, with originals selling for up to £2000. The business does not sell open editions.

Its framers are qualified Guild Commended Framers and the business's USP is its wide range of specialist framing materials and museum quality framing service.

The business has tried diversifying into stitch-craft kits and digital printing, but has now made the decision to focus on the core business of art and framing. The owner believes that concentrating on what you do best maximises profit potential.

Bricks and mortar

One of the outlets is freehold, the other is leasehold, and each is about 600 square foot. The leasehold property is rented from a private landlord who has treated the owner very well. The rent is £9000 per annum, and the owner is half way through his second ten year lease.

The framing shop is now freehold. The owner's previous landlord attempted to put the rent up astronomically, so he made the decision to buy an empty shop next door for £35,000 in 2000.

Customers

Customers are locally based and 97 per cent are private individuals. A wide range of local people buy from the business, from various income groups. Not all customers are wealthy.

Finances

The annual turnover of the business for the tax year ending 2006 was £160,000. This was a poor trading year, and profits were lower than usual, largely because of problems with staff.

The framing workshop generates 40 per cent of turnover, and the retail unit 60 per cent.

In the year ending 2006:

- The net assets of the business were audited at £68,000
- Sales totalled £160,000
- Expenses totalled £89,000
- Profit for the year was £19,500, before tax

Staffing

The owner works full-time and also employs a full-time framer and two part-time sales staff.

Opening hours

The business is open five days a week from 9.30am - 5pm. It is closed on Wednesday and Sunday. The owner is often on the premises much earlier and is happy to stay later to accommodate customers.

Suppliers

The business now has accounts with three framing suppliers, one of which is only used occasionally. The owner used to have accounts with ten suppliers, but realised this was not efficient so made a conscious decision to rationalise his supplies.

None of the major print publishers supply the business. He buys from four key publishers, all of whom are professional yet small. He also works directly with artists.

Marketing and advertising

The only advertising the owner does is Yellow Pages, which works well for him. Local paper advertising is not successful in his catchment area. Sponsorship and involvement with the local art community are not an option in the business's location, which does not have a thriving art scene or any tourists.

Two leaflets are printed each year, which take the form of a newsletter, and are mailed to the business's database of 800 customers.

The owner and his staff are responsible for window dressing. The framing workshop window has no backdrop so that passers-by can see people actually making frames. Just two or three framed prints are in the window, plus a tower of frame chevrons, so that people can see straight away what the business does. The windows of the gallery are changed regularly.

The gallery holds one private view each year for one of its best-selling artists, and does not plan to extend this.

Sales and offers

The owner believes that holding sales would de-value his products and services. If an image has not sold he will discreetly take an offer from a customer, but would not advertise a proper sale.

Computers

A computerised mountcutter was bought in 2006 and the owner believes that this is the best thing he has ever bought. It automates a routine task and allows him to add value to frames with fancy options that take seconds to create.

A frame pricing program has been in use since 2001.

A wide-format digital printer was bought in 2002. He and a business partner planned to offer a printing and marketing service to local artists, but soon found that this was highly labour-intensive for little return.

The business does not use barcodes, as these are not appropriate to the types of products being sold.

The website was designed by the owner, who also updates and manages it. The site began as an information point, but people started emailing requests to buy artwork so it made sense to automate this with a secure online shopping option. A third party provider handles this, which currently costs £250 each year. People tend to buy established artwork online, rather than try out new artists.

A text-based HTML newsletter is regularly emailed to 400 customers. The owner has recently delegated this task to a member of staff. Customers can click on links which take them to particular pages of the website, and the owner can see how many people have visited his site.

Accounts

The accounts are all handled by the owner himself, who has used a Sage accounting package since 1997. His accountant checks the year-end figures and submits them to HM Revenue & Customs.

Appendix

Useful contacts

Organisations

Anti Copying in Design (ACID) Ltd
PO Box 5078, Gloucester GL19 3YB
0845 644 3617
www.acid.uk.com
An action group committed to fighting copyright theft

Artists' Collecting Society
17-19 Galway Road, London W2 4PH
0845 11122400
www.artistscollectingsociety.org.uk
An agency set up to collect fees for the Artist's Resale Right

The Arts Council
2 Pear Tree Court, London EC1R 0DS
0845 300 6200
www.artscouncil.org.uk
The national development agency for the arts in England, providing
funding for a range of arts activities

Arts Council of Northern Ireland
77 Malone Road, Belfast BT9 6AQ
02890 385200
www.artscouncil-ni.org
Supporting and promoting the arts in Northern Ireland

Arts Council of Wales
36 Prince's Drive, Colwyn Bay LL29 8LA
01492 533440
www.artswales.org.uk
For information and funding of the Arts across Wales

The Association of Illustrators
2nd floor, Back Building, 150 Curtain Road, London EC2A 3AR
020 7613 4328
www.theaoi.com

British Association of Paintings Conservator-Restorers
PO Box 258, Blofield, Norwich NR13 4WY
01603 858129
www.bapcr.org.uk

British Jewellery, Giftware & Finishing Federation (BJGF)
Federation House, 10 Vyse Street, Birmingham B18 6LT
0121 236 2657
www.bjgf.org.uk
A long established trade body, which includes the Giftware Association

Business Link
www.businesslink.gov.uk
An official government service, providing advice and information for new and small businesses. There is a main information website plus regional offices

Companies House
0870 33 33 636
www.companieshouse.gov.uk
The official UK government register of UK companies. If you decide to become a limited company you need to register here. There are regional offices plus a central telephone number and website

The Crafts Council
44a Pentonville Road, London N1 9BY
020 7336 8811
www.craftscouncil.org.uk

Crime Reduction Service
Home Office, Direct Communications Unit, 2 Marsham Street,
London SW1P 4DF
020 7035 4848
www.crimereduction.gov.uk
Provides information and resources to people working to reduce crime
in their local area

Department for Business, Enterprise and Regulatory Reform (DBERR)
1 Victoria Street, London SW1H 0ET
020 7215 5000
www.dti.gov.uk
The government body which works to create the conditions for busi-
ness success and help the UK respond to the challenge of globalisation.
Includes a range of information and business support services

Department for Work & Pensions
Contact details vary for each aspects of the department's work
www.dwp.gov.uk
The government department responsible for pensions and benefits

Design & Artists' Copyright Society (DACS)
33 Great Sutton Street, London EC1V 0DX
020 7336 8811
www.dacs.org.uk
An organisation set up to protect artists' copyright and, from 2006, to
collect the Artist's Resale Right

Directgov
www.direct.gov.uk
Public services all in one place. Links to sites of all central and local
government departments

The Embroiderers' Guild
Apartment 41, Hampton Court Palace, East Molesey, Surrey KT8 9AU
020 8943 1229
www.embroderersguild.com

Fine Art Trade Guild
16-18 Empress Place, London SW6 1TT
020 7381 6616
www.fineart.co.uk

The trade association for the art and framing industry. Develops and maintains industry standards. Qualifying body for Guild Commended Framer vocational qualifications. Publishes leading trade magazine *Art Business Today*. Publishes industry directory and product sourcing guide, *The Directory*

The Fire Service
Contact details vary by region
www.fireservice.co.uk
Website with information about fire regulations and best practice

Greeting Card Association
United House, North Road, London N7 9DP
020 7619 0396
www.greetingcardassociation.org.uk
The trade association for greeting card publishers

Health & Safety Executive
Caerphilly Business Park, Caerphilly, CF83 3GG
0845 345 0055
www.hse.gov.uk
An official service providing advice and information on health and safety at work

HM Revenue & Customs
Contact details vary by region
www.inlandrevenue.gov.uk
Your starting point for information on how to register for VAT and all tax matters

Institute for Conservation
3rd floor, Downstream, 1 London Bridge, London SE1 9BG
020 7785 3807
www.icon.org.uk
Formerly: Care of Collections Forum; Institute of Paper Conservation; National Council for Conservation Restoration; Photographic Materials Conservation Group; Scottish Society for Conservation & Restoration; United Kingdom Institute of Conservation

Nominet UK
Sandford Gate, Sandy Lane West, Oxford OX4 6LB
01865 332244
www.nominet.org.uk

A leading body for registering and managing website domain names

Office of Fair Trading
Fleetbank House, 2-6 Salisbury Square, London EC4Y 8JX
020 7211 8000
www.oft.gov.uk
Enforces consumer protection law

Scottish Arts Council
12 Manor Place, Edinburgh EH3 7DD
0131 226 6051
www.scottisharts.org.uk
The lead body for the funding, development and advocacy of the arts in Scotland

Society of London Art Dealers
Ormond House, 3 Duke of York Street, London SW1Y 6JP
020 7930 6137
www.slad.org.uk

Framing training

A-Frame Plus
Carmashee, Kilrush Road, Kilkee, County Clare, IRELAND
[353] 65 905 6653

Applegarth Framing
78 High Street, Repton, Derbyshire DE65 6GF
01283 703403

Art of Framing Training School
The Workshop, Great Down, Hog's Back, Farnham, Surrey GU10 1HD
01483 810555
www.fringearts.co.uk

Atkin Framers
12 Knightsridge East Units, Livingston, West Lothian EH54 8RA
01506 440300
www.atkin-framers.co.uk

The Bespoke Framing Company
Unit 15 The WENTA Business Centre, Colne Way, Watford, Hertfordshire WD24 7ND
01923 251568
www.bespokeframingcompany.com

Colliers
Milburn House, Dean Street, Newcastle-upon-Tyne, Tyne & Wear NE1 1LF
0191 232 3785/2819
www.colliersgallcry.co.uk

Cregal Art Limited
Monivea Road, Galway City, County Galway, IRELAND
[353] 9175 1864
www.cregalart.com

DIY Framing
Woodlands Farm, Burnham Road, Beaconsfield, Buckinghamshire HP9 2SF
01494 670411
www.diyframing.com

Down School of Picture Framing
6 Church Street, Dromore, County Down BT25 1AA
028 9269 3807
www.downschoolofpictureframing.co.uk

Galerie Lafrance
15 Pinewood Avenue, Northbourne, Bournemouth, Dorset BH10 6BT
01202 582957
web: www.galerielafrance.com

Hedgehog Art and Framing
21 Forest Close, Lickey End, Bromsgrove, Worcestershire B60 1JU
01527 876293
www.hedgehog-art.co.uk

LION Picture Framing Supplies Ltd
148 Garrison Street, Heartlands, Birmingham, West Midlands B9 4BN
0121 773 1230
www.lionpic.co.uk

Manse Studio
The Old Manse, Brecon Road, Bwlch, Powys LD3 7HJ
01874 730115
www.christinascurr.co.uk

Northern Framing School
37 Bedford Street, Sheffield, South Yorkshire S6 3BT
0114 272 2948

Royall Framing
Woodside Court, Hortham Lane, Almondsbury, Bristol BS32 4JH
01454 617022
www.royallframing.co.uk

Sports Framing Ltd
29 Booth House, Featherstall Road, Oldham, Lancashire OL9 7TQ
0161 665 2891
www.sportsframing.co.uk

Stowford Framing
Stowford Manor Farm, Wingfield, Trowbridge, Wiltshire BA14 9LH
01225 781274
www.stowfordframing.co.uk

Village Framing
29 Candover Close, Harmondsworth, Middlesex UB7 0BD
020 8897 7670 / 01895 824394
www.villageframing.com

Wessex Pictures (Croydon Branch)
Unit 2b Beddington Lane Ind Estate, 117 Beddington Lane, Croydon,
Surrey CR0 4TD
020 8683 0055
www.wessexpictures.com

Trade shows

100% Design
020 8910 7724
www.100percentdesign.co.uk
A leading interior design trade show

Artists & Illustrators Exhibition, London
020 7349 3150
www.aimag.co.uk
An exhibition of art materials aimed at artists

Autumn Fair Birmingham
020 8277 5863
www.autumnfair.com
A leading gift fair which includes greeting cards and art

Decorex
020 7833 3373
www.decorex.com
A leading interior design trade show

Home & Gift Fair, Harrogate
020 7370 8051
www.homeandgift.co.uk
A well-established trade gift fair

Maison et Objet, Paris
020 8216 3100
www.maison-objet.com
A well-established gift and homewares show, with two events each year

Paperworld, Frankfurt
020 7688 6655
www.paperworld.messefrankfurt.com
A trade show dedicated to paper products

Pulse by Top Drawer, London
020 7370 8051
www.pulse-london.com
A well-established trade gift fair

Spring Fair Birmingham
020 8277 5863
www.springfair.com
The leading trade fair for framing and art, with a hall dedicated to these products. There are also halls dedicated to gifts and greeting cards

Top Drawer Autumn, London
020 7370 8051
www.topdraweronline.com
A well-established trade gift fair

Top Drawer Spring, London
020 7370 8051
www.topdraweronline.com
A well-established trade gift fair

Useful further reading

Books

500 Years of Graphic Art Techniques
By Kristin Amderson
Published by FACTS
www.artfacts.org
£12.50 from the Fine Art Trade Guild

The Articles of Business
By Vivian Kistler CPF GCF
Published by Columba Publishing Company, USA
www.columbapublishing.com
ISBN 0-938655-28-0
£17.95 from the Fine Art Trade Guild

The Artist's Guide to Selling Work
By Annabelle Ruston
Published by A & C Black Publishers Ltd and the Fine Art Trade Guild
www.acblack.com
www.fineart.co.uk
ISBN 0-7136-7159-9
£9.99

The Art of Framing
By Piers and Caroline Feetham
Published by Ryland, Peters & Small

www.rylandpeters.com
ISBN1-900518-29-5
£25 from The Fine Art Trade Guild

The Art of Mountcutting
By Lyn Hall GCF
Published by the Fine Art Trade Guild
www.fineart.co.uk
£12.50

Collecting Original Prints
By Rosemary Simmons
Published by A & C Black Publishers Ltd
www.acblack.com
ISBN 0-7136-6847-4
£16.99

Conservation Framing
Published by the Fine Art Trade Guild
www.fineart.co.uk
ISBN 0-9526294-6-1
£7.50

The Directory
Published by the Fine Art Trade Guild
www.fineart.co.uk
An annual publication
£45

Framing Collectibles
By Vivian Kistler CPF GCF
Published by Columba Publishing Company
www.columbapublishing.com
ISBN 0-9386-55-29-9
£16.95 from the Fine Art Trade Guild

Framing Photography
By Alan R Lamb CPF
Published by Columba Publishing Company
www.columbapublishing.com
ISBN 0-93865-5-05-1
£16.95 from the Fine Art Trade Guild

Framing Fabric Art
Published by the Fine Art Trade Guild
www.fineart.co.uk
ISBN 0-9526294-1-0
£9.50

Good Small Business Guide: how to start and grow your own business
By Val Clark
Published by A & C Black Publishers Ltd
www.acblack.com
ISBN 0-7136-7501-2
£19.99

Guild Commended Framer Advanced Accreditation: Conservation Framing
Published by the Fine Art Trade Guild
www.fineart.co.uk
£25

Guild Commended Framer Advanced Accreditation: Mount Design & Function
Published by the Fine Art Trade Guild
www.fineart.co.uk
£12.50

Guild Commended Framer Advanced Accreditation: Textile Framing
Published by the Fine Art Trade Guild
www.fineart.co.uk
£12.50

Guild Commended Framer Study Guide
By Annabelle Ruston & Fiona Ryan GCF
Published by the Fine Art Trade Guild
www.fineart.co.uk
£12.50

How to Identify Prints
By Bamber Gascoigne
Published by Thames & Hudson
www.thamesandhudson.com
ISBN 0-500-28480-6
£19.95 from the Fine Art Trade Guild

Practical Gilding
By Peter and Ann MacTaggart
Published by Archetype Publications
www.archetype.co.uk
ISBN 1-873132-83-2
£11.50 from the Fine Art Trade Guild

Start and Run Your Own Shop: how to open a successful retail business
Published by How To Books Ltd
www.howtobooks.co.uk
ISBN 1-84528-046-6
£12.99

Magazines

a-n magazine

First Floor, 7-15 Pink Lane, Newcastle upon Tyne, NE1 5DW
0191 241 8000
www.a-n.co.uk
A magazine mainly read by artists and art students. Useful reading if you are thinking of selling highly contemporary art

Antiques Trade Gazette
Equitable House, Lyon Road, Harrow HA1 2EW
020 7420 6600
www.antiquestradegazette.com
If you will be buying at auction or need to source antiquarian prints this weekly newspaper would be useful

Art Business Today
16-18 Empress Place, London SW6 1TT
020 7381 6616
www.artbusinesstoday.co.uk
The leading trade magazine for the art and framing industry

The Artist
The Artists' Publishing Co. Ltd, Caxton House, 63-65 High Street,
Tenterden, Kent TN30 6BD
01580 763315
www.theartistmagazine.co.uk
This magazine aimed at professional artists is useful to retailers selling
art materials or offering art courses

Artists & Illustrators Magazine
The Chelsea Magazine Company Ltd, 26-30 Old Church Street,
London SW3 5BY
020 7349 3150
www.aimag.co.uk
This magazine aimed at professional artists is useful to retailers selling
art materials or offering art courses

Crafts Magazine
44a Pentonville Road, London N1 9BY
020 7278 7700
www.craftscouncil.org.uk
Published by the Crafts Council, this magazine is useful to those sell-
ing craft products

Galleries
Barrington Publications, 54 Uxbridge Road, London W12 8LP
020 8740 7020
www.galleries.co.uk
Various regional editions list galleries and exhibitions in major UK
cities. Useful way of seeing what other galleries are selling

Greetings Today
Federation House, 10 Vyse Street, Birmingham B18 6LT
01442 289930
www.ga-uk.org
A trade magazine for the greeting card industry

Picture Business
Unit 1, Hartridge Manor Barn, Paley, Cranbrook, Kent TN17 2NA
0845 370 7037
www.picturebusiness.uk.com
A trade magazine for the art and framing industry

Printmaking Today
99-101 Kingsland Road, London E2 8AG
020 7739 8645
www.printmakingtoday.co.uk
A magazine for printmakers and those selling artists' prints

Progressive Greetings Worldwide
Max Publishing, United House, North Road, London N7 9PD
020 7700 6740
www.greetingcardassociation.org.uk
A trade magazine for the greeting card industry

Index